into the wilderness

AN ARTIST'S JOURNEY

PAINTINGS AND PHOTOGRAPHY BY

Stephen Lyman

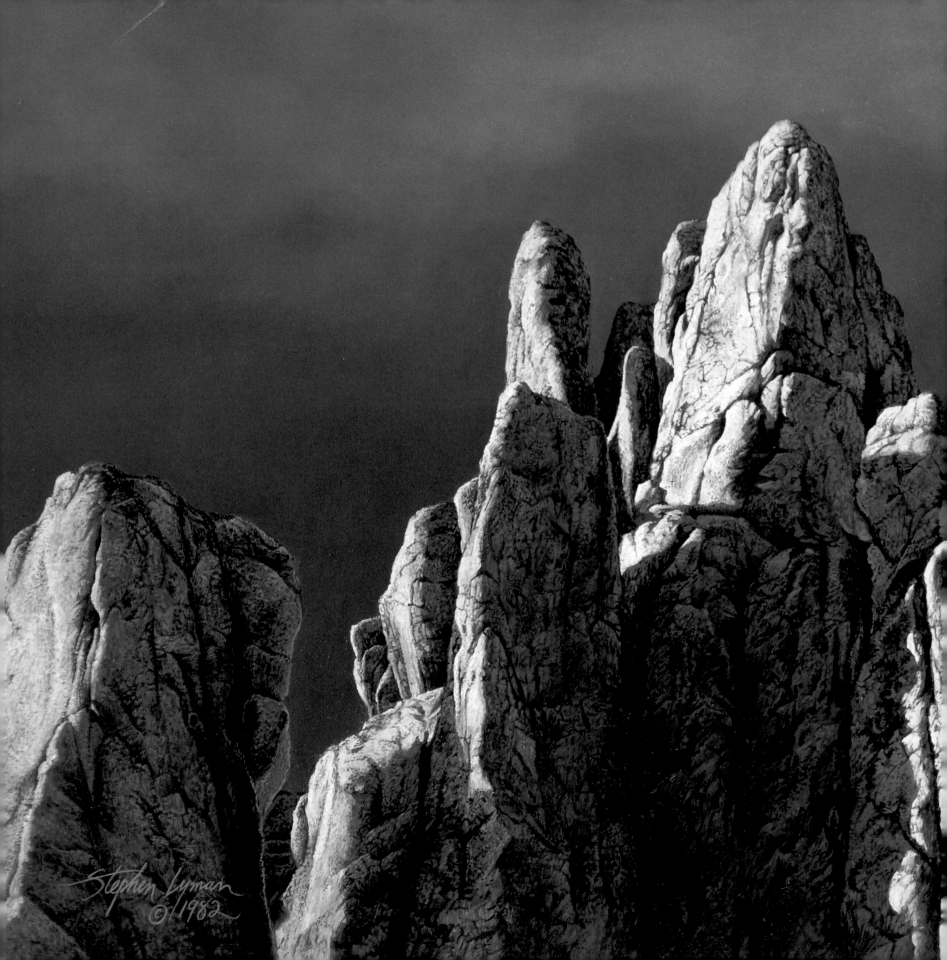

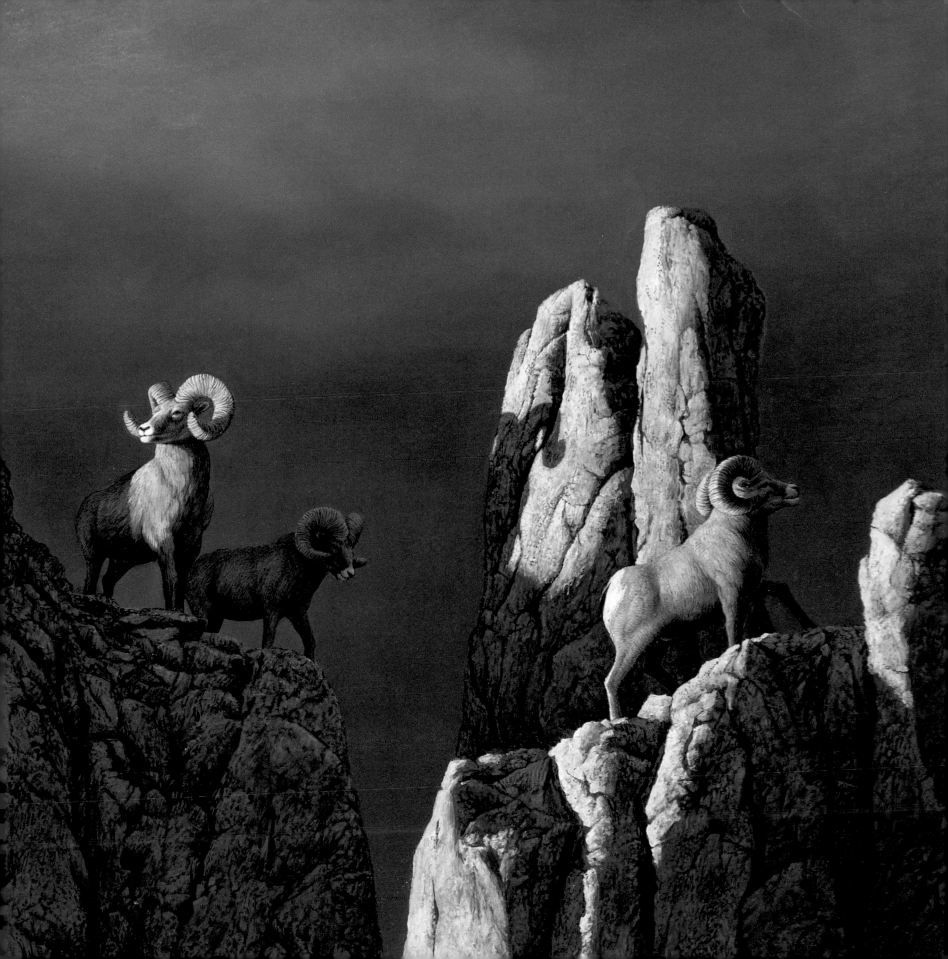

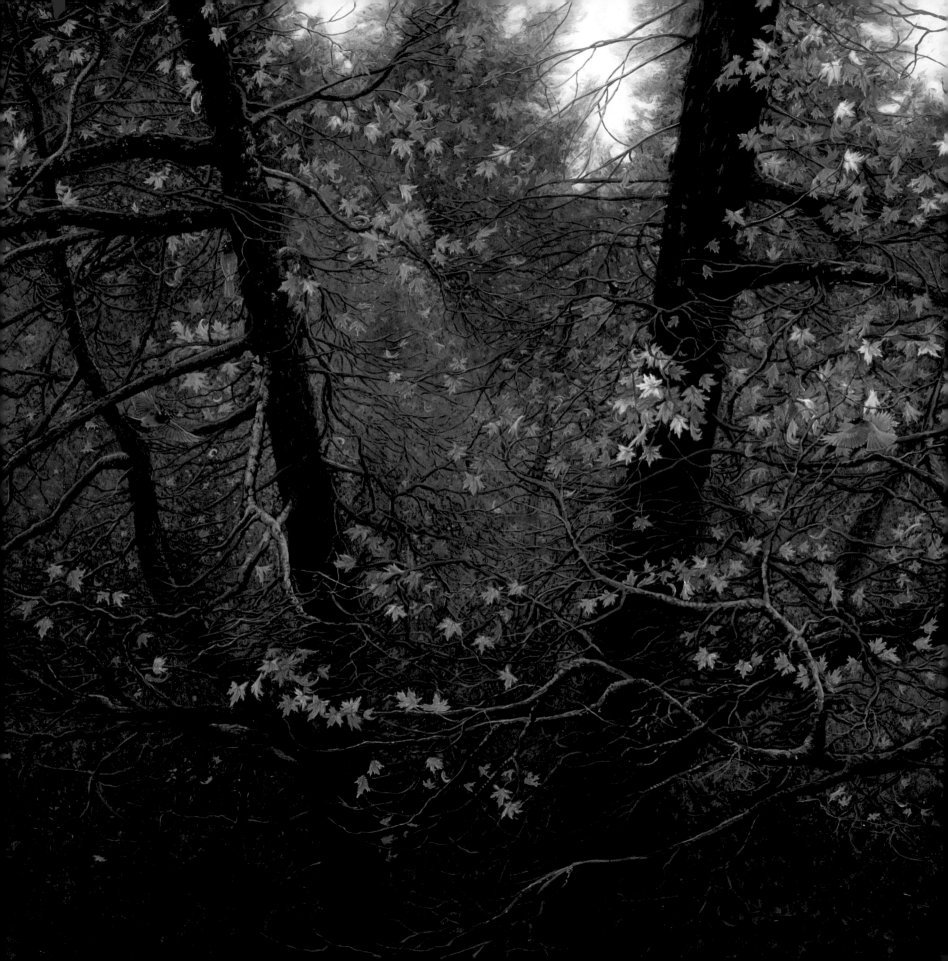

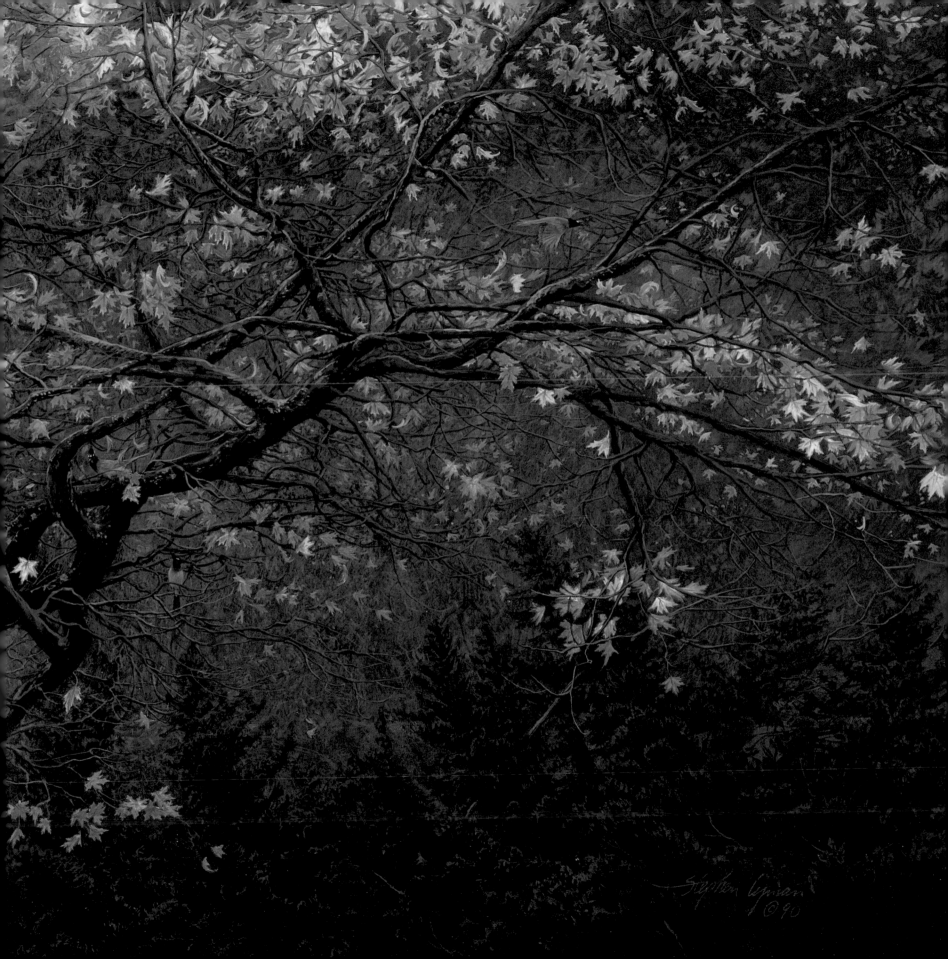

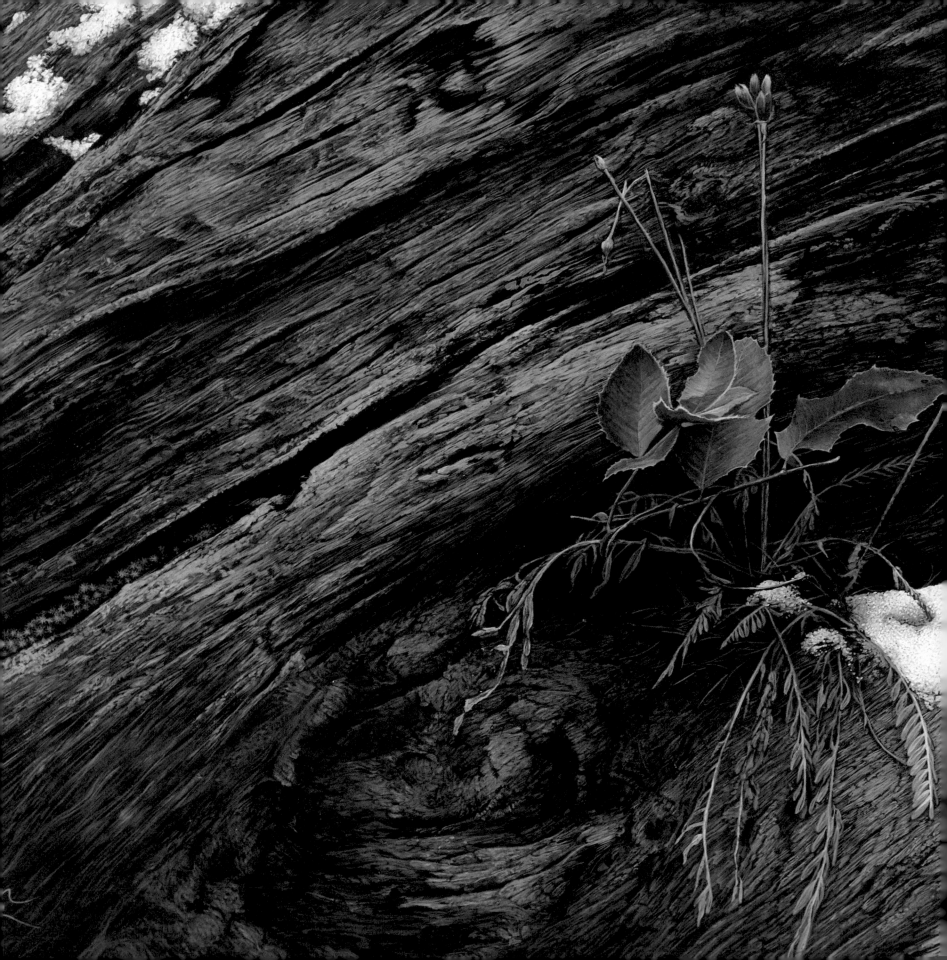

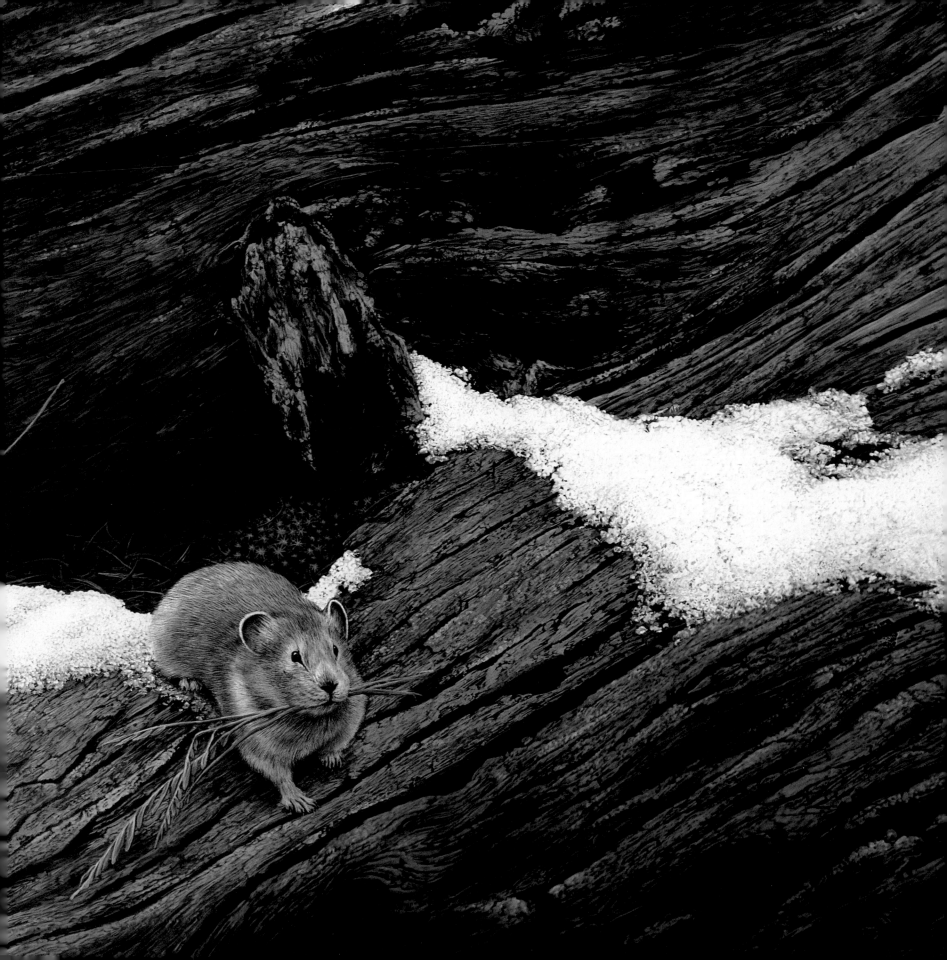

TEXT BY MARK MARDON
INTRODUCTION BY BEV DOOLITTLE

the wilderness

AN ARTIST'S JOURNEY

PAINTINGS AND PHOTOGRAPHY BY

Stephen Lyman

THE GREENWICH WORKSHOP

ARTISAN • NEW YORK

To Great Spirit
Who moves and lives through All

THANKS FROM THE ARTIST:

To my dear family, Andrea, Muir, and Jarré; my parents, Stan and Sylvia; brother, Scott; and sister, Shauna, who have all shared journeys with me into the wilderness, a deep and loving thank you; to the dedicated ones in the National Park Service and many other organizations who love and care for wilderness; to the people at The Greenwich Workshop, for joining me in the discovery of wilderness through my art, and collecting it into this book; to the Four-Legged Ones, who know wilderness as home and teach us how to live there; to the Winged Ones, who see the larger picture from above; to the Many-Legged Flyers and Crawlers of this world, who provoke us into seeing the Sacred at every level; to the Plant People, who live the bloom of life constantly; to miraculous Water, who keeps life flowing into myriad forms; to the Stone People, who ground life with ancient wisdom and mountains of beauty; to the Earth, who holds and nurtures us all.

Published in 1995 by Artisan, a division of Workman Publishing Company, Inc., 708 Broadway, New York, NY 10003.

Library of Congress Cataloging-in-Publication Data:
Lyman, Stephen.
 Into the wilderness: an artist's journey: paintings and photography / by Stephen Lyman; text by Mark Mardon: introduction by Bev Doolittle.
 Includes index.
 ISBN 1-885183-31-3
 1. Lyman, Stephen—Themes, motives. 2. Wildlife art—United States. I. Mardon, Mark, 1953– . II. Title.
N6537.L96A4 1995
759.13—dc20 95-9421
 CIP

The author and publisher have made every effort to secure proper copyright information. In the event of inadvertent error, the publisher will be happy to correct it in subsequent printings. The Greenwich Workshop extends grateful thanks for material that appears by permission of the following: Beaumont & Nancy Newhall Estate, courtesy of Scheinbaum & Russell Ltd., Sante Fe, New Mexico, for quote p. 16 by Nancy Newhall from *This is the American Earth*; St. Martin's Press, Inc., New York, for quote p. 21 by Edward Abbey from "A Voice Crying in the Wilderness: Some Notes from a Secret Journal" copyright © 1990 by Edward Abbey; North Point Press for quote p. 25 by Wendell Berry from *The Gift of Good Land*; David R. Brower for quote p. 34 by David R. Brower from "Wildlands in Our Civilization," June 1957 *The Sierra Club Bulletin* and for quote p. 65 about campfires by David R. Brower in the February 1940 *The Sierra Club Bulletin*; Viking Penguin for excerpt p. 87 by Gretel Ehrlich from *The Solace of Open Spaces*. Copyright © 1985 by Gretel Ehrlich. Used by permission of Viking Penguin, a division of Penguin Books USA Inc. Bantam Doubleday Dell for quote p. 87 by Wallace Stegner from *The Sound of Mountain Water*, an essay contained in a collection bearing the same name. © 1968 by Wallace Stegner.

Limited edition prints and posters of Stephen Lyman's paintings have been marketed since 1983 through The Greenwich Workshop and its 1,200 dealers in North America. Collectors interested in obtaining information on available releases and the location of the nearest dealer are requested to write or call:
The Greenwich Workshop, Inc., One Greenwich Place, Shelton, Connecticut 06484
(203) 925-0131 or (800) 243-4246

FRONTIS ART
2–3 Detail from *The Pass*
4–5 Detail from *Steller Autumn*
6–7 Detail from *Pika*

•

Book design by Peter Landa • Calligraphy by Philip Bouwsma
Manufactured in Japan by Toppan Printing Co., Ltd.
First Printing 1995
95 96 97 0 9 8 7 6 5 4 3 2 1

Contents

INTRODUCTION

1

THE UNSPOKEN REASON

14

2

THE EDGE OF THE WILDERNESS

32

3

INTO THE FOREST

58

4

AT WATER'S EDGE

84

5

TOWARD THE SUMMIT

114

6

THE PEAK EXPERIENCE

136

7

A HOME IN THE WILDERNESS

160

LIST OF PHOTOGRAPHS

178

LIST OF ARTWORK

180

INTRODUCTION

he paints the wilderness…with a knowledge and genuineness that can only be expressed by someone who has "been there"

I've known Steve since he first joined The Greenwich Workshop in 1982. When I was first shown some slides of his paintings I remember thinking then, "This guy's going to make it in this business!" I *love* it when my instincts prove right! I sensed a fellow with lots of energy, desire, sensitivity, and, most important, a deep reverence for the subjects that he paints. He paints the wilderness and its animal inhabitants with a knowledge and genuineness that can only be expressed by someone who has "been there."

He paints what he loves, what he knows, and he paints for himself—a combination that can only spell success.

Over the years I have enjoyed many accounts of his daring treks *alone* into the wilderness areas of Yosemite National Park in *winter*. My respect for Steve (on a scale of 100 points) soared to 99! The last point I chalked up to "folly"! I can't imagine myself hiking in freezing temperatures in a blizzard for days all for the sake of that wondrous photograph just over the crest. However, when you lay your eyes on the incredible collec-

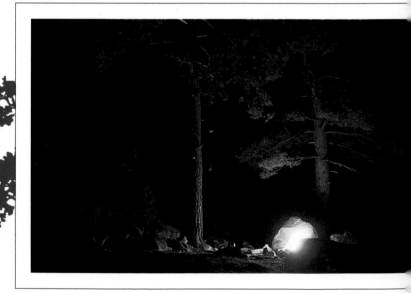

tion of photos in this book, you will know that the effort was worth every foot in elevation.

"Being there" at the right moment is what makes good photography great. It not only requires an artistic eye to see the endless moods, textures, and patterns of nature, but it helps greatly to be young and physically fit!

I think of Steve as "the *other* John Muir." He wears many hats…environmentalist, painter, photographer, outdoorsman, naturalist, writer, and explorer, not to mention husband and father!

It's not enough that Steve's developed great artistic skill. He's an artist with something to say, a "must" for any good artist. He has a passion for whatever he chooses to communicate to others, and it comes from the unique being that he is.

His sincerity of purpose and his reverence for the earth shine through in his artwork. I think this integrity of his approach to creating art is what captures the attention of his many print collectors and explains why his work is so popular. Through his art, he reminds us of the naturalness of nature. We can feel the heat from a campfire in

the cold of an alpine night, witness the magic of mist rising from a lake's surface in the morning hours, or feel the warmth of rim-lit sunshine carressing pine needles.

Nature is thrilling—its solitude, its peace. It is spiritual. Nature reminds us of who we are and how we fit into the web of life. Man was meant to be a part of nature, not live apart from nature.

Steve's artwork is a celebration of the beauty our earth provides for us in its many forms. The spiritual beauty of our wilderness presents endless possibilities for the artist. Captured here in this book are visions from the artist's eye as well as the soul.

Enjoy. —Bev Doolittle

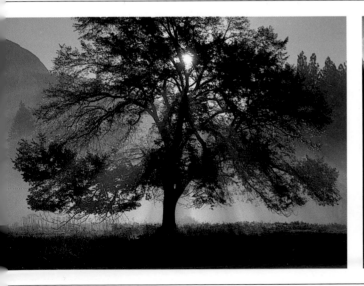

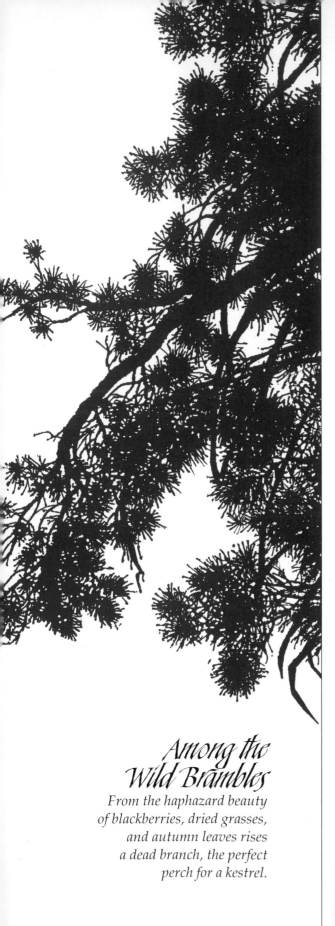
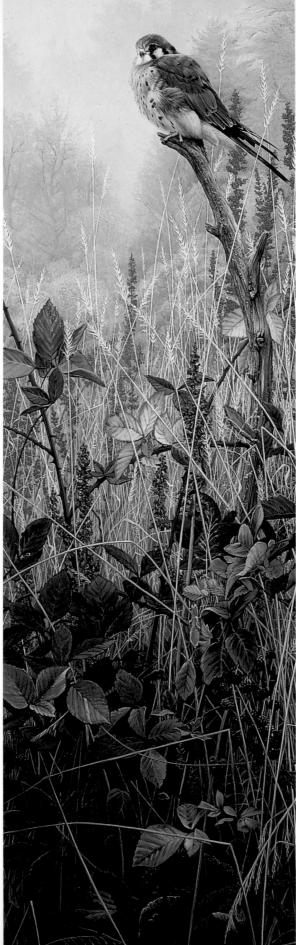

Among the Wild Brambles

From the haphazard beauty
of blackberries, dried grasses,
and autumn leaves rises
a dead branch, the perfect
perch for a kestrel.

THE UNSPOKEN REASON

the wilderness
holds answers
to more questions
than we yet
know how
to ask

THE UNSPOKEN REASON

*the wilderness
holds answers
to more questions
than we yet
know how to ask*

—NANCY NEWHALL

On an especially clear morning in Yosemite Valley, on the north bank of the Merced River, Stephen Lyman awakes from a night of slumber and for a long while remains stretched out in his sleeping bag, meditating on the scenery surrounding him. A sublime daybreak, he thinks, especially with craggy old Half Dome already exuberantly awake, busy catching and pitching back the first rays of a new spring sun. It is an image the artist has absorbed again and again on visits to Yosemite—this is his 35th trip to the national park in the last 17 years—and one that, as usual, fills him with an eagerness and anticipation verging on giddiness.

Why the feeling of such elation is hard to say precisely. Perhaps it's that the monolith's wise, wrinkled face, beaming down, beckons him to begin yet another backcountry adventure, promising myriad discoveries along the way. Or maybe it's that after too long a period of winter dormancy in his northern Idaho home, he will once more be shedding the habits of the artist's studio life to run and climb free in the wilds, reveling in

the majestic Sierra Nevada landscape, testing his mountain-climbing reflexes, regaining his bearings, stretching his senses to the limit.

His body is groggy at the moment, not from sleep but from a winter spent tending to work, family, and community. But soon he will rebound, as he treks cross-country toward hard-to-reach places recommended to him by Jim Snyder, Yosemite National Park historian and good friend. Jim has explored pretty much all of the park and knows which hiking challenges will earn Steve the greatest scenic rewards.

Within hours of embarking on the trail, he'll once again become fully alert, attuned to the subtlest natural phenomena: a tiger swallowtail butterfly emerging from its chrysalis after a long winter spent dangling from a twig, newly resplendent in its lemon-yellow and black-striped gossamer apparel; blossoms of dwarf huckleberry, livening a stream side, that will soon be yielding sweet berries for hungry black bears; the long, noisy *kaaaaa* of a Clark's nutcracker, flitting from tree to tree in search of a mate, its black-and-gray plumage

stark against the snowy ground at timberline.

Perhaps the simplest way the artist can explain his high spirits is to recognize his intense attraction to mountains and all the living things that abound in them, much like John Muir, his spiritual mentor. Through his explorations and paintings of the wild country of the American West, Steve exults in the variety and depth of feelings evoked in this, "the Range of Light," and its rocky kin in Oregon, Idaho, Alaska, and other rugged states. He never ceases to marvel at the way a Yosemite landscape can emerge and vanish and reemerge again as clouds and fog roll in and out of the valley. "It's rather like a dream sometimes," he says. "You turn your back for a moment and the mountain disappears."

With an artist's eye, Steve sees the mountains and valleys as Muir did, vivid in shadow and light. A "pale rose and purple sky changing softly to daffodil yellow and white," Muir wrote of a sunrise in the Sierra. "Sunbeams pouring through the passes between the peaks and over the Yosemite domes, making their edges burn."

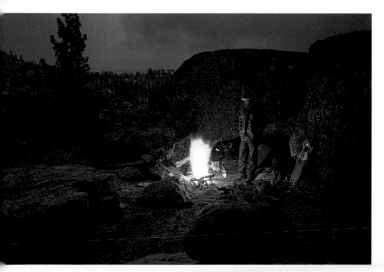
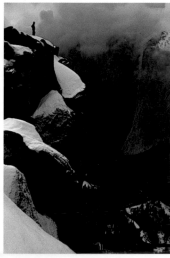
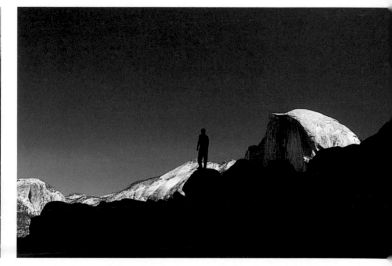

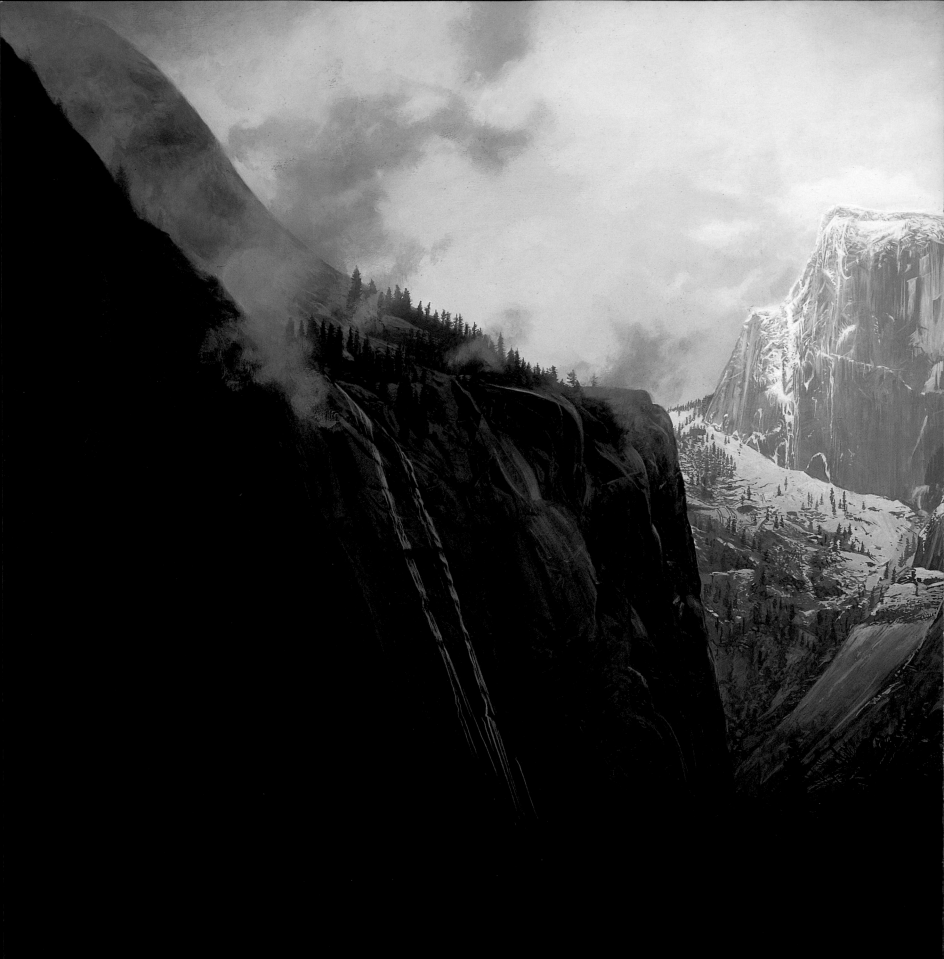

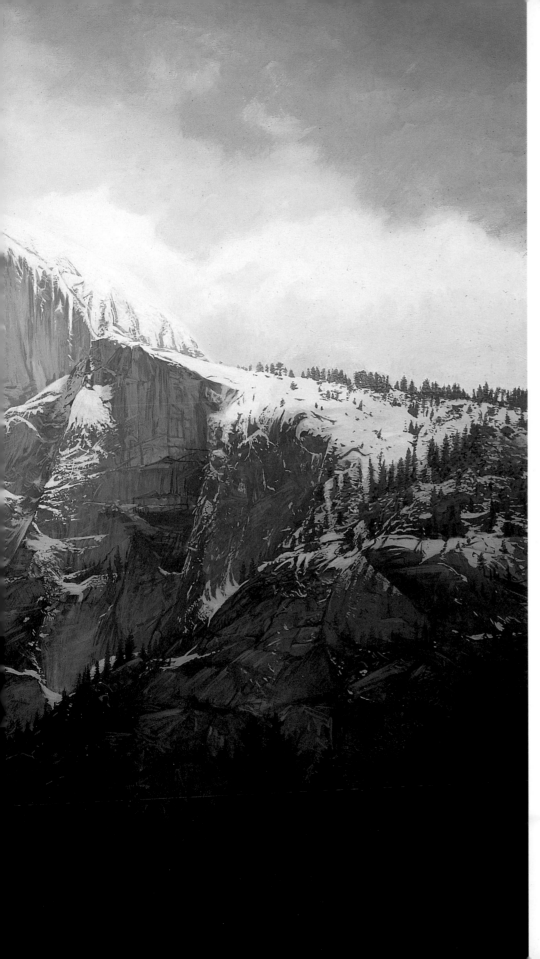

But even the urge to partake of such visual nourishment cannot in itself properly explain why Steve so eagerly takes to the heights. It's that old question: why climb a mountain? The answer is not something that can be adequately expressed in words. The only way to understand what motivates a mountaineer is for one to seek out and engage the wilderness, for only in climbing the mountain does the answer become clear.

Most people hold varied ideas as to what wilderness signifies. To those with a grasp of ancient history, it is the threatened remnants of the disappearing, primeval landscapes that once dominated this earth—Eden before Adam and Eve. For others of a scientific bent, it is a vast research library, field museum, and living laboratory all rolled into one. Legalistic minds tend to conceive of it as road-

Dance of Cloud and Cliff

Yosemite's Half Dome, caressed by gossamer
clouds and bathed in the fleeting alpenglow.
Can words convey this mountain drama?
This is why I paint the wilderness.

[19]

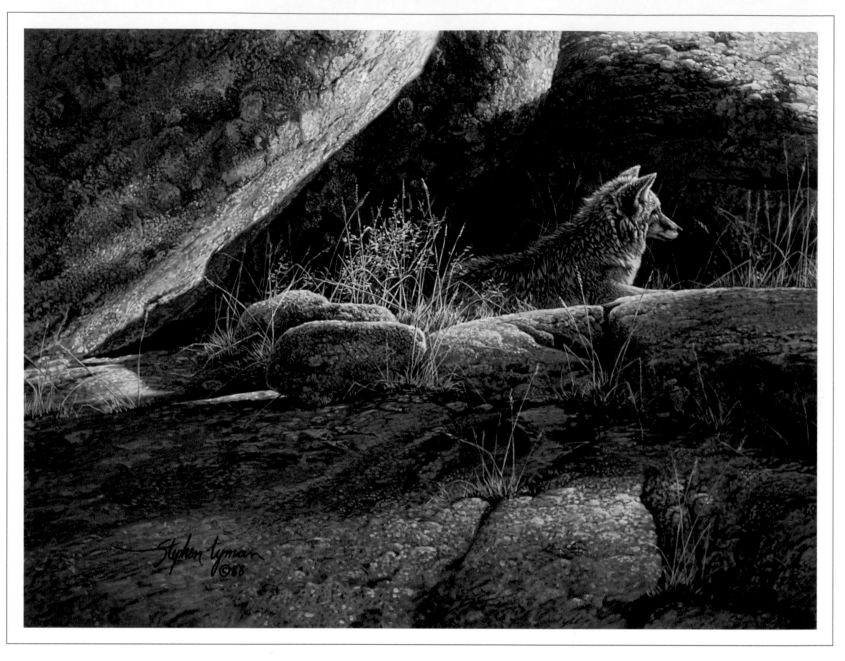

Coyote Afternoon

I have a great admiration for the coyote. It's a survivor, very smart, quick, inquisitive, and independent. It's a beautiful animal.

less areas undisturbed by motor vehicles, harboring particularly fine scenic or biological values worthy of public protection—areas where, as the Wilderness Act of 1964 puts it, "the earth and its community of life are untrammeled by man, where man himself is a visitor who does not remain." Mining, timber, and grazing

interests eye public lands as a commercial bounty ripe for the harvesting. Certain politicians beholden to those interests see wilderness protection as an outmoded idea, another prime target for budget cuts. Romantics in the tradition of Muir look upon mountains, forests, deserts, prairies, and wild seashores as conscious, breathing

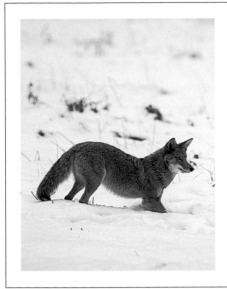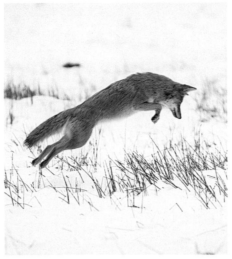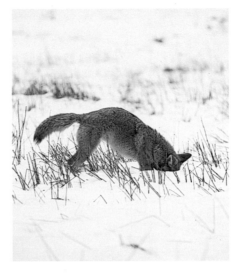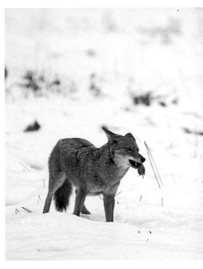

entities, sensitive to the way humans and other creatures touch them. This surely gets close to the heart of the matter, the artist nods to himself, else why would so many people run to the wilderness with such a yearning, as though it were their lover?

For Edward Abbey, wilderness represented nothing less than liberation. "It is my fear," he once wrote in his journal, "that if we allow the freedom of the hills and of the wilderness to be taken from us, then the very idea of freedom may be taken with it." Thoreau, whom Abbey revered, put it even more concisely: "In wildness is the preservation of the world."

For some unlucky souls, wilderness is no comforting companion and nature appreciation is a fine art that requires tutoring. Those who have never experienced the solace and grandeur of such untamed wonderlands as Yosemite, Alaska's Denali National Park, Oregon's Columbia Gorge, or any of a thousand other untrammeled places may all too casually shrug off the importance of wild country, or even come to fear it. They may consider undeveloped landscapes to be environments separate from and uninviting to human society, places alien, remote, harsh, and inhabited by fearsome creatures. Such thinking is as old as civilization itself. The very idea of hearth and home came about from people's struggle with a wilderness vastly more powerful than themselves, seemingly always on the verge of overwhelming them. Prior to the marriage of science and technology in the mid-19th century, humans may have shaped the land—as did the Romans, Egyptians, Hollanders, and even Native Americans (in different ways and to varying degrees)—but they never became divorced from it in pursuit of their livelihoods. As individuals went to work in factories and started consuming packaged products, however, many became estranged from it, to the point that they grew increasingly indifferent to it or even contemptuous of it.

[21]

Some great writers of that time—Thomas Hardy, Joseph Conrad, and Herman Melville—warned us against our newfound sense of superiority over the wilderness, but not against our impending alienation from it. Ultimately, man was an animal and the wilderness a great, untamable beast. Try as we might, it was something we would not overcome.

The Big Country

My most memorable impression of traveling through the Alaskan landscape was how big it was — vast distances, enormous mountains, huge grizzlies. A grand wilderness that does things in a big way.

[22]

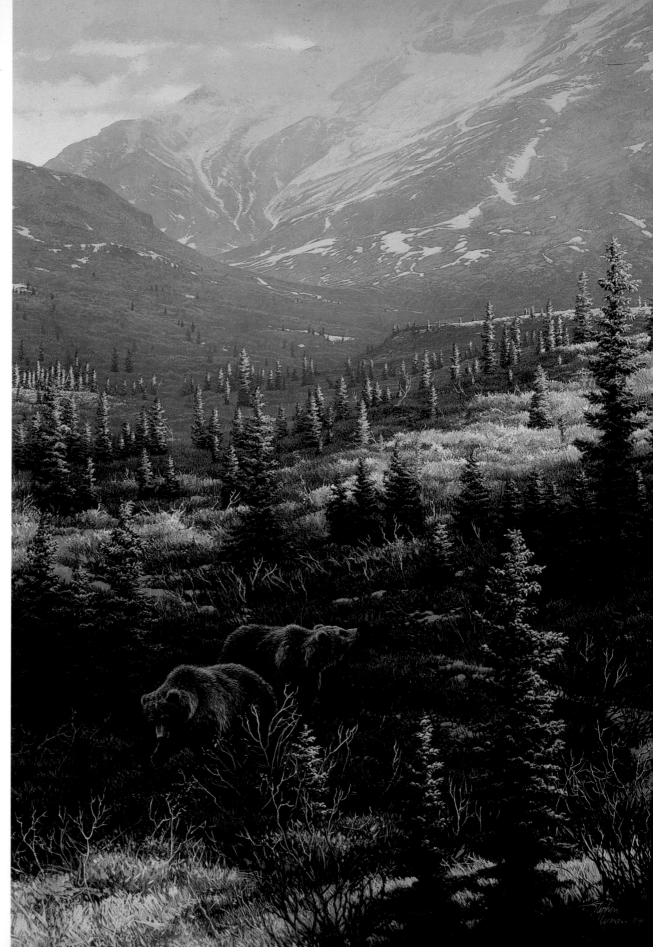

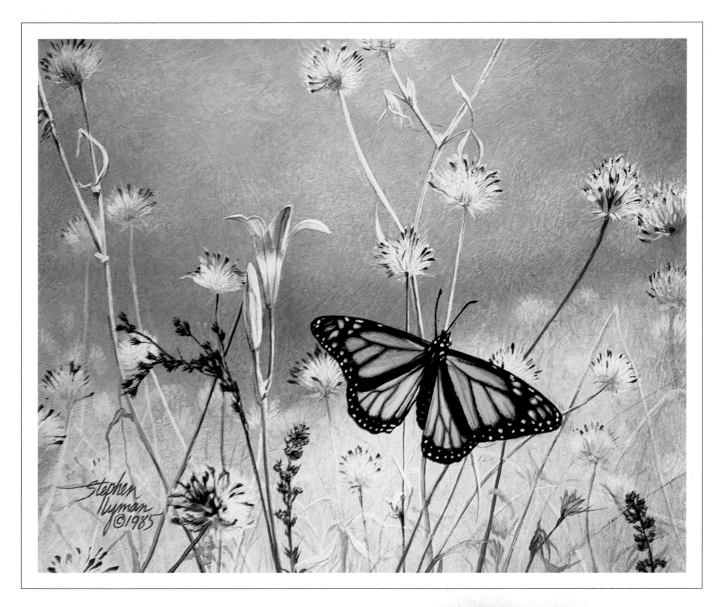

Monarch
of the Meadow

The butterfly, small and delicate,
nonetheless has a royal air about it.

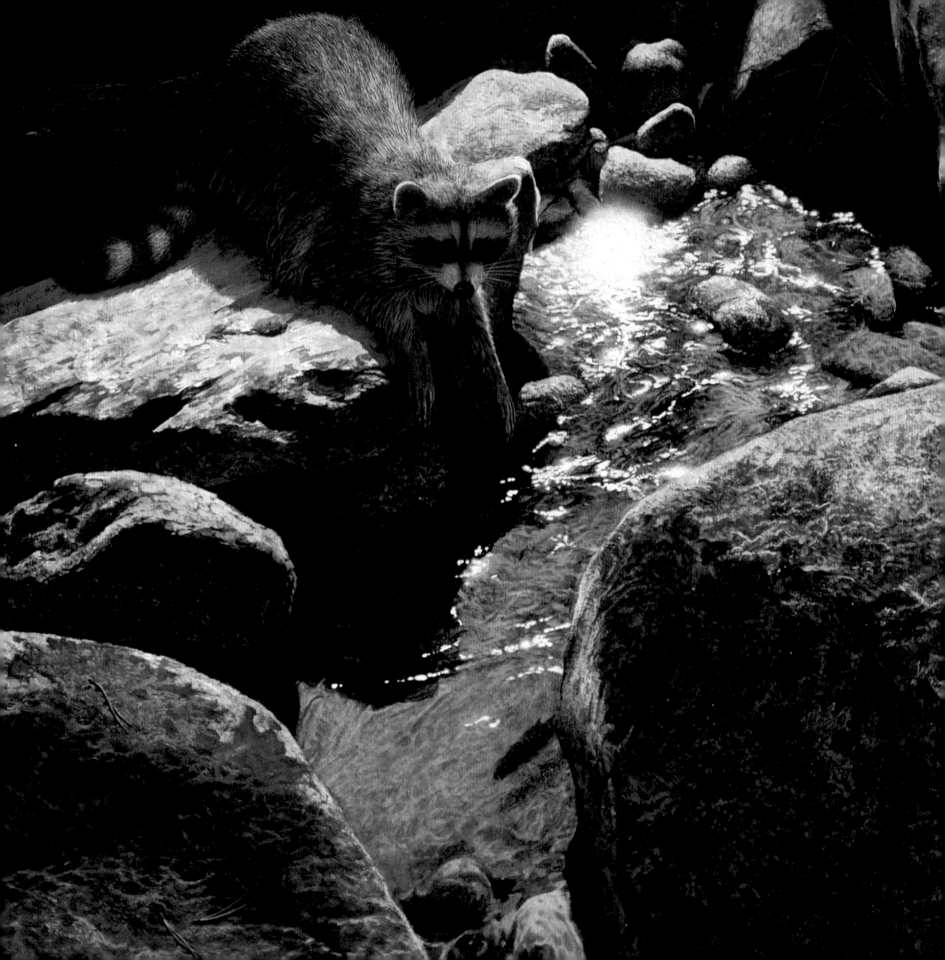

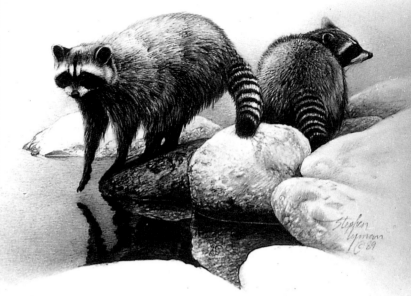

Technological optimism has changed that idea dramatically. Farmer and philosopher Wendell Berry observes in *The Gift of Good Land* that, until the industrial revolution, the dominant images in people's minds were organic. "They had to do with living things; they were biological, pastoral, agricultural, or familial." Now, he laments, people are referred to as "units," the body as a "machine," food as "fuel," thoughts as "inputs," and responses as "feedback." In such a lexicon, where does the wilderness survive? Ours is a society that thinks it doesn't need wilderness anymore, that believes people can invent their own life-support systems and artificial environments rather than having to put up with the inconveniences of nature's cycles.

Yet we are also living in a time when people feel increasingly that something spiritual is missing from their lives, that the natural rhythms and cycles that formerly sustained

Fishing with Patience
Captivating sparkles of sunlight on the crystal-clear water along with the timeworn drama of "fishercoon and fish."

[25]

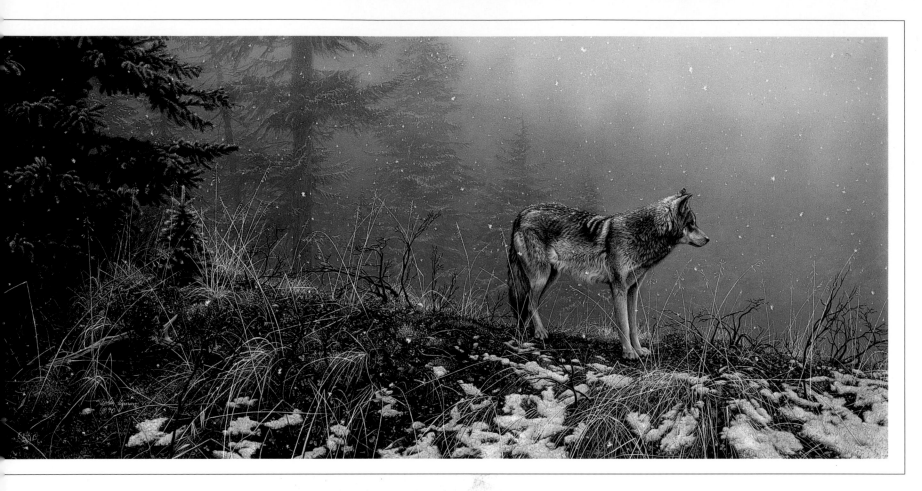

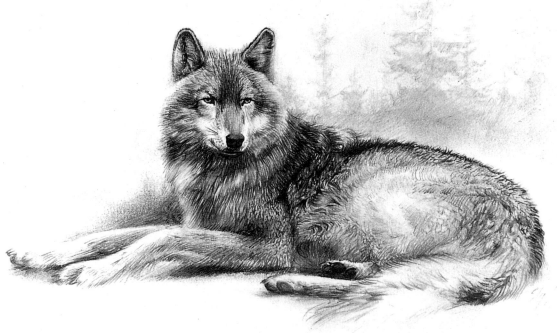

humanity are breaking down. Something has been lost, a spiritual and intimate connection to the earth without which people's lives can never be full.

To Steve Lyman, once again enjoying the freedom of the hills, what civilization truly needs in order to shore up its crumbling foundation is

Silent Snows

(Above) The mist and clouds in the background, together with the wolf's gazing at something out of the picture, lends a mysteriousness — that feeling of something else out there.

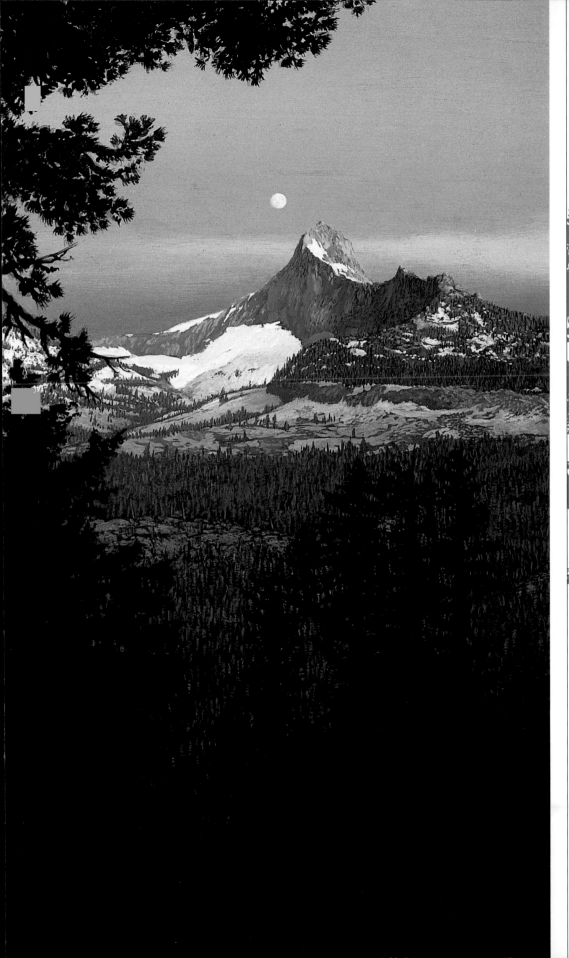

acknowledgment that wilderness, in the final analysis, may be the ultimate salve for psyches wounded by humanity's alienation from nature. Muir himself expressed the notion that wilderness, like poetry, music, art, and religion, nurtures that part of us for which science cannot account. In the mountains, he observed, there are times when a person's soul sets forth upon rambles of its own accord, without first consulting with mind or body. On such occasions, "brooding over

Colors of Twilight

This depicts Mount Clark, southeast of Yosemite Valley. It's named after Galen Clark, who Muir said was the best mountaineer he ever met.

some vast mountain landscape, or among the spiritual counte-
nances of mountain flowers, our bodies disappear, our
mortal coils come off without any shuffling, and
we blend into the rest of Nature, utterly
blind to the boundaries that measure
human quantities into sep-
arate individuals."

Last Light of Winter

*Typically, in my landscape paintings, wildlife plays
an incidental role in the image. The flying
Canada geese are placed in front of the dark
trees instead of silhouetted obviously against the
sky. This delays their discovery until the viewer gets a
first impression of the spectacular winter sunset. So, too, with
the deer and the crescent moon. I also try to suggest something
that underlies the physical, visible landscape. Here the wind
ripples the waves.*

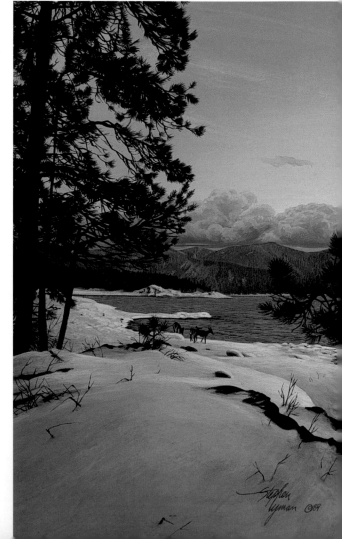

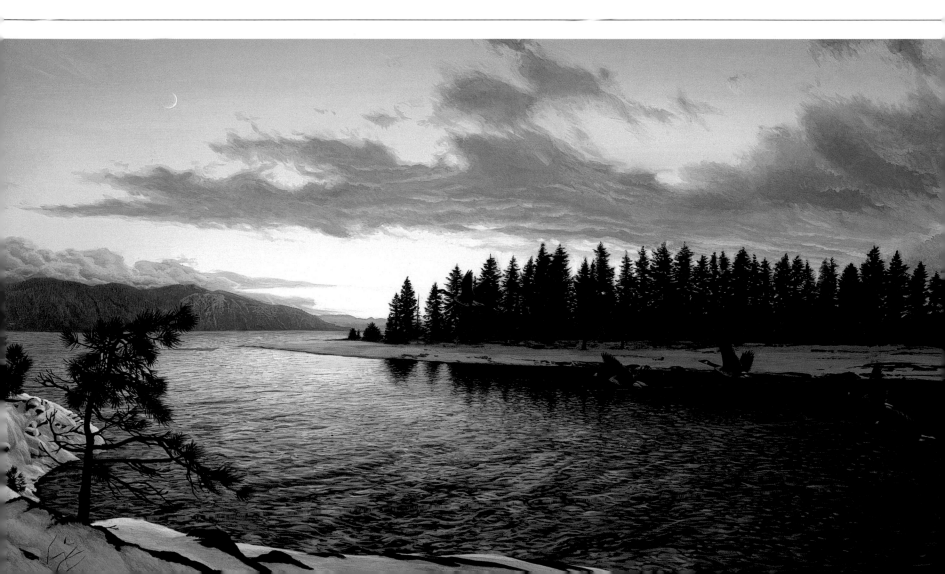

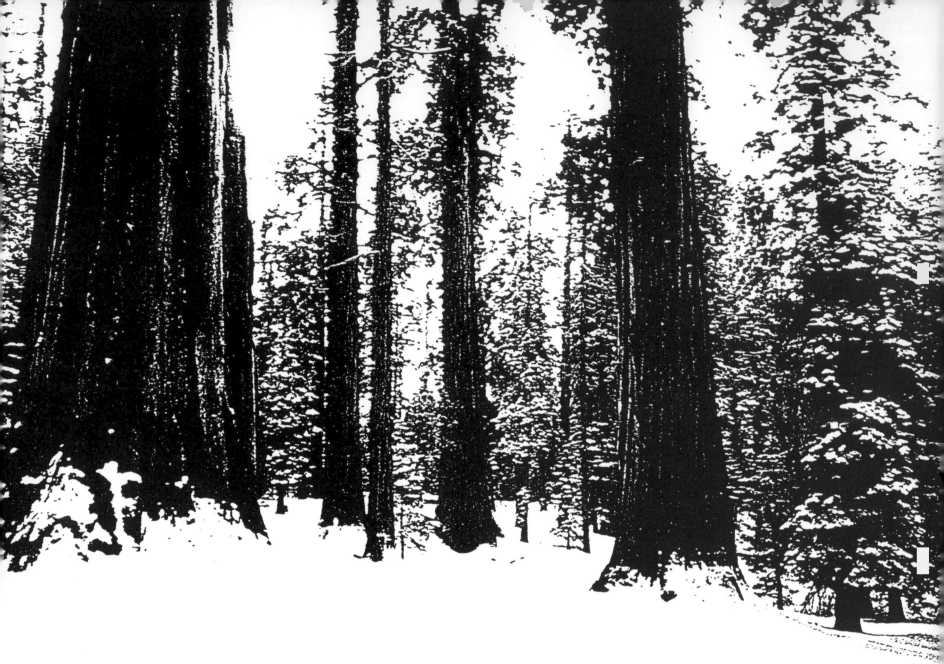

The snowmelt on the rim of Yosemite Valley, Steve observes as he packs his gear and prepares to set out on his trek, has hardly swollen the Merced. The river's low waterline and placid current are what he would expect during summer rather than early spring. But in the wilderness, expectations are often confounded. That's part of the allure of backpacking: the surprise, the serendipitous discoveries. Indeed, Steve has come to understand that the best journeys are often those arrived at spontaneously, without the burden of detailed planning. Rather than plotting every leg of a hike from start to finish and then attempting to follow the preordained route step by step, he prefers to arrive at the edge of the wild country with no clear itinerary, to camp wherever for a night and let the mountains' spirit embrace him during his sleep. That way, in the morning he can embark on a more spontaneous, free-spirited, and fulfilling adventure. The wilderness itself will point the way. He likes to let the mountains be his guide.

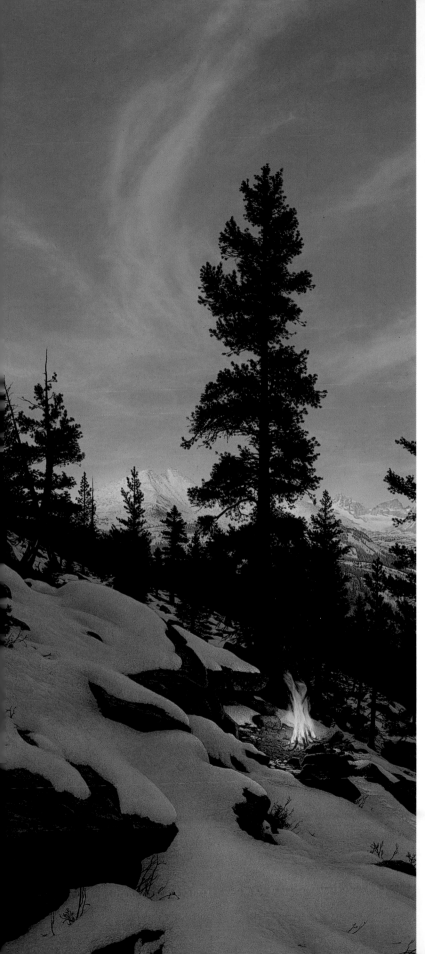

Fire Dance

One November I had wanted to return to the high alpine lake depicted in Embers at Dawn *to gather material and inspiration for the painting* Moonfire. *However, the first storm of the season had already passed through, and I found myself wallowing through three feet of snow, miles from my intended destination, without snowshoes or skis. So instead I took in the spectacular alpenglow on the mountains that evening and dried my wet clothing with a fire in my camp on the steeply sloped mountainside. Firedance was the result of this unplanned and unexpected experience.*

[31]

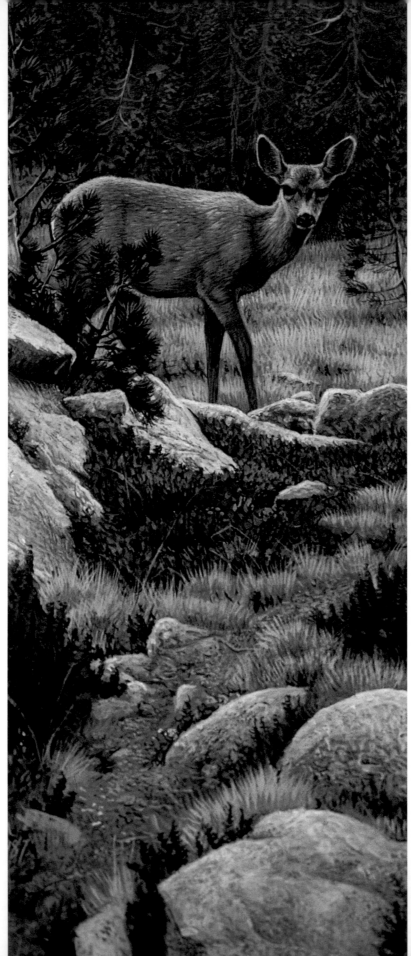

At Meadow's Edge

(Detail) This mule
deer has that pose of
hesitancy its kind
adopts when they're
coming out from cover,
making sure there's
nothing dangerous
out in the meadow.

THE EDGE OF THE WILDERNESS

*the wilderness
we now have
is all we shall
ever have*

THE EDGE
OF THE WILDERNESS

*the wilderness
we now have
is all we shall
ever have*

—David R. Brower

No designated wilderness area exists in isolation. This is important to keep in mind, since the ideal of wilderness as an area "untrammeled by man" tends to overshadow the significance of many of those environments outside the boundaries of parks and refuges. Though these may be utilized by people, they nevertheless harbor an abundance of wildlife and natural resources that are vital to the integrity of entire eco-regions. Such is the case with areas bordering Yosemite National Park, places through which Steve must pass in order to reach his wilderness destination.

It takes only a few hours by car over well-engineered highways to travel from the California coast to the Sierra, a journey that John Muir first made in 1868 on foot. Like Muir, Steve first has to cross the Great Central Valley of California to reach Yosemite in the middle of the 350-mile-long mountain range. But the present-day valley is a far cry from what it was when Muir stood upon the summit of Pacheco Pass in the Coast Range and for the first time looked east across a "vast golden flower-bed," a "sea of golden and purple

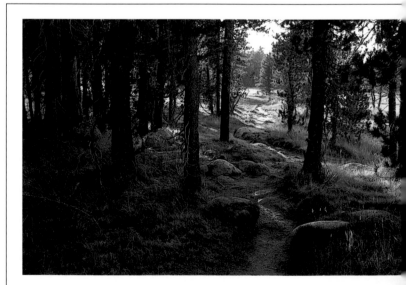

bloom, so deep and dense that in walking through it you would press more than a hundred flowers at every step." He declared this landscape to be the most beautiful he had ever beheld. Now the valley is a patchwork of power lines, fields, orchards, irrigation channels, highways, bridges, and cities. Of the lakes and marshes, alluvial plains and grasslands, as well as riparian waterways, only a vestige of each habitat remains.

At the eastern edge of the valley, the road begins climbing upward, curving among rolling foothills and into a lush green savanna, carpeted with grasses, dotted by blue oaks and outcroppings of metamorphic rock. Pastoral and serene, these hills are picturesque even in summer when their grasses turn golden brown, but they are hardly wild. Miles of fences partition them into livestock ranges. The fragile native perennial bunchgrasses that once flourished here have long since been replaced by tougher annuals from southern Europe. The dominant animals in this region are now cattle and sheep, which graze the land that once was home to indigenous tule elk and pronghorns. With their hearty appetites, the livestock ensure that the native grasses will never make a comeback.

Yet despite these alien species, wildlife thrives in these foothills. Kingbirds and red-tailed hawks perch on fence posts and power lines; shrikes flit from oak to oak. When the first wildflowers of spring are in bloom, they include masses of baby blue-eyes, purple owl's clover, and goldfields—a dazzling display of color harking back to the spectacle witnessed by Muir 130 years ago.

With the road gaining still further in elevation, the terrain becomes steeper, rockier, and furrowed by canyons. The grasslands give way to woodlands dominated by blue oaks, interior live oaks, and digger pines.

The foothill woodlands are the Sierra's wild edge, and there is an often-missed diversity of life in them. Many of the creatures here have uniquely adapted to this particular ecological niche, sandwiched between the grazing lands below and the ponderosa-pine forests above.

But the woodlands are not the only type of habitat at this elevation. Dense chaparral occupies

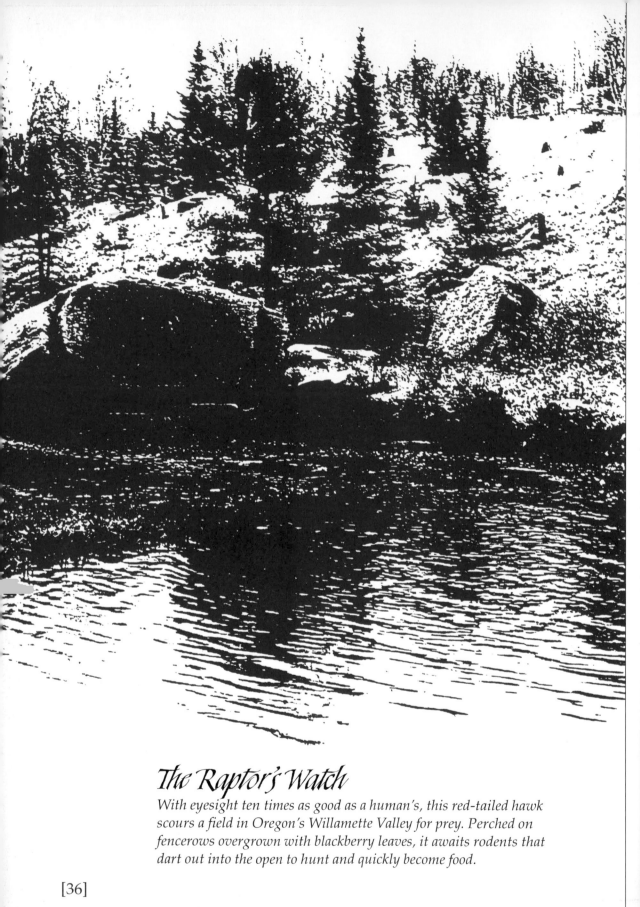

The Raptor's Watch

With eyesight ten times as good as a human's, this red-tailed hawk scours a field in Oregon's Willamette Valley for prey. Perched on fencerows overgrown with blackberry leaves, it awaits rodents that dart out into the open to hunt and quickly become food.

[36]

Stephen Lyman
© 1985

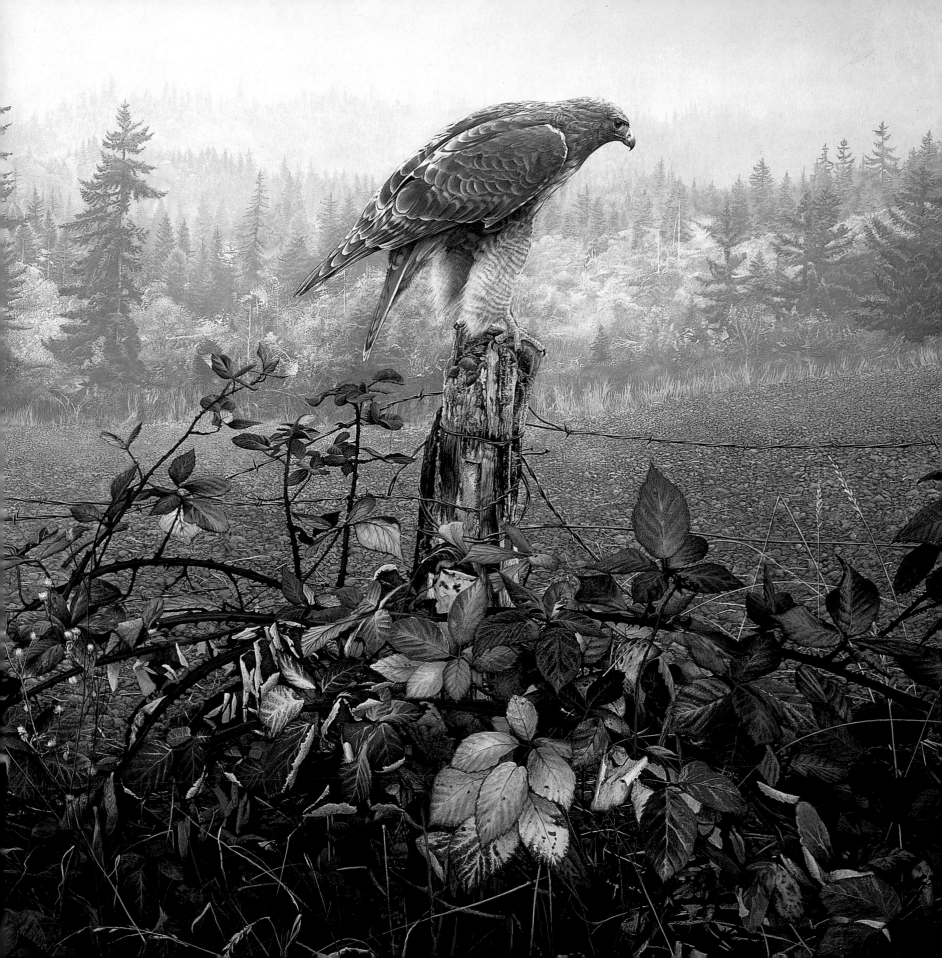

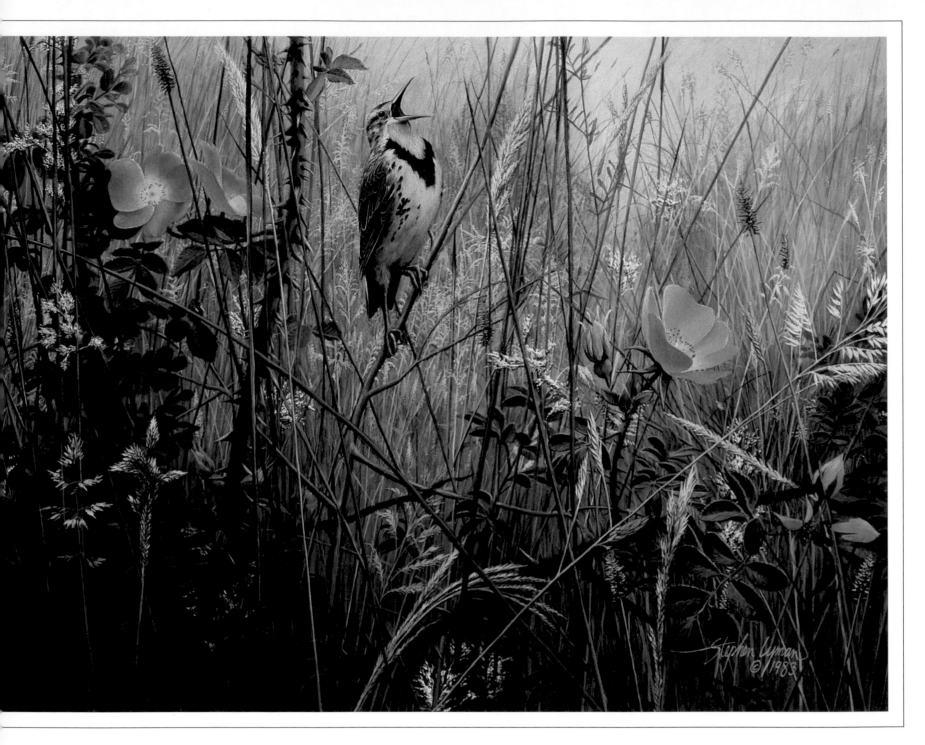

Song of the Meadow

A meadowlark's joyous voice bursts forth with the new life of spring.
The visual harmony is provided by the grasses and wild rose.

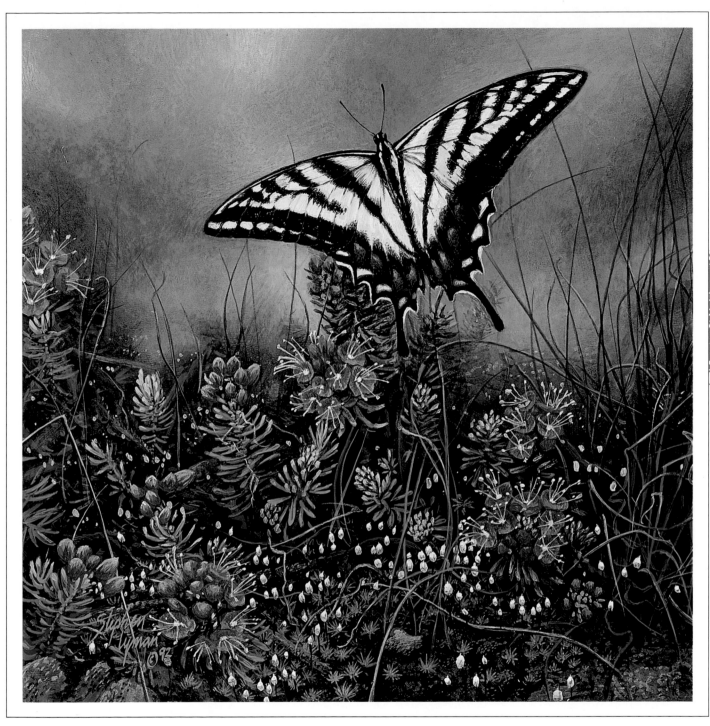

Swallowtail Butterfly and Pink Mountain Heather

I've painted this from the insect's point of view. I like to take on these different perspectives in looking at the intricacies and delicacies of the miniature landscape.

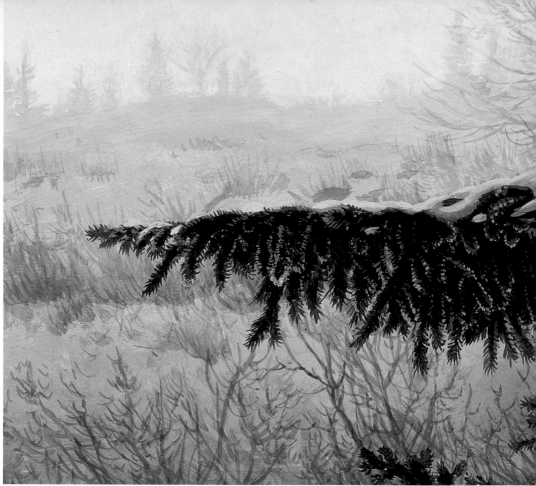

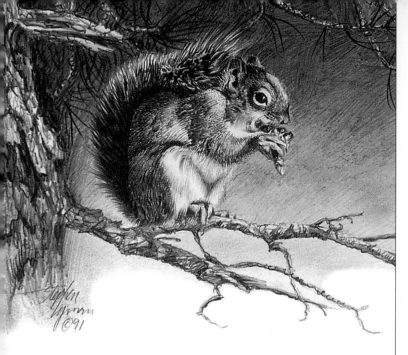

Winter Fir

As you wander here from the open field, up along the curving branch of a Douglas fir, you "get into the woods." There you discover the great horned owl silently perched, watching.

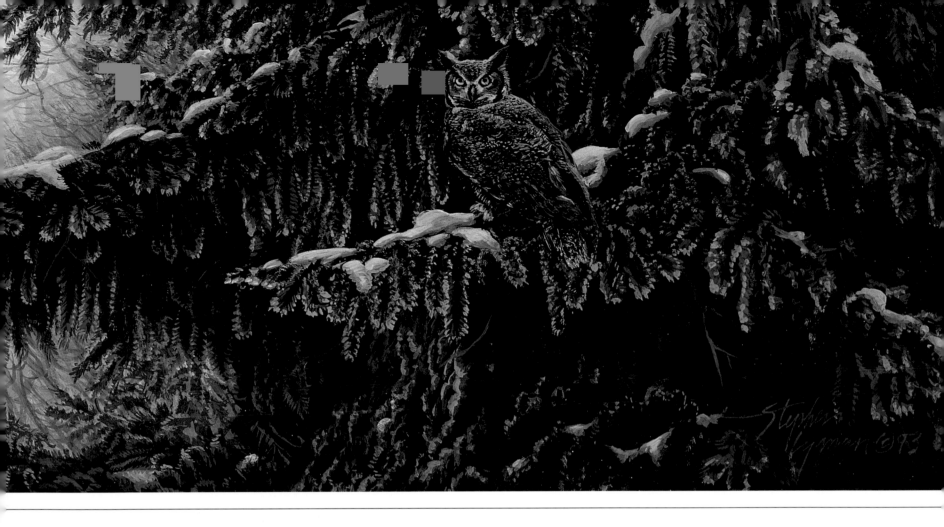

the hotter, drier sections of these lower slopes, in places where the ground is rocky and the soil thin. It's a stickery environment, inhospitable to humans but a boon to wildlife. Thickets of manzanita, coyote brush, mountain mahogany, whitethorn, and that bane of all hikers, poison oak, are home to whiptails, buntings, jackrabbits, pocket mice, and alligator lizards, among myriad other species. Niches along stream courses provide some measure of respite from the thorns, softened as they are by willow, poplar, white alder, bigleaf maple, and spice bush.

Transported higher and higher into the mountains, Steve can now smell the ponderosa pines that appear to either side of the road, while the blue oaks and digger pines become fewer and

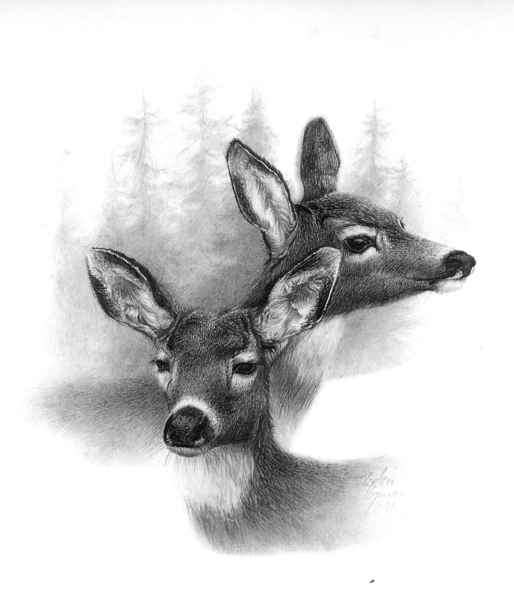

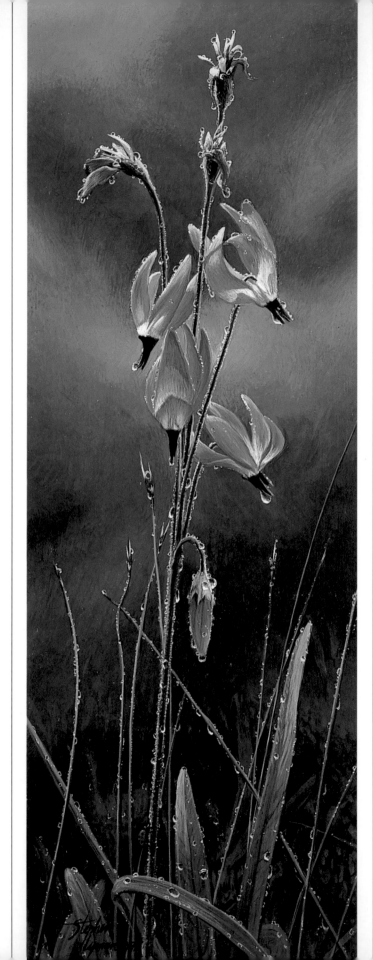

fewer. And then at last is the park itself, an immense conifer forest, a mix of many tree species presided over by the stately ponderosa, his favorite tree to paint.

Now, at the fringe of this forest, surrounded by pines, black oak, and incense cedar, Steve hoists his backpack onto his shoulders, prepared to set out on a week-long Yosemite trek. Behind him stands 600-foot-long O'Shaughnessy Dam, the concrete monolith whose construction in Hetch Hetchy Valley began in 1914 over the vehement objection of conservationists. Most notable was Muir himself, who decried the dam as a blasphemous intrusion into the spiritual sanctity of the young national park he had helped establish.

Looking at the inundated valley, where once the Tuolumne River flowed freely, Steve understands the grief that Muir must have felt. This place, with its concrete dam, its rusted

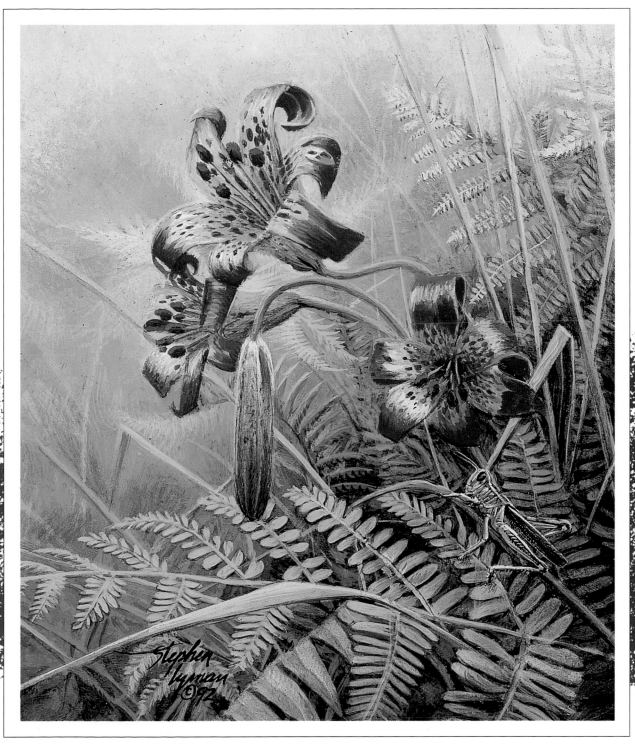

Tiger Lilies and Grasshopper

I was very surprised on one of my backpacking trips to come across this flower. It looked like such a cultivated, showy thing. With tiny flowers like this, insects are the appropriate wildlife.

Shootingstars and Lady Bug

(Left) When I got down on my hands and knees to look closely at these flowers, my attention was riveted on the jewels of morning dew, their delicate form and their color.

metal footbridges, and its lake rippling amid towering granite walls, was once as ravishing a natural beauty as its big sister, Yosemite Valley. Now it seems a grave.

Yet even here, life still blooms. As Steve hikes along the steep trail of Hetch Hetchy Reservoir's north shore, a flash of iridescent red and green catches his attention: a male hummingbird. Out and about early in the season, it darts hither and thither while feeding on the nectar of flowers newly sprouting from the moist soil. A fence lizard, also taking advantage of the midday warmth at this lower-mountain level (just under 4,000 feet), is doing its comical push-ups on a rocky outcrop. At Steve's approach, it skitters under a boulder's protective bulk. In looking for artistic inspiration, Steve has trained himself to look beyond the obvious. He is as much inclined to turn his attention to the seemingly insignificant plants, animals, and rock forma-tions he encounters along the trail as he is to focus on charismatic "megafauna" such as bears and wolves. He prefers to consider him-self to be not a "wildlife artist" per se, but a painter of wilderness. He views the natural world not as a series of static portraits but as a dynamic process, the sum of many parts all intricately entwined, the whole-ness of which can only be hinted at and painted about.

"I want to make my images timeless and ageless," he says, "to portray the depth of wisdom and longevity the wilderness possesses. It's constantly being reborn. I'm

Bear & Blossoms

The massive bear, the center of attention and focus in most paintings, is relegated to the background. It blends into the dark forest and is upstaged by the delicate stalks and bright blossoms of grasses and wildflowers, equally beautiful and worthy of admiration.

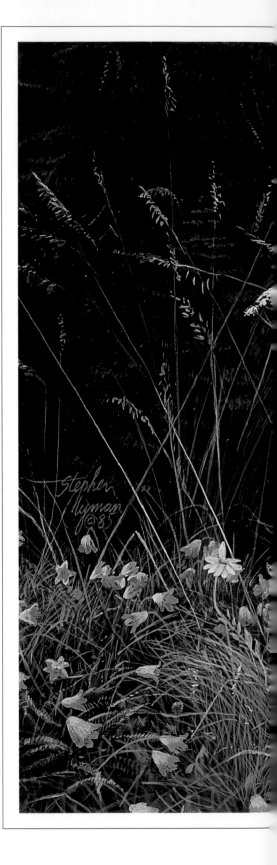

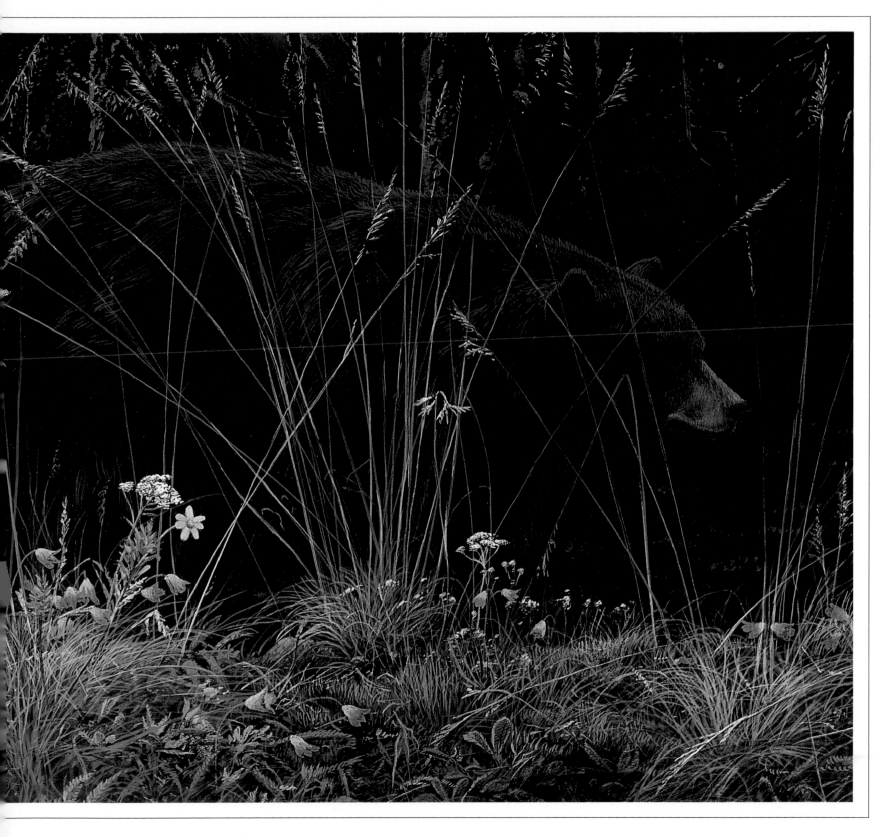

adopting Muir's language of the earth as alive, to be treated with respect and love, not as a material resource or something for us to conquer."

"This grand show is eternal," wrote Muir. "It is always sunrise somewhere; the dew is never all dried at once; a shower is forever falling; vapor is ever rising. Eternal sunrise, eternal sunset, eternal dawn and gloaming, on sea and continents and islands, each in its turn, as the round earth rolls."

When Steve does depict bears and wolves, it's often in a way that subordinates them to their surroundings. They appear as diminutive forms in a vast landscape, or as dim shapes camou-

Ahwahnee—The Deep Grassy Valley

"Ahwahnee" was apparently the native Miwok people's name for Yosemite Valley. Initially, white men understood it to mean "deep grassy valley." Recently, some researchers have questioned the original interpretation and believe Ahwahnee means "wide gaping mouth." The valley, however, is still deep and grassy with verdant bunches of bear grass along the Merced River.

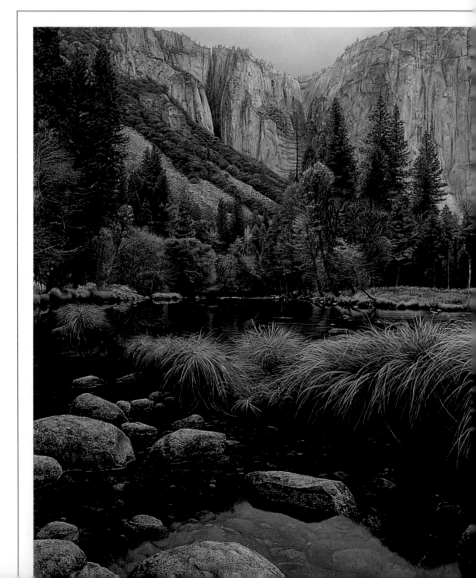

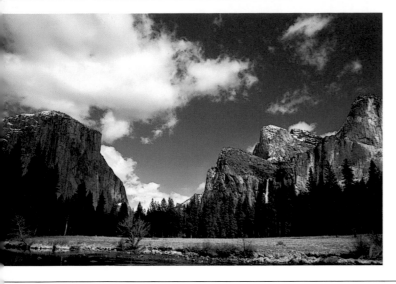 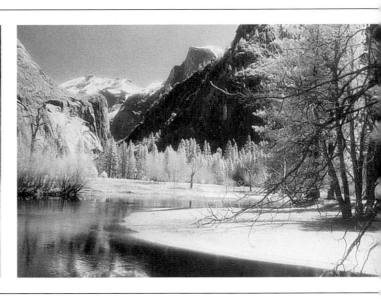

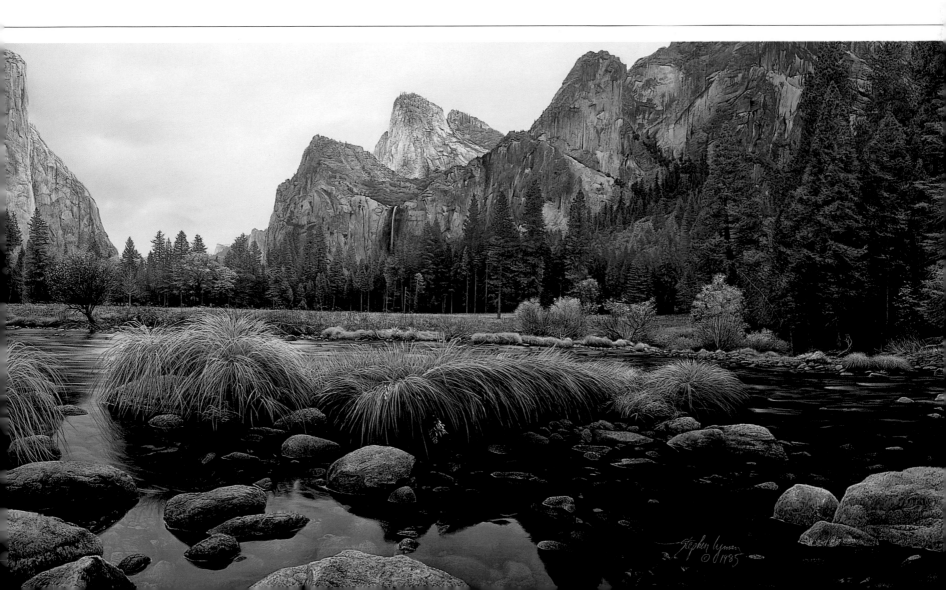

Stephen Lyman © 1985

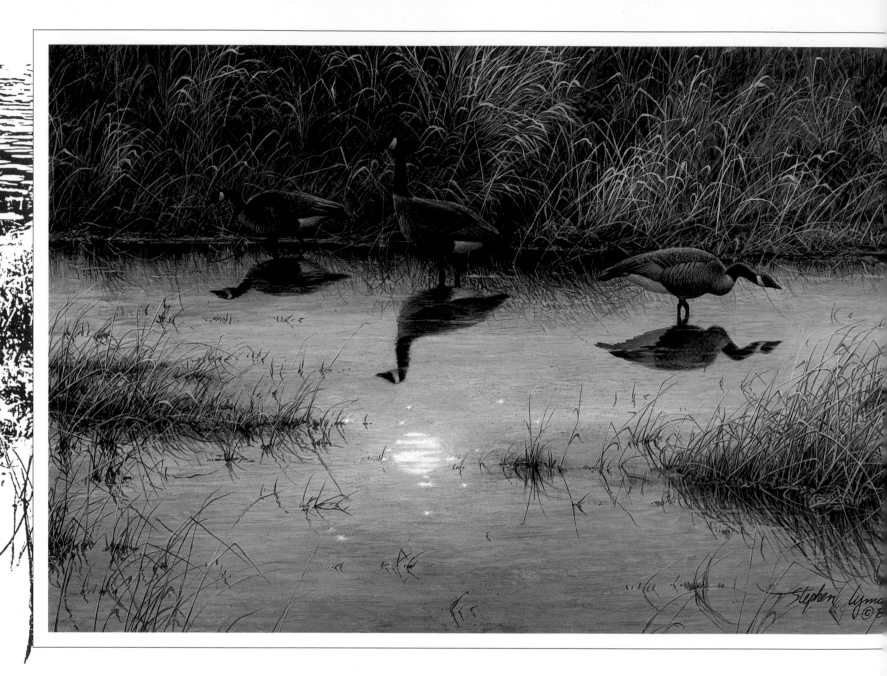

flaged amid wild brambles or behind a screen of tender flowers and grasses. The settings in Steve's paintings put wildlife in perspective while enhancing the shapes of mountains, streams, trees, clouds, snowfall, flowers, and the many other elements that comprise the *dramatis personae* of the wilderness stage. They play out their diverse roles in the grand spectacle of nature as everything from supernumeraries to chorus members,

from second-string players to star performers.

The only actors not visibly playing a role in Steve's paintings are humans. The decision to exclude people is a conscious one. "At this point in history," he says, "we're destroying wilderness rapidly. I want to portray an ideal that's opposite what's really happening today. I'm not saying that humans shouldn't be in the wilderness, or couldn't fit, or don't belong. I know that we can.

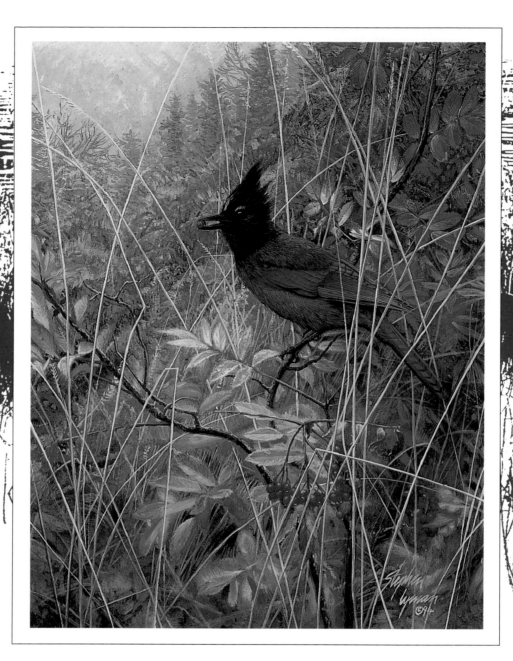

For hundreds of thousands of years, people lived in wilderness and didn't ruin it. But in the last 150 years, we've developed the power to destroy it. There are many very good artists who paint people—Native Americans and mountain men, for instance—in the wilderness. I feel I'm best at portraying a wilderness without a human influence or intrusive presence."

In the late afternoon, after climbing a set of

Moon Shadows

(Left) Reflection on water is something I like to paint— the sparkle of moonlight in particular. Here, the elegant shapes of the Canada geese complement the moon.

Crimson Indigo

A Steller's jay in a mountain ash. The intensities of the colors play off each other, blue being a complementary color to reds and oranges. The loud colors for the raucous bird are appropriate, I think.

[49]

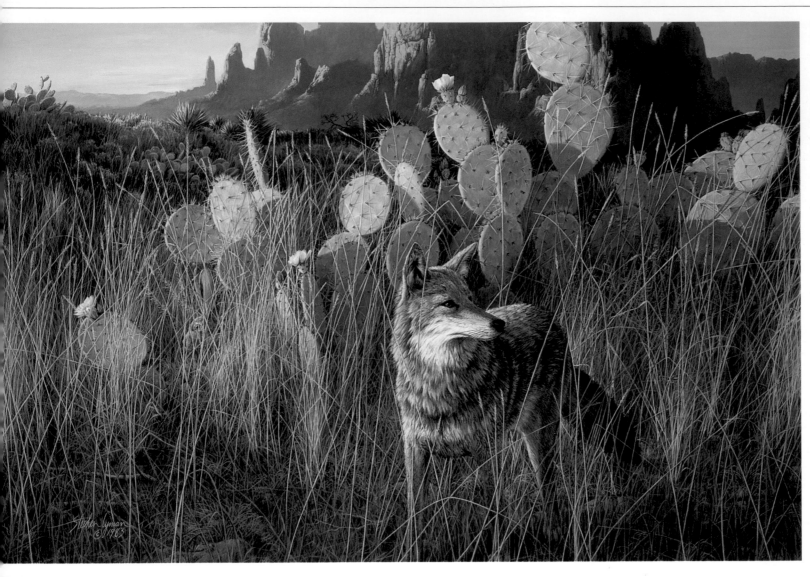

A Pause in the Hunt

The intense, warm colors of sunset in the desert southwest are attractive to me but have not prompted many paintings. In this prickly exception, a coyote has lost the trail of a very clever jackrabbit hidden in the grasses, silently awaiting the predator's passing.

switchbacks and passing by dense thickets of Jeffrey pine, incense cedar, and black oak, Steve arrives at the top of Rancheria Falls. The creek is a torrent, its waters swooshing over a rocky ledge and plunging 25 feet to the reservoir below. Here Steve spends the remaining hour of daylight photographing the sun's descent behind Kolana Rock, a granite dome on Hetch Hetchy's opposite flank. But the light fades sooner than he had hoped. Clouds gathering overhead blot out the last rays. He lays out his sleeping bag on a flat-rock bench and boils water for supper. The falls roar below him. A lone frog croaks nearby. The moon and lordly Orion peek at him through seams in the clouds.

He is glad to be alone. A little later in the season, there will be many other backpackers here; campfire

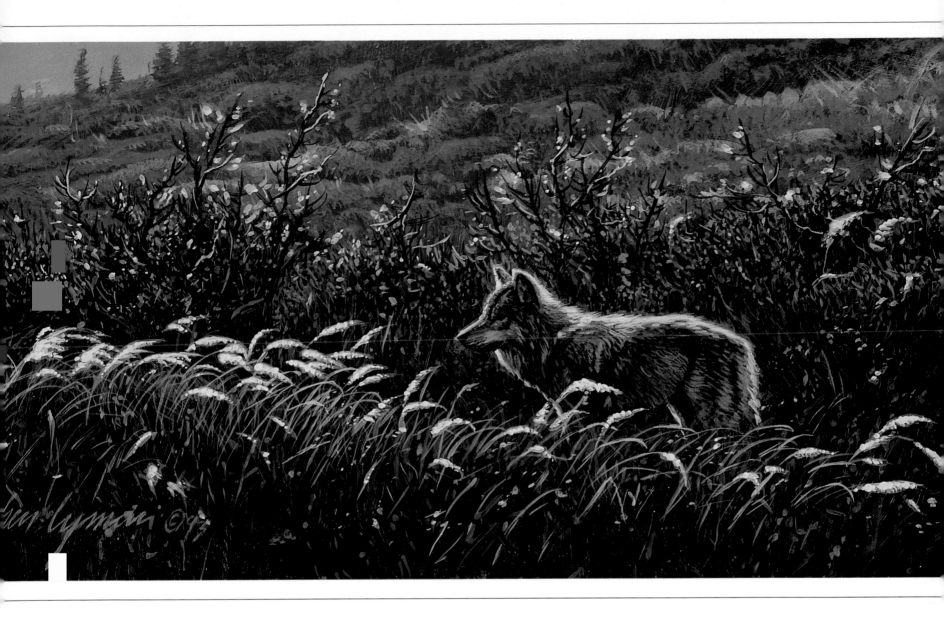

rings dot the area. In going to the wilderness, he seeks to be alone with his thoughts, undistracted by other voices. Best of all is to be in a place that shows no evidence of anyone's having passed that way before, even if he knows that most likely somebody has. The point is to lose himself where the imagination soars in the solitude amidst the trees and rocks. Here freedom of spirit and soul is easily attainable.

Venturing into the wilderness is, in its purest sense, a transformative process, akin to the Buddhist quest for nirvana. Through physical exertion and contact

Autumn Breeze

It was just getting dark in Alaska's Denali National Park when I saw a shadow moving through the trees. It stopped about 10 feet away, totally silent. For a few seconds I was face to face with this wolf. Then I must have moved or made a noise, because, in a heartbeat, it disappeared.

with the elements, the mountaineer aspires to renewal, hoping to purge built-up anxieties, doubts, fears, perplexities, or other discordant feelings. When motivated strongly enough, the seeker embarks on a jour-

ney toward fulfillment, recognizing full well that the way will be long, arduous, and rocky.

At some point in every wilderness journey, a moment comes when, triggered by a sudden sensation, a glance backward, or a stop to look all around, the trekker realizes that a threshold has been crossed, that the last vestiges of tamed landscape have been left behind and the surrounding territory is purely wild. The frontier

The Field Watcher

The kestrel, also known as the sparrow hawk, is North America's smallest falcon, the male sporting handsome rust and blue-gray feathers.

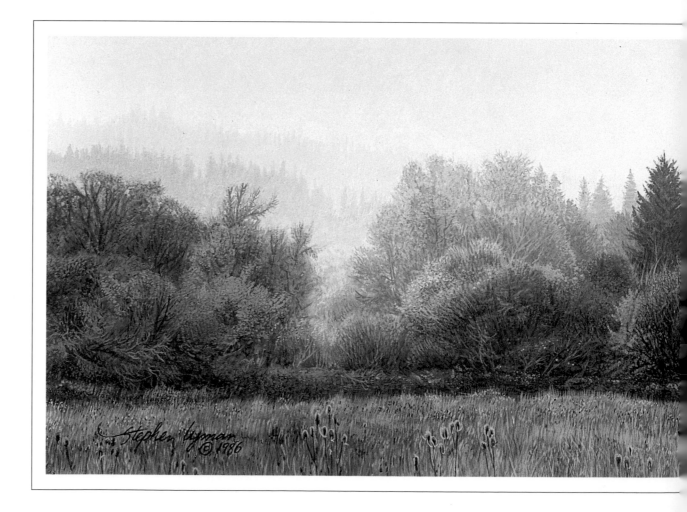

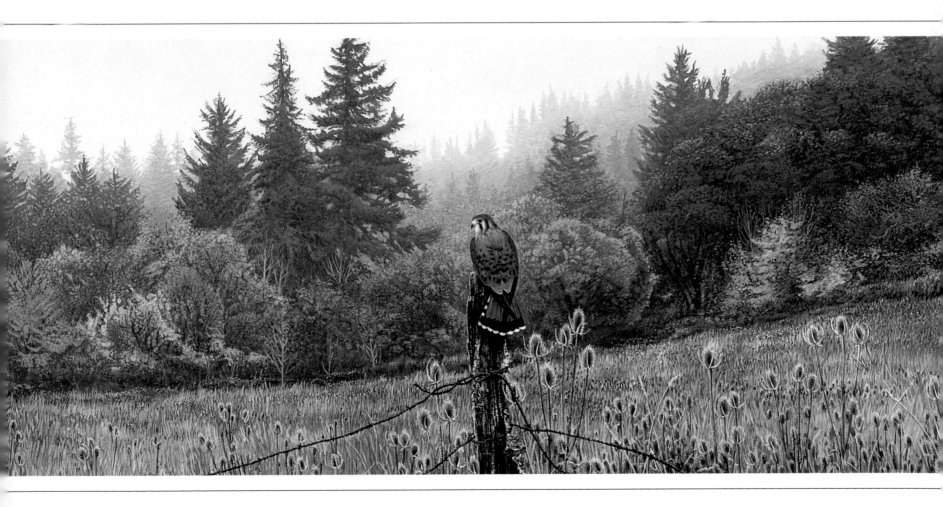

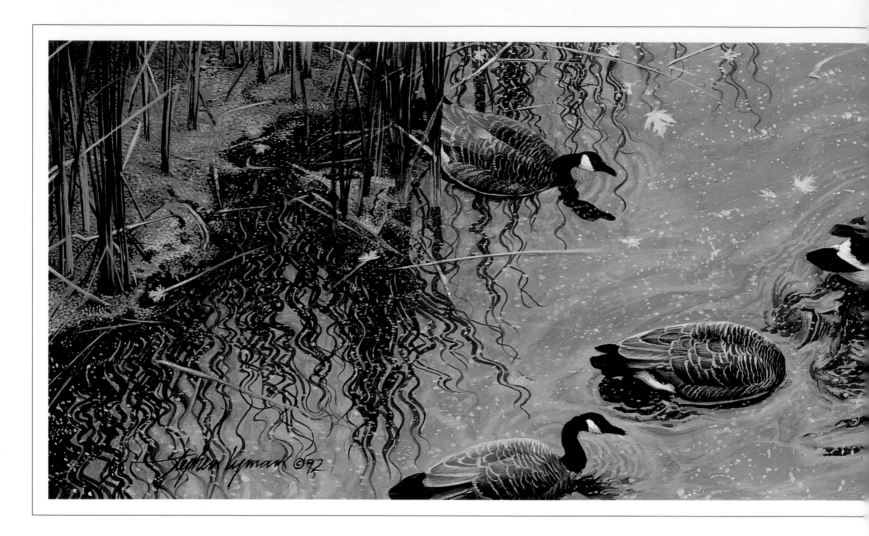

has been broached. Wildness presses in all around. There's no turning back.

That point, for Steve, arrives as he leaves the trail and scrambles up boulder-strewn Rancheria Creek. About a mile and a half up the gorge, the slope gets progressively steeper and the going tougher. He makes his way through tighter and tighter passages, occasionally sliding backwards on loose scree.

Eventually, the canyon walls press in so narrowly that he has precious little room to maneuver. Steve is forced to shed his pack and shove it ahead of him so that he can proceed unencumbered. He needs to be nimble. He can't afford a

fall, so he carefully gauges the risk of each step and handhold. His bulky pack is a hindrance, occasionally throwing him off balance. At one point it shifts abruptly and dashes him face-first against a stone wall, causing a bloody nose.

He wonders if he isn't pushing beyond his limits. But during a momentary pause in his climb, the wilderness sends him a reassuring message. As he becomes aware of the splendid series of waterfalls beside him, his tiredness falls away. The water slips effortlessly through smooth chasms and tumbles vigorously over immense granite outcroppings. This, he realizes, is where his quest truly begins.

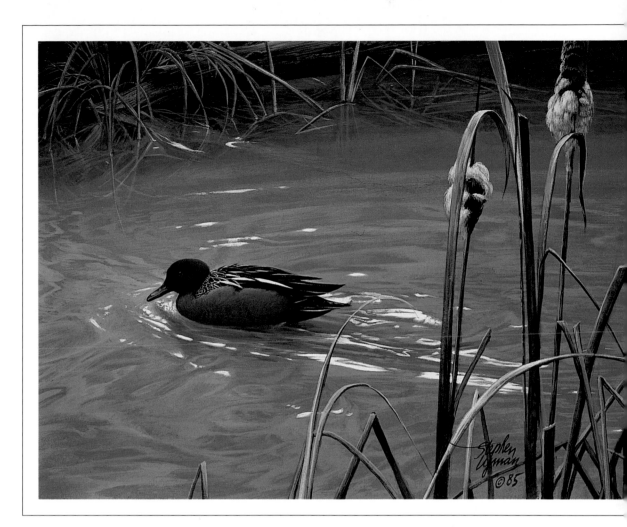

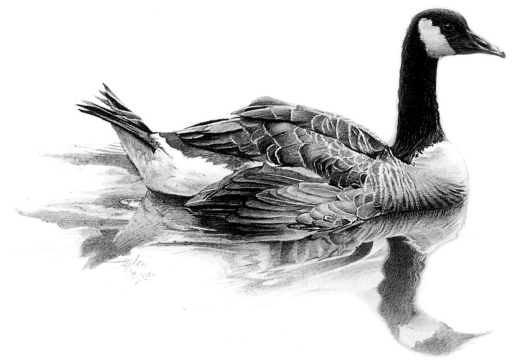

Good Food, Good Drink
(Left) Canada geese can be very comical with their tails sticking up in the air and their legs kicking around in the water as they feed.

Cinnamon Teal
(Right) Sometimes, the understated eloquence of nature is best left to describe itself.

[55]

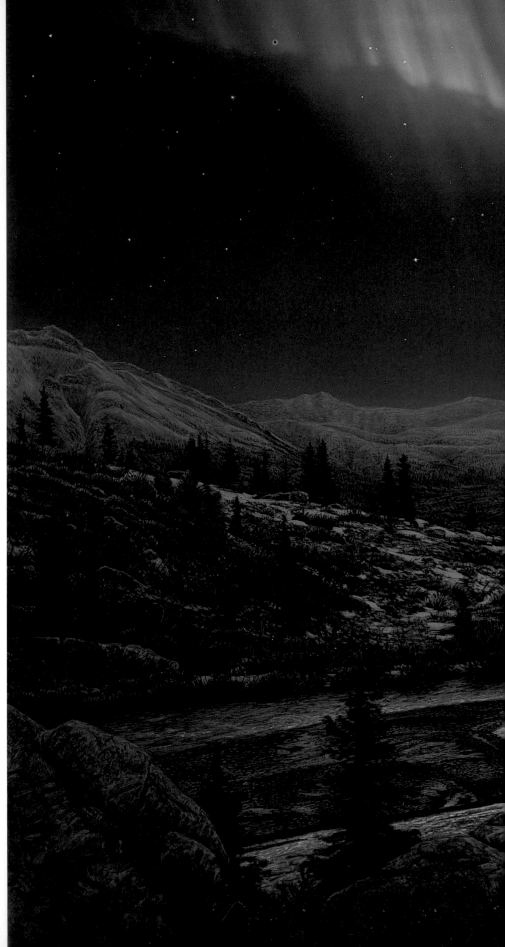

Midnight Fire

The aurora borealis is a wondrous phenomenon.
Throughout the world, it inspires legends and myths
of spirits in the sky. The immense silent "curtains"
of light move through the night, captivating every-
one's attention much the way a campfire does.

[56]

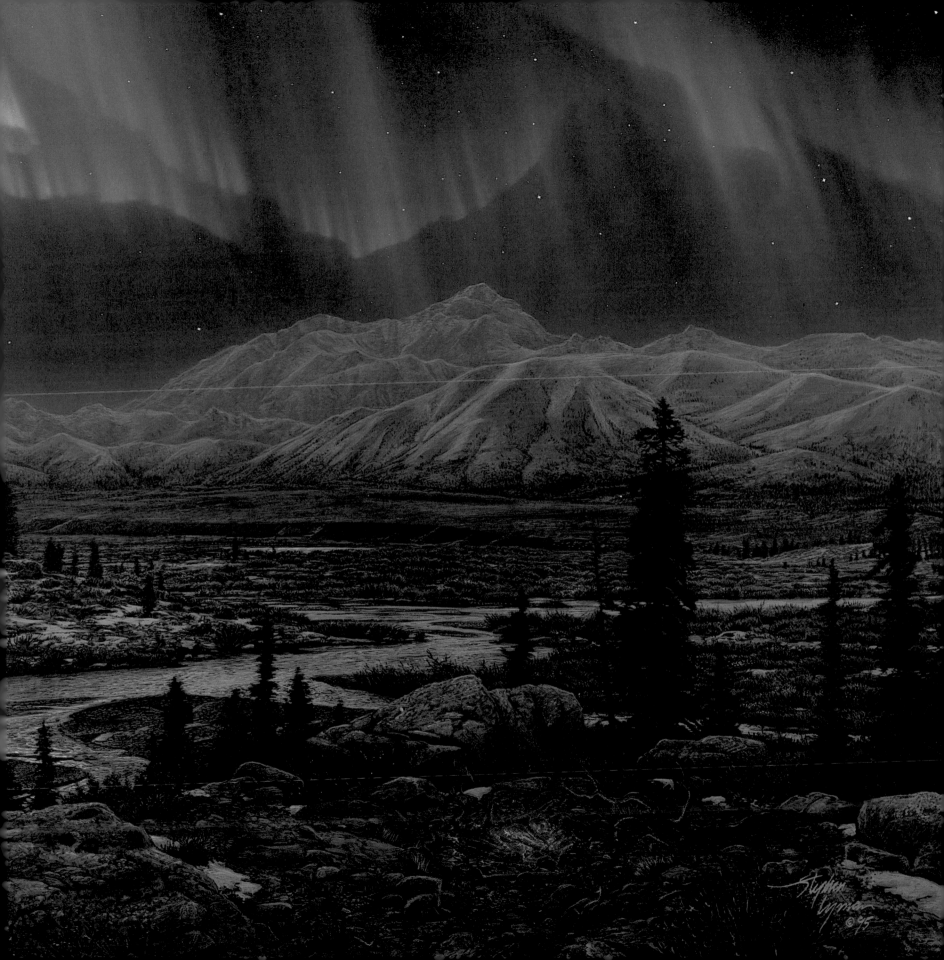

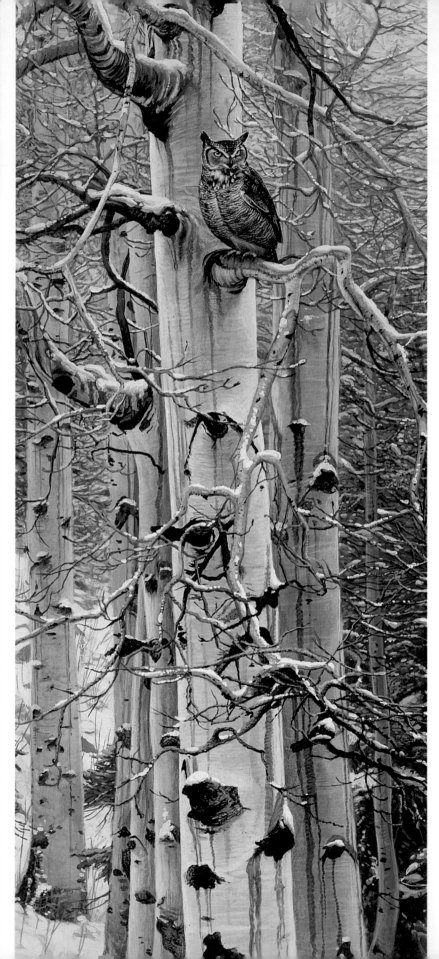

Sentinel of the Grove

The patterns of myriad aspen branches created a fascinating background for this great horned owl.

-3-

INTO THE FOREST

*the clearest way
into the universe
is through
a forest
wilderness*

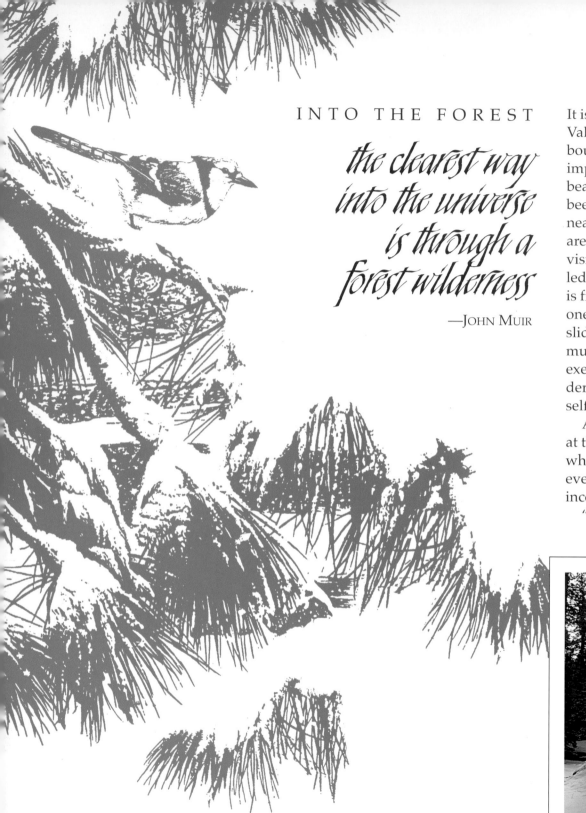

INTO THE FOREST

*the clearest way
into the universe
is through a
forest wilderness*

—JOHN MUIR

It is evening as Steve clambers down to Tiltill Valley, through a narrow gorge choked with talus boulders, willow, and oak. The way seems nearly impassable. Somewhere along the route there's a bear trail he could conceivably follow—or so he's been told—but he has little hope of finding it beneath four inches of snow. Fat flakes of the stuff are falling heavily around him, obscuring his vision. He crouches under limbs and climbs over ledges and tries to avoid obstacles, but the effort is frustrating with a heavy pack. Inevitably, after one barrier is surmounted, a new cliff or rockslide presents itself, slowing his progress. His muscles are aching, crying for rest, but he keeps exerting himself, sometimes leaping from boulder to snowy boulder, other times wedging himself down a rock chimney to descend a precipice.

At last, though, wet and bedraggled, he stands at the edge of Tiltill's open expanse, a wintry white field punctuated by groves of snow-laden evergreens. He makes his way to a cluster of incense cedars that looks like promising shelter.

"It would be delightful to be stormbound

beneath one of these noble, hospitable, inviting old trees," Muir once wrote of the incense cedar, "its broad sheltering arms bent down like a tent, incense rising from the fire made from its dry fallen branches, and a hearty wind chanting overhead."

Indeed, the cedars' plumes of foliage provide Steve with a nearly ideal refuge from the continuing snowfall. As the final hints of gray daylight fade, he gathers handfuls of relatively dry tinder and fallen branches from beneath the spreading canopy and begins to prepare a fire to warm himself and dry his clothing.

Just as he's about to strike his first match, he hears the muffled sound of footsteps in the snow. A trio of mule deer, all does wearing gray winter coats, has sauntered from the forest into the clearing, casually nibbling at the sedges and other marsh plants that poke through the snow. They stop abruptly, ears back and noses in the air, as they get a whiff of Steve's presence. They're not spooked, but they decide not to linger, and go trotting off toward the far side of the meadow. They're followed in short order by a buck, a mas-

sive old fellow, bareheaded from his recent annual shedding of antlers. Whether he notices Steve or not is hard to tell, for the big animal is moving at a good clip, not pausing to browse, seemingly intent on catching up with the females.

Once Steve gets the fire going, he collects several sticks and pokes them into the ground, draping them with his gloves, pants, jacket, socks, cap, and other assorted soggy items. As steam begins to rise, he goes about the business of heating water and spreading out his sleeping bag. Then he sits in his circle of light, listening to the silence, snug in his cozy mansion.

Out beyond the grove, from somewhere in the deepening night, comes the friendly yip, yap, and yammer of coyotes. Moments later a great horned owl calls out: *hoo hu-hoo hoo hoo*. Steve waits a few moments to hear if another owl will answer, then decides to respond himself. Apparently he does a passable hoot, for the bird acknowledges him, replying in its turn. For several minutes they communicate with each other in this way.

Here in the wild Sierra, in the midst of the forest, with a fire crackling beside him, Steve is wholly in his element. He is alive, alert, in touch with the sentient earth that pulses beneath and all around him with an infinitesimally slow rhythm, barely detectable by ordinary

A Walk in the Woods

The bulk and majesty of a bull moose moves slowly and quietly through a forest of aspen trees. The whole animal isn't seen at one time. It appears and disappears as it walks behind the trees.

[62]

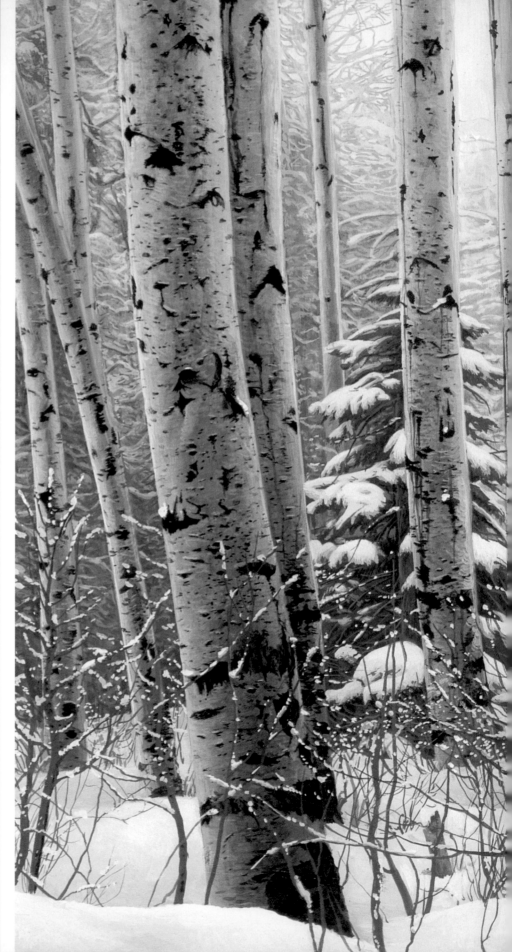

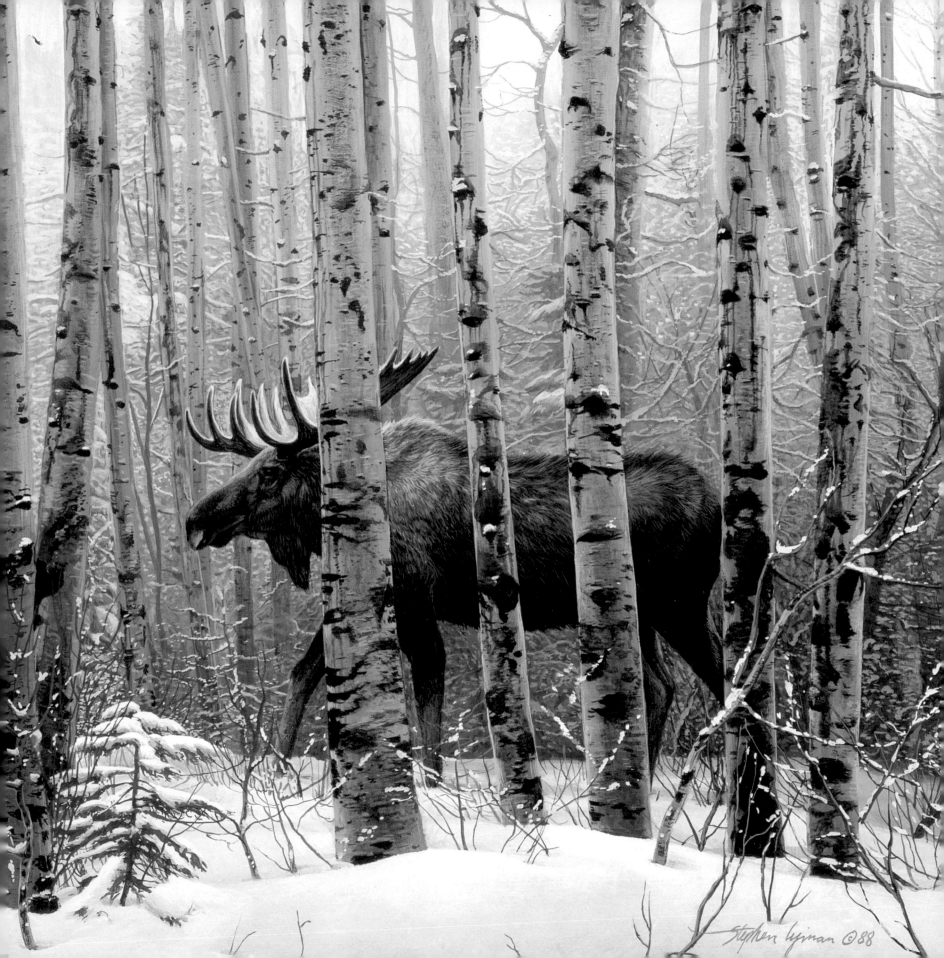

Stephen Lyman ©88

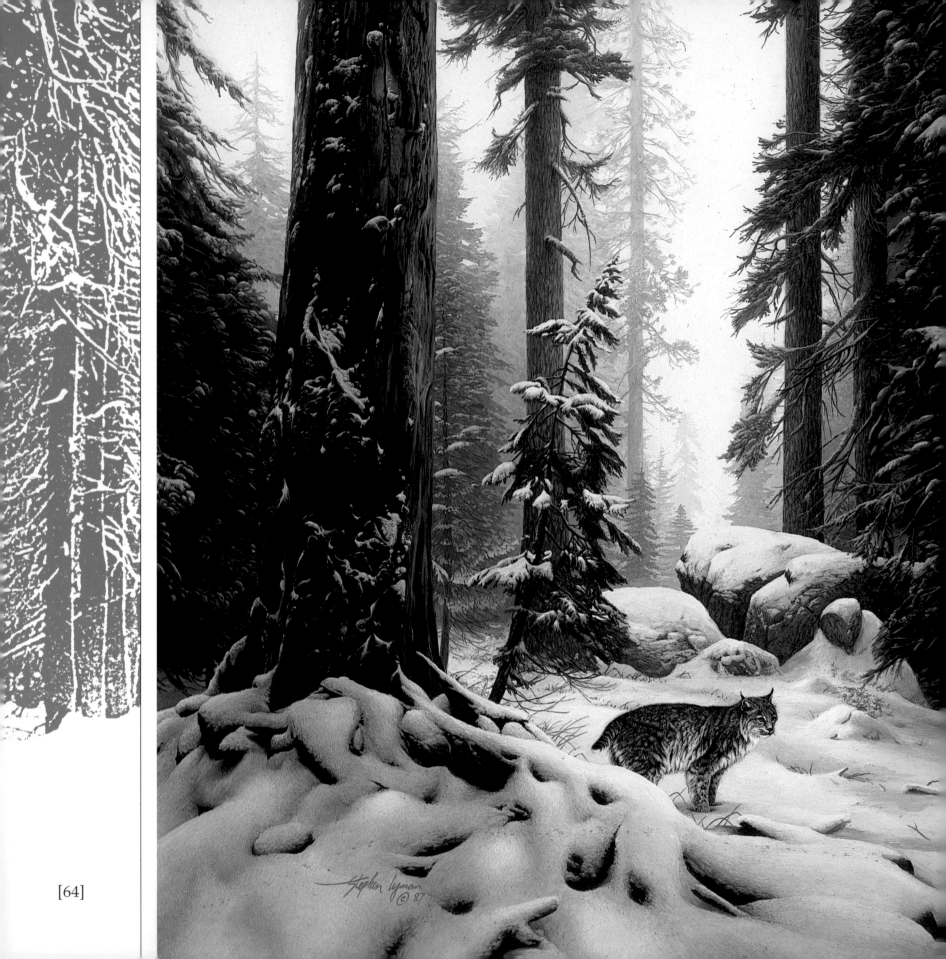

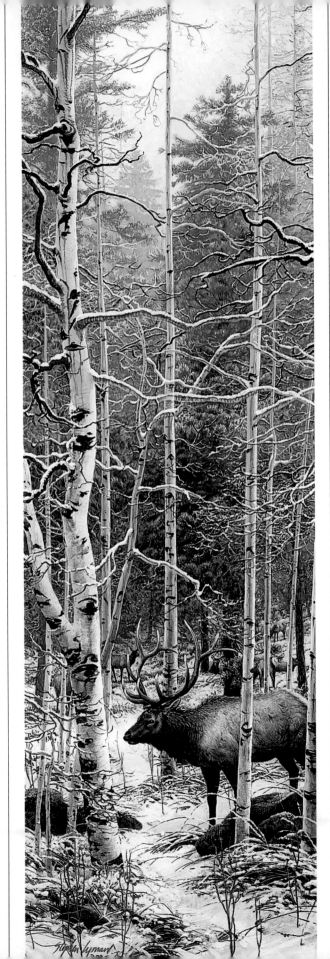

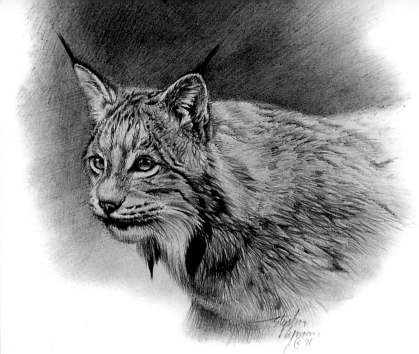

senses. Only by sitting perfectly still, listening intently, breathing softly, and concentrating to the utmost is he able to perceive the forest's heartbeat.

"Why is it that memories of campfires are so long-lasting?" asked David R. Brower in *The Sierra Club Bulletin* of February 1940. "They don't fill a particularly large portion of the day. Just the quiet hours after dusk when we're too healthily tired to want to do anything else. Perhaps we remember these hours best because here, at last, the mind is in the ascendancy; unfettered by demands of a body, now only too willing to rest, it becomes hypersensitized. A brief exposure in firelight, and a balanced composition of human values is deep-etched."

Snow Hunter

(Opposite) Although the focus here is on a bobcat, I was more interested in portraying the hushed feeling one gets in a very grand forest of old-growth trees.

Woodland Haven

This painting is mostly about textures and patterns. It depicts a bull elk with a harem of cows in an aspen grove. The format emphasizes the slender, vertical shape of the trees with their unique black markings.

When you toss wood onto a campfire, wrote Muir, "the bossy boles and branches ascend in fire to heaven, the light slowly gathered from the suns of centuries going again to the sun.... Sparks stream off like comets or in round starlike worlds from a sun. They fly into space in milky ways of lavishness, then fall in white flakes feathery and pure as snow."

It was on a night such as this, Steve reflects, in surroundings incandescent with leaping flames, that he first conceived of making a campfire the subject of a painting. It seemed like an ideal element for a landscape painting, since anyone who has spent time in the wilderness has pleasant memories of sitting in front of a warming blaze, watching sparks drift up into the night sky.

Steve knew that such a painting would pose a fine challenge to his artistic skills. To render a moving source of light such as a fire with acrylics and brushes is no easy accomplishment. The trick was going to be to convey the effects of the light-

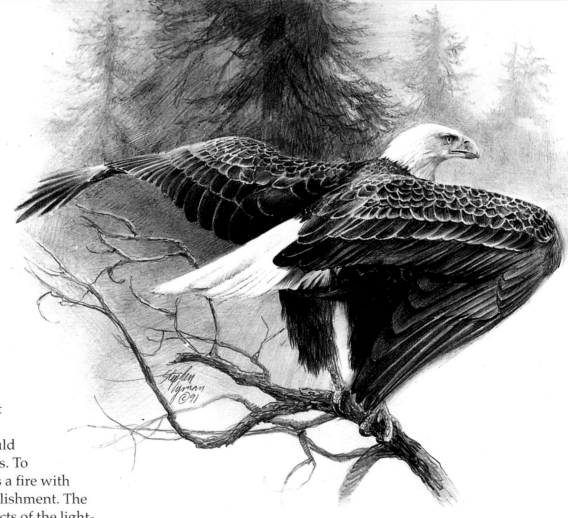

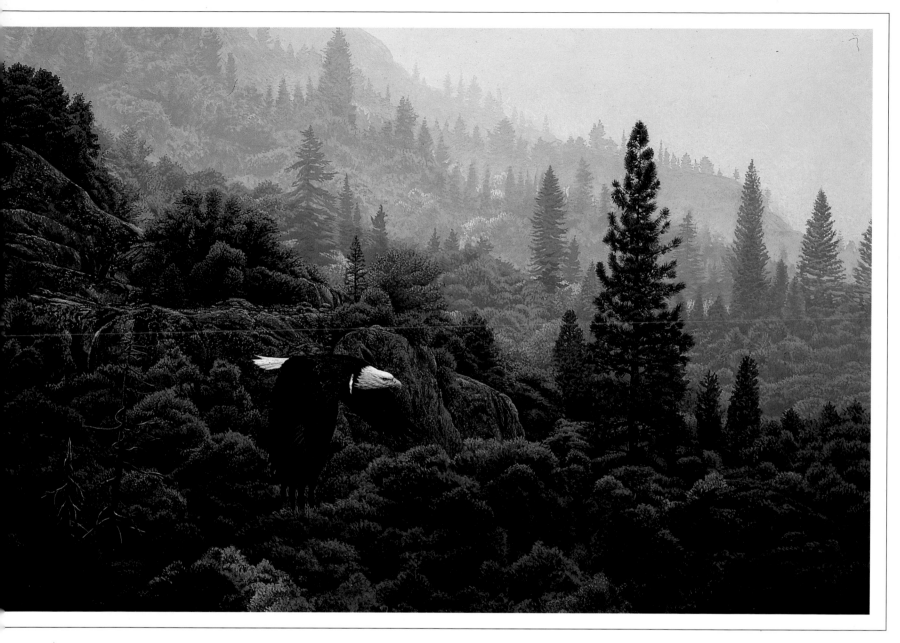

ing without losing the details of the surrounding landscape—to let the viewer focus on the flickering embers and yet be able to see beyond the light into the distance, to the pines and snowy peaks in the starlit background.

He had learned much about light from his photographic work. Setting shutters and lenses to record certain moods in shadowy terrains required enormous patience and much experi-

October Flight

Imagine you are a bird perched in the top of one of these trees. This is the view you'd see — the beauty and majesty of a bald eagle flying over the forest canopy.

mentation. Most importantly, it called for an understanding of how the eye and mind adjust subjectively to the erratic play of light and dark across irregular, multilayered surfaces. Cameras,

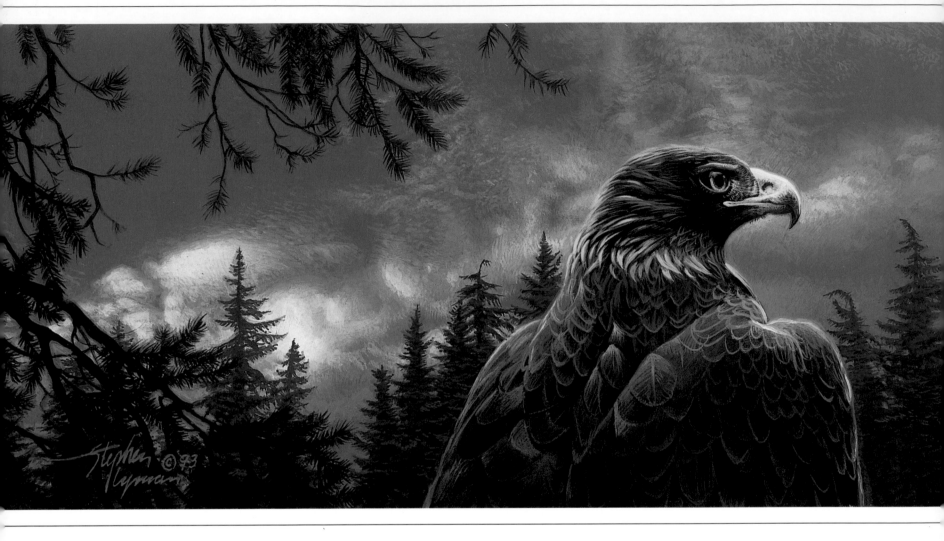

Blue and Gold

A small portrait of a golden eagle with some simply beautiful cloud formations in a deep blue sky.

on the other hand, record their impressions technically, unemotionally, compensating for vagaries in brightness only as much as their inherent limitations allow. To paint a fire's image successfully, Steve would need to more closely approximate the human, emotional vision.

All of these thoughts are playing in his head when, suddenly, *ker plop!* The heat of the fire, rising into the cedar branches, has begun sending bombs of melting snow sloughing down onto the ground below, drenching everything.

It's a startling occurrence, reminiscent of a scene in the Jack London story "To Build a Fire." That tale, set in the spruce timberlands of the Yukon in the dead of winter, portrays a man, trekking solo in seventy-five-below-zero weather, who has the misfortune of stepping through a thin skin of ice concealing a bubbling spring, wetting his feet and calves thoroughly. In a desperate attempt to keep from freezing, he hur-

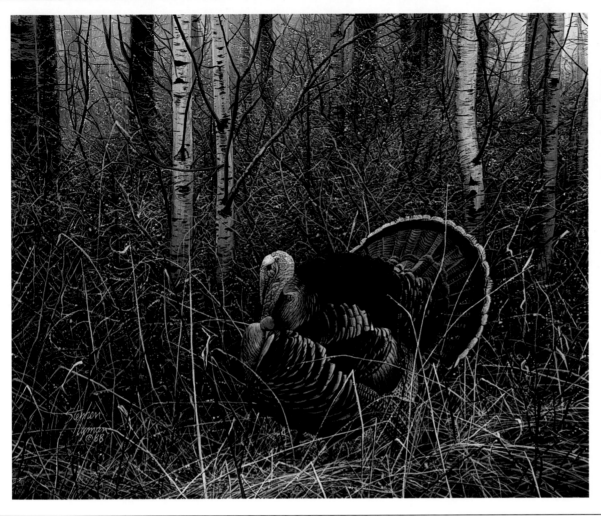

riedly builds a fire beneath a towering spruce, a location with a convenient supply of twigs and branches for fuel.

"Now the tree under which he had done this," wrote London, describing the man's relief at finally being able to remove his stiff moccasins and thick German socks so that he could thaw his feet, "carried a weight of snow on its boughs. No wind had blown for weeks, and each bough was fully freighted.... High up in the tree one bough capsized its load of snow. This fell on the boughs beneath, capsizing them. This process continued, spreading out and involving the whole tree. It grew like an avalanche, and it descended without warning upon the man and the fire, and the fire was blotted out! Where it had burned was a mantle of fresh and disordered snow."

Steve is more fortunate. The temperature in Tiltill Valley is a comfortable dozen or so degrees below freezing—and the snow slipping from the cedar boughs is a mere nuisance, not a threat to life and limb.

He would have been spared even this minor inconvenience had he brought along a camp stove and eschewed building a campfire. Indeed, he usually does so, being

Tom

Wild turkeys are smart birds, very cautious and observant and difficult to approach. I wanted to play the complex pattern and texture of its feathers against an equally complex setting. But if you take a detail of the grasses and shrubbery, it's very abstract. I'm fond of painting the beauty of wilderness in its abstract manifestations, but I always include something recognizable or realistic that people can relate to.

[69]

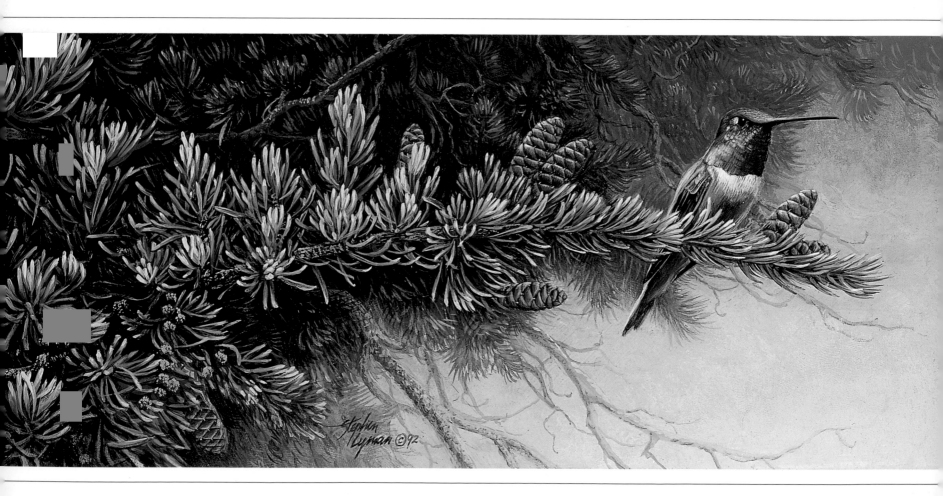

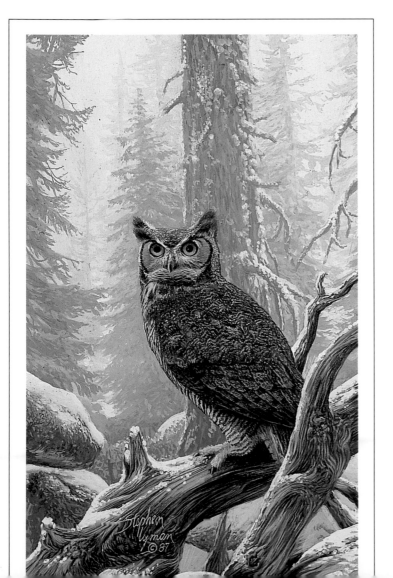

well aware that the heavy use of firewood by campers in popular backcountry areas leads to considerable ecological and aesthetic harm. Besides, often he is too busy watching the dramatic end of the day to build a fire. But there are times, such as this, when a stove is no substitute

Rufous Hummingbird and Mountain Hemlock

(Opposite) I was catching my breath after a difficult hike through Cathedral Creek Canyon when this hummingbird flew up and perched on a branch about three feet away. So happy and full of energy, it seemingly stopped by just to cheer me up.

Sounds of Silence

To humans, a forest like this would sound hushed. But a great horned owl can hear a mouse scurrying over the snow a hundred yards away.

[71]

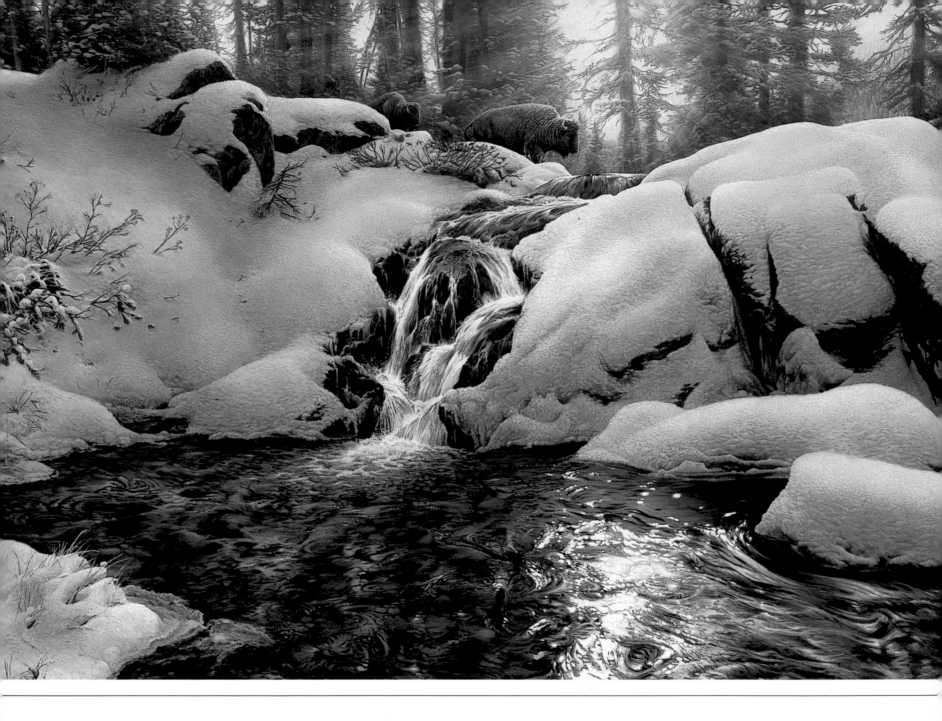

for a warming blaze, and a seasoned woodsman like Steve knows how to have his fire while conserving fuel and leaving no trace.

Within an hour or two, the sky over the meadow clears, the snowfall ceases, and a full moon, which till now had been in abeyance, emerges in full force to bathe the landscape in soft, glistening light.

The fire has died out. Silence enfolds Steve like a cocoon. For a long while he gazes across the luminescent landscape. Shadowy shapes of lodgepole pines are silhouetted around the meadow's circumference. Hummocks protrude in the otherwise flat terrain. A lone coyote prances about, searching for voles; it toys with one for a few minutes before pouncing on it,

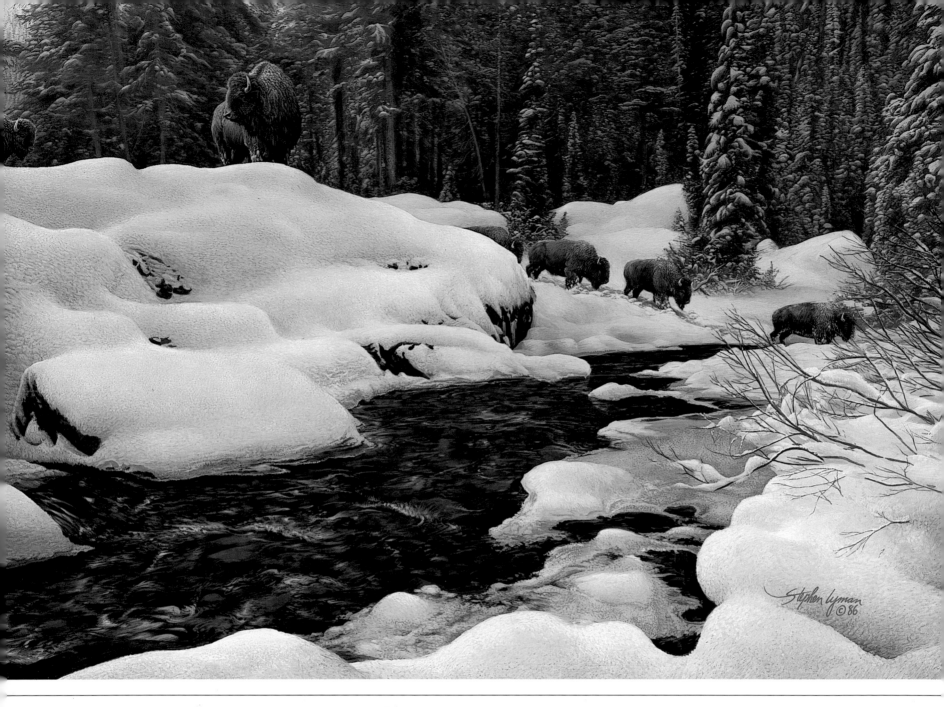

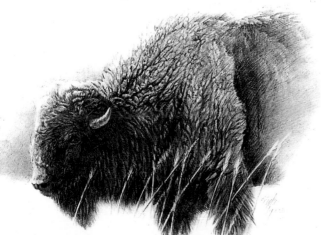

High Creek Crossing

Historically, the bison roamed not only on the
Great Plains, but well into the mountains and
forests, especially to take shelter from storms.
This scene combines elements I love to paint:
light, water, reflections, and textures.

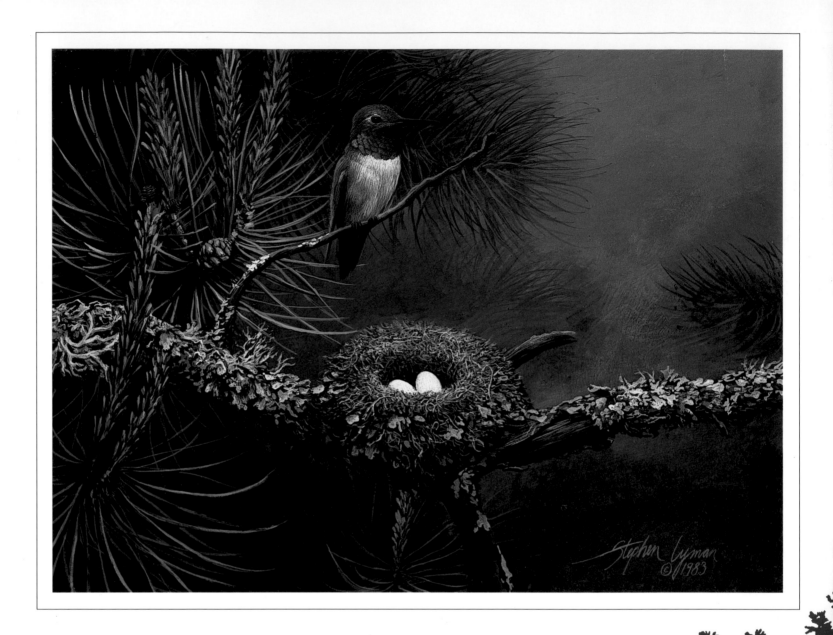

grabbing it up by the tail, and swallowing it with a gulp.

Steve tries to imagine what this meadow will look like in the blush of summer, on a glorious Sierra morning: a verdant carpet of sedges and grasses, adorned with corn lilies and alpine laurel. There will be shoot-ing stars, marigolds, paintbrush, pen-stemon, lupine, elephant's head, or any of dozens of other wildflowers that dwell in such open, ever-moist abodes.

Rufous Hummingbird and Nest

In the most intimate recesses of the forest, high above the ground among thick branches, there are tiny cradles of life such as this.

Shortly after bedding down for the night, Steve becomes aware of a rustling among the branches. The wind is picking up—just a whisper at first, but steadily increas-ing. Soon it's whistling through the trees, stirring the cedars into a wild dance, shaking the remainder of their soft white burden onto the sleeper. But the

gale's serenade, with its rhythmic bending of fronds—like brushes across a kettle drum—eventually lulls Steve into sleep. Now and then he is interrupted by the splatter of snowmelt against his bag's waterproof outer shell.

Sleeping beneath spreading boughs is a lesson Steve learned from Muir, who often made his bed in pine thickets. Muir was, apart from being a phenomenal mountaineer, geologist, and glaciologist, a botanist of exceptional perspicacity, who took an especially keen interest in trees. Studying and admiring their form and habits, he focused on their relationships with other wildlife, those with whom they associated. To know them well, he slept among them. Once, on the rim of a glacial basin, Muir lay snug as a squirrel beneath a roof of pine branches, inhaling spicy odors (as he put it) and listening to the wind-played needles singing him to sleep. "I little expected company," he wrote of the occasion, "but creeping in through a low side-door, I found five or six birds nestling among the tassels. The night-wind began to blow soon after dark; at first only a gentle breathing, but increasing toward midnight to a rough gale that fell upon my leafy roof in ragged surges like a cascade, bearing wild sounds from the crags overhead. The waterfall sang

[75]

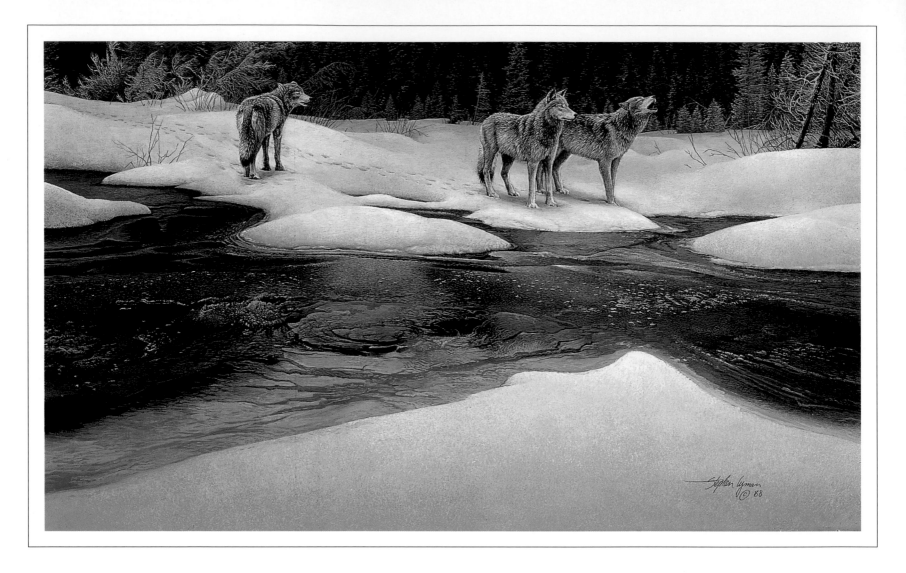

in chorus, filling the old ice-fountain with its solemn roar, and seeming to increase in power as the night advanced—fit voice for such a landscape."

Muir extolled at length the virtues of "The Big Trees" of the Sierra, the giant sequoias, "exquisitely harmonious and finely balanced…in all their proportions and circumstances. No other tree in the world…has looked down on so many centuries as the sequoia…kings of their race…preaching God's forestry fresh from heaven."

But Muir was equally effusive in singing the praises of other "tree people," as he called them. To him, the Douglas fir (or Douglas spruce, as he called it—a species named after botanical collector and fel-

low Scotsman David Douglas) was "the king of the spruces…ever beautiful, welcoming the mountain winds and the snow as well as the mellow summer light, and maintaining its youthful freshness undiminished from century to century through a thousand storms." Sugar pines, a species only slightly less dramatic than either the sequoias or Douglas firs, were "the priests of pines, and seem ever to be addressing the surrounding forest.… In approaching it, we feel as if in the presence of a superior being, and begin to walk with a light step, holding our breath." As to the unassuming Jeffrey pine, it "gives forth the finest music to the wind. After listening to it in all kinds of winds night and day, season after sea-

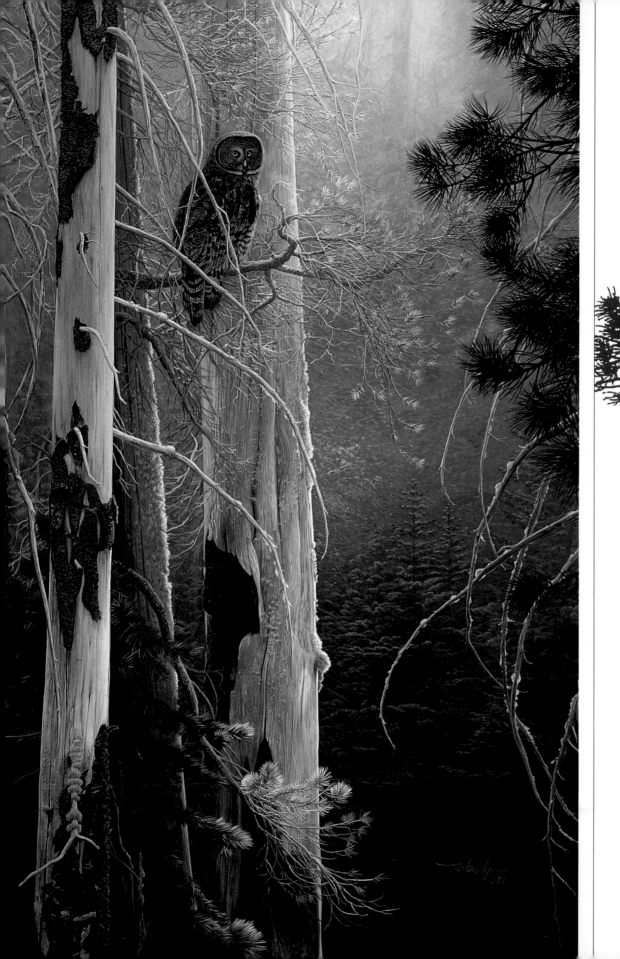

son, I think I could approximate to my position on the mountains by this pine-music alone." The pure stands of red fir that perch in solemn splendor on the upper Sierra slopes, in autumn "are hushed in the hazy light, and drip with balsam; the cones are ripe, and the seeds, with their ample

The Intruder

(Opposite) Some animal outside of the picture has intruded into the territory of this pack of wolves. This is happening at the edge of a frozen creek, where the layers of ice have built up into beautiful crystal terraces.

Silent Sentinel

In Yosemite, great grey owls keep a watch from the lodgepole pine fringe along favorite meadows. A human clomping through the area is like thunder to their extraordinary hearing. However, imagine what you would see if you could sneak up behind one of these magnificent birds.

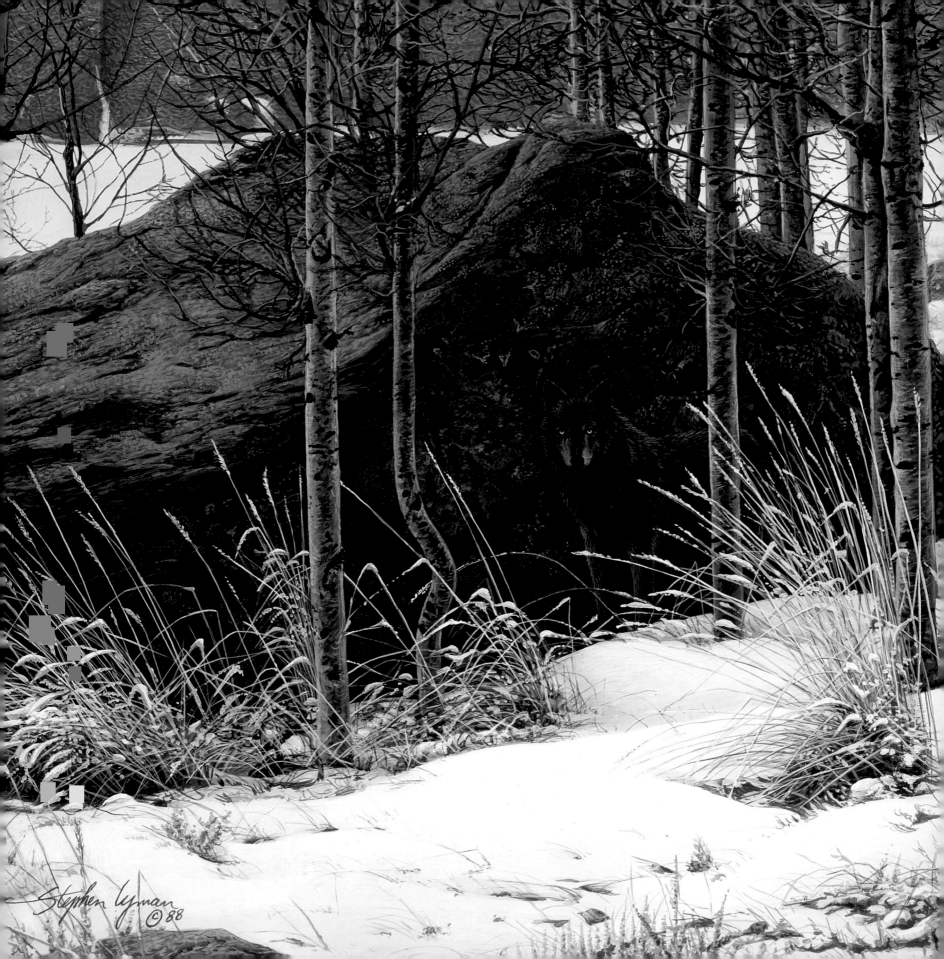

Stephen Lyman
©88

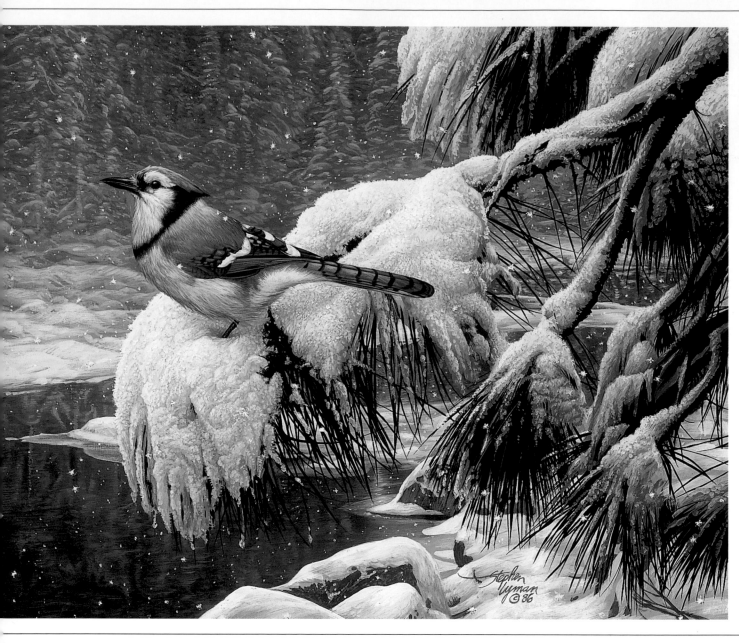

Winter Shadows

(Previous page) The black wolf in front of this rock is something you don't see right away. When you finally notice it, you realize it has been watching you all along.

purple wings, mottle the air like flocks of butterflies; while deer feeding in the flowery openings between the groves, and birds and squirrels in the branches, make a pleasant stir which enriches the deep, brooding calm of the wilderness, and gives a peculiar impressiveness to every tree."

The incense cedars sheltering Steve this night are of a species that is common on the west slope of the Sierra—one that, along with the ponderosa pine, dominates the floor of Yosemite Valley. As such, while not holding the celebrity status of the giant sequoia, the cedar nevertheless has become a familiar attraction for the thousands of people who visit the national park each year.

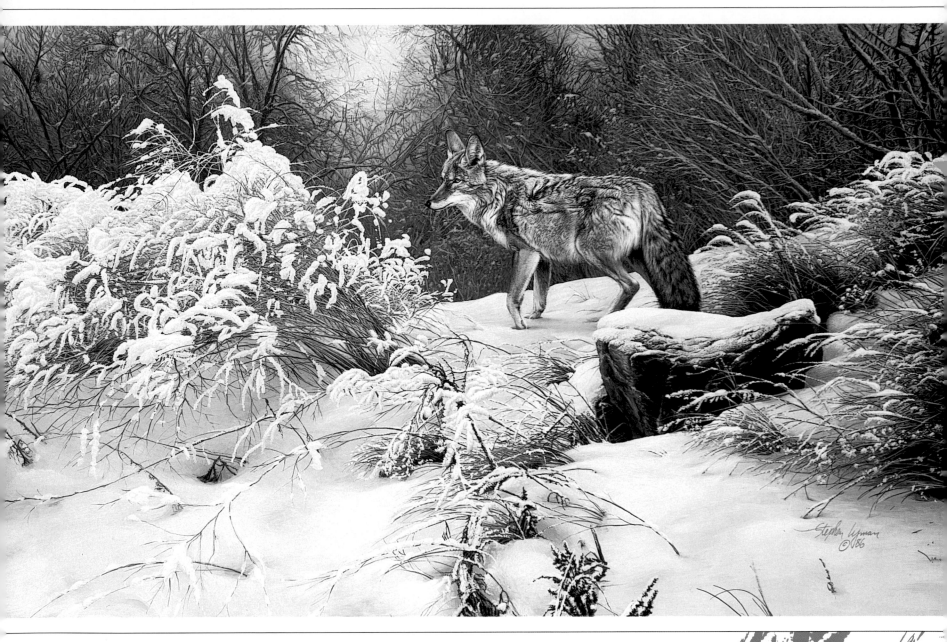

Twilight Snow

(Left) *I recently saw a blue jay like this one near my house, flying*
around with a Steller's jay — an unusual visitor to north Idaho.

A Winter's Hunt

A coyote with a particularly shaggy coat, its warmth and lushness
contrasting with the cold textures of the snow
and all the grasses and branches.

Right now a cedary incense is a welcome wakener, as tantalizing as the smell of baking breakfast muffins. Steve rouses himself to the accompaniment of a raucous chirping, chattering, fluttering of wings, singing, screaming, tapping of beaks, and clattering of claws. It's a glorious, bright dawn. Spring has arrived with abandon, filling the meadow with glad spirits. Steve props himself up in his nest, leaning on his elbows, and takes a glance around. In the branches just over-head, a pair of mountain chick-

adees is having a rollicking good time, occasionally behaving like acrobats, hanging upside down as they sing their hearts out. A yellow-rumped warbler, just a tree away, is competing for airtime, getting its song in when-ever there's a lull. A knocking jackhammer sound, echoing faintly from among the lodgepoles at the meadow's edge, indicates a woodpecker early at work, while a high-pitched scream from atop the tallest pine in sight announces the presence of a red-tailed hawk, who surveys its domain with stoic detachment. It almost loses its composure, though, when a clownish Steller's jay, poking around in the duff under the cedars, mockingly imitates its call. Ignoring them all, a ground squirrel off to one side of Steve whistles and talks to itself as it gathers its breakfast, running back and forth with a load of seeds.

After a leisurely morning, having partaken of bread and sunshine enough to get his internal combustion engine started, Steve packs his gear, painstakingly removes any traces of his presence under the cedars, hoists his backpack, and strikes out across the meadow, searching for the trail that will take him higher into the Sierra. He finds it about halfway across, its entire length to the meadow's edge submerged in spring meltwater. Ah, well, what could be more refreshing than a nice foot bath in clear, cold water? Steve removes his boots and socks, rolls up his pant legs, and wades into the stream, its submerged grasses cushioning his footsteps and caressing his toes. He can't imagine a better beginning for the climb up to his next camp on his journey to the timberline.

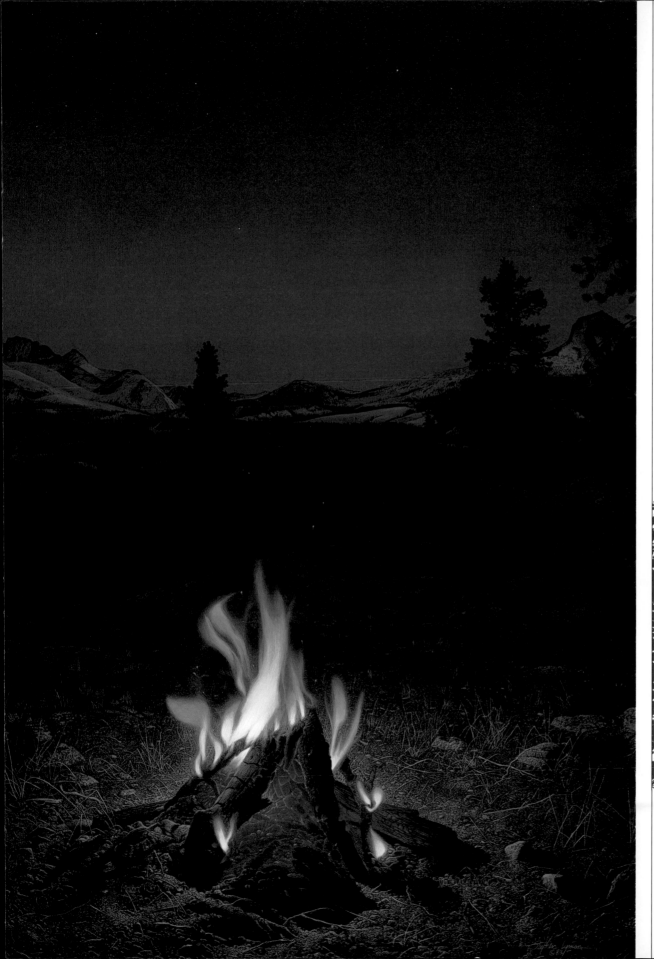

A Mountain Campfire

A *milestone in my career,
this painting was a deliberate
departure from my wildlife
subject matter. It is a land-
scape, but with a very attrac-
tive element added, one that
I have experienced many times
in my wilderness journeys.
As I painted, I could feel the
excitement and meaning that
this image would generate.
It flowed out so smoothly and
effortlessly, as if it were meant
to be. Are there any hidden
animals here? Yes — in the
background are nearly five
million mosquitoes.*

[83]

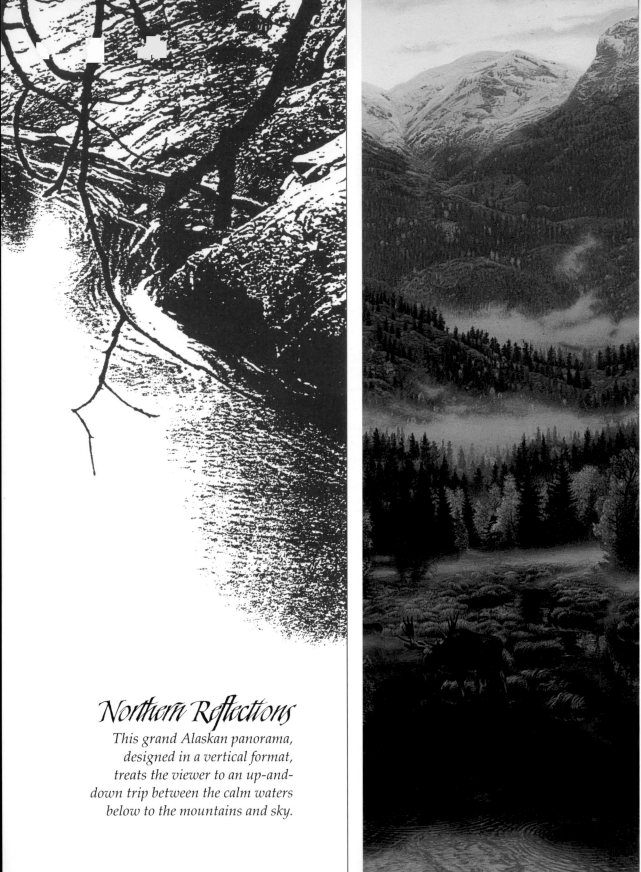

Northern Reflections

This grand Alaskan panorama,
designed in a vertical format,
treats the viewer to an up-and-
down trip between the calm waters
below to the mountains and sky.

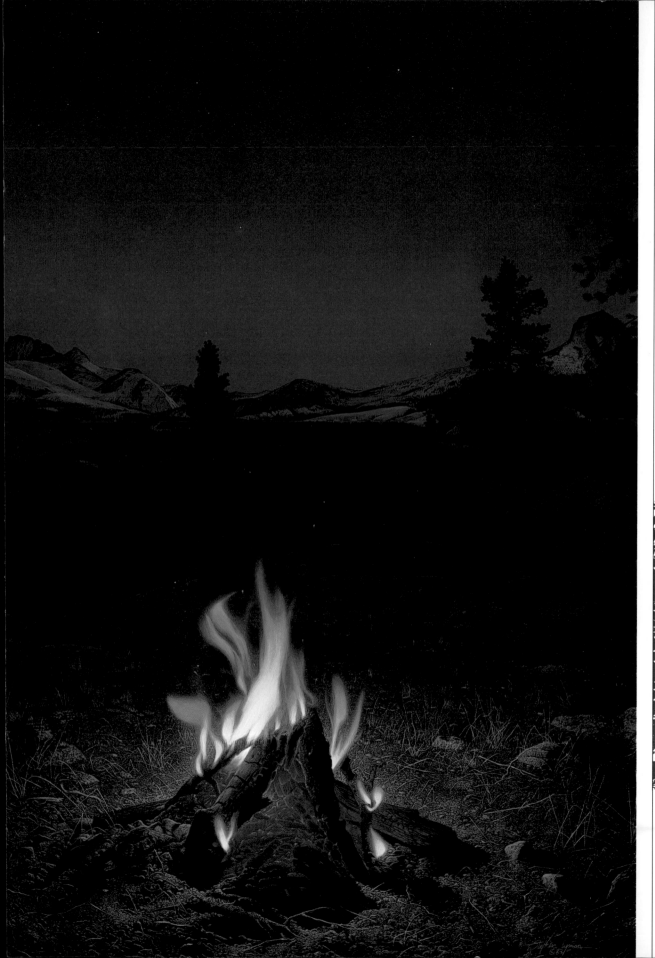

A Mountain Campfire

A milestone in my career, this painting was a deliberate departure from my wildlife subject matter. It is a landscape, but with a very attractive element added, one that I have experienced many times in my wilderness journeys. As I painted, I could feel the excitement and meaning that this image would generate. It flowed out so smoothly and effortlessly, as if it were meant to be. Are there any hidden animals here? Yes — in the background are nearly five million mosquitoes.

[83]

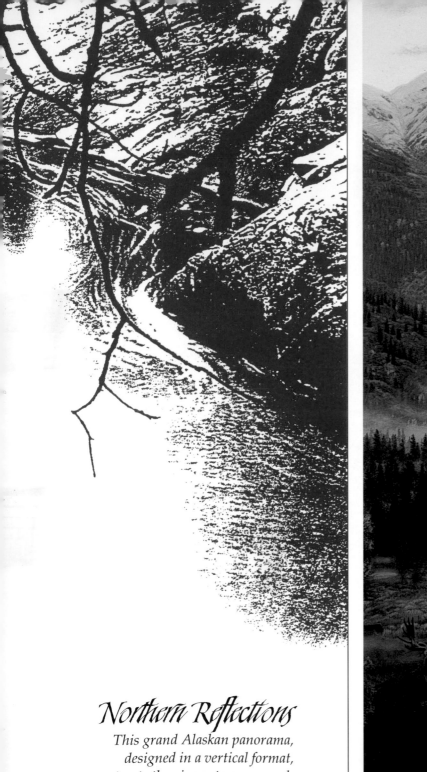
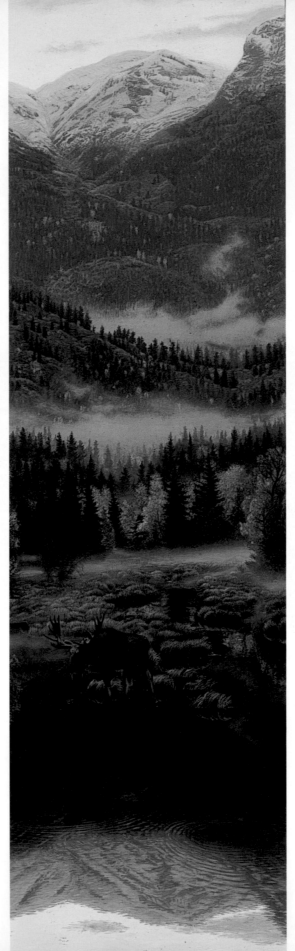

Northern Reflections

This grand Alaskan panorama, designed in a vertical format, treats the viewer to an up-and-down trip between the calm waters below to the mountains and sky.

-4-

AT WATER'S EDGE

a man's life
should be as fresh as
a river…the same channel
but a new water
every instant

AT WATER'S EDGE

*a man's life
should be as
fresh as a river
...the same
channel but a
new water
every instant*

—HENRY DAVID THOREAU

On this night, in the deepest, steepest, most remote section of the Rancheria Creek gorge, Steve is serenaded by the swift flow of water over sculpted granite. The cataracts' ceaseless rumble, at times surging and booming, periodically rouses him from his sleep, but it doesn't bother him. On the contrary, waking at intervals in the darkness allows him to track the progress of Gemini's brightest stars, as they wheel directly overhead, and to observe the hunter Orion's steady march across the southern horizon.

A shimmering glow emerges above the cliffs to the east, like steam rising off the warming land. With it comes the enthusiastic song of a water ouzel fishing for its breakfast—a deliriously happy melody sung in harmony with the churning rapids, yet soaring above them, filling the gorge with its solitary voice.

As light begins filtering into the gorge, Steve hops down the few ledges between his sleeping bag and the stream to fill a pan with water for tea. At streamside, he gazes transfixed at the long chain of inky black pools that, with each new shaft

of light, metamorphose into emerald green—pools in which the water appears to rest briefly before continuing its dance ever downstream in a series of graceful arcs.

Beauty overlaid with beauty, thinks Steve. This is what makes the mountaineering challenge worthwhile. He is well off the beaten path; probably very few travelers have passed this way. He feels privileged to be here now, to be experiencing this cascading creek's grace and power.

"We are often like rivers," wrote Gretel Ehrlich in *The Solace of Open Spaces*, "careless and forceful, timid and dangerous, lucid and muddied, eddying, gleaming, still."

So moody and yet so gorgeous: it's little wonder that water, for a wilderness painter as for a nature writer, holds an irresistible allure. Not only is it a sensuous form, curvaceous and soft, but a primary force essential in the creation of life, ever renewed and renewing.

Steve is drawn to streams, rivers, lakes, and ponds as if somewhere in his subconsciousness a memory as ancient as Earth were reminding

him that he and his remotest ancestors derived from the watery realm. In respect to the birth-giver's spirit, he makes a pilgrimage to the source, so as to not wither inside as corn does on a drought-stricken stalk. As Henry David Thoreau put it, "a man's life should be as fresh as a river. It should be the same channel but a new water every instant."

Nature writers, like wilderness painters, almost invariably devote a significant part of their work to water, affirming its hold on their imaginations. Wallace Stegner did so in *The Sound of Mountain Water*. He described the effect that landscapes with white-water streams had on him when, as a boy in the company of his family in 1920, he first visited Yellowstone National Park:

I gave my heart to the mountains the minute I stood beside this river with its spray in my face and watched it thunder into foam, smooth to green glass over sunken rocks, shatter to foam again…. By such a river it is impossible to believe that one will ever be tired or old.

Part of water's allure is its complexity, the textures it reveals in its relationship with the land,

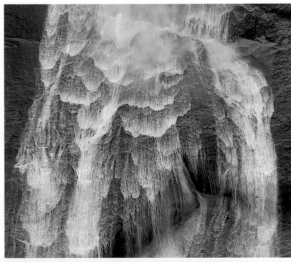
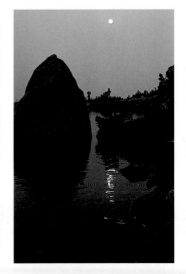

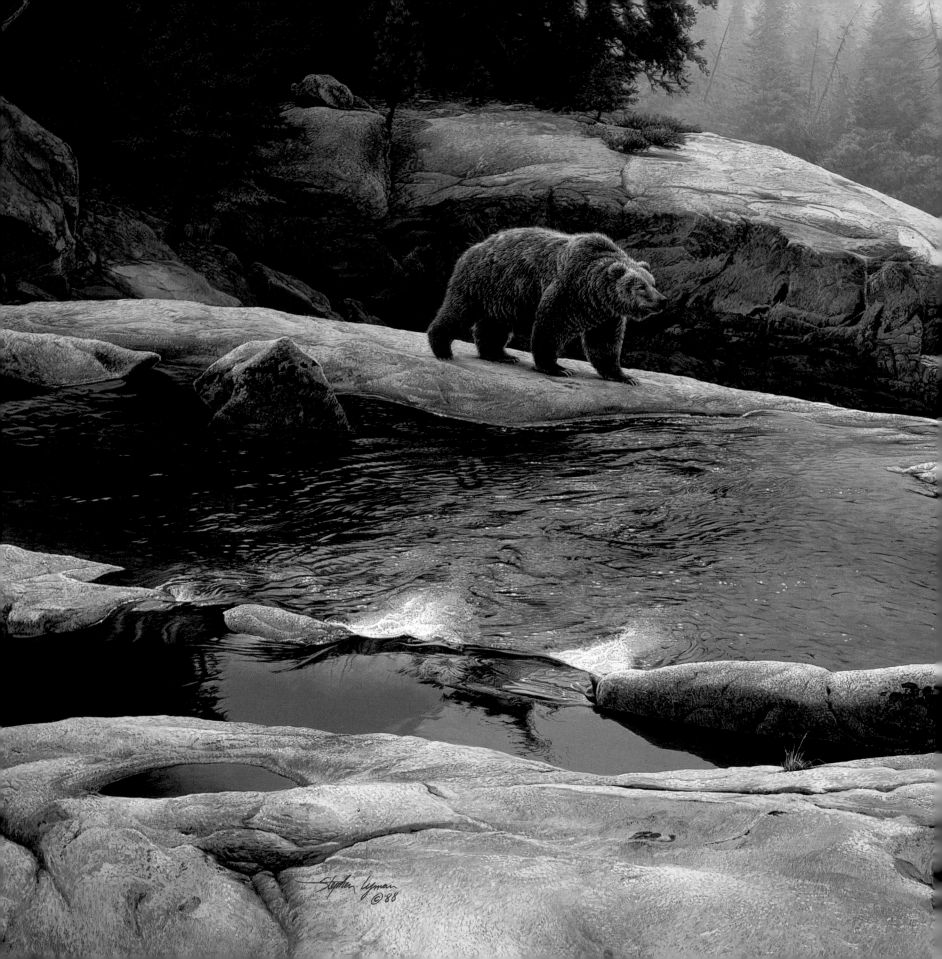

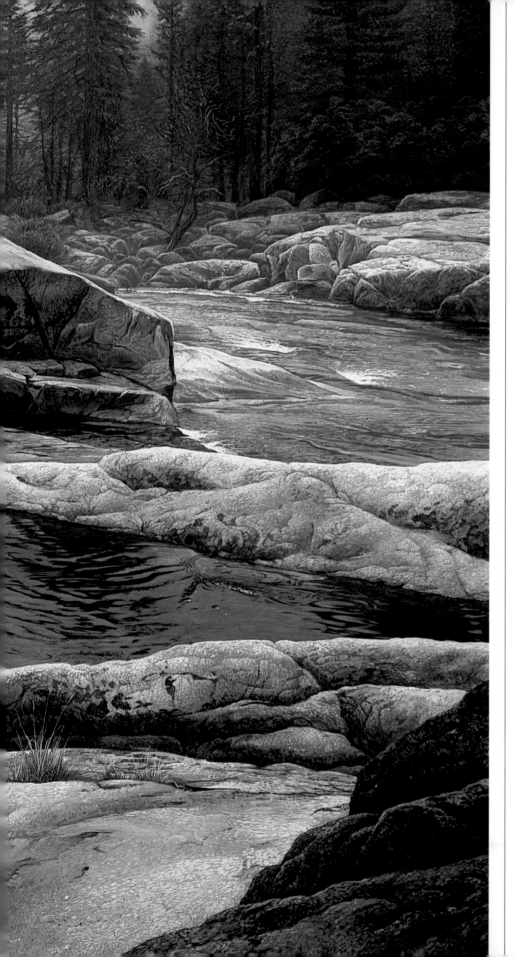

and its associations with wildlife: the way it laps at a grassy shoreline or gathers in a boulder's shallow depression; the ripples in concentric circles around the legs of a wading great blue heron; the way it glissades in silvery rivulets down an embankment during a gentle rain; or how it stands utterly still and silent in the wake of a thunderstorm, mirroring the shoreline and the parting clouds. Water's absence defines its power: curling mud cakes; brittle, browning leaves; desiccated lakebeds encrusted with plant detritus and fish skeletons; dusty trails; parched throats. Rich in meanings both overt and subliminal, metaphorical and lit-

Uzumati—The Great Bear of Yosemite

Before European settlers started exterminating them during the Gold Rush, there were tens of thousands of grizzly bears in California. My research has turned up reports of 2,000-pound bears and of hunters boasting of killing 45 bears in one year. By 1925 they were gone. "Uzumati" was the native Miwok word for grizzly bear and is the source of the name we use for the park today—Yosemite.

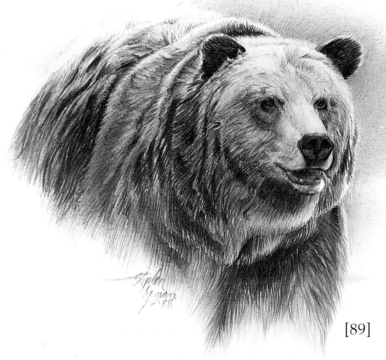

[89]

eral, water is for the landscape
painter what wind is for the kite-
flyer and soil is for the farmer: an
indispensable medium.

Steve's journey to the river's
source now takes him to the top
of the series of falls, whereupon
he makes a pleasant discovery: the
deepest pool of all—a sort of hold-
ing tank before the final plunge—
complemented by a sandy beach.
If it were summer, and he were hot
and sweaty, a cool dip in the pool
and some moments of basking
in the sun would be tempting.

Riparian Riches

*"Riparian" refers to the life zone along
a waterway or a lake. The riches are
the life inhabiting that zone — the fishes
in the water, the insects the fish eat,
the great blue heron that eats the fish,
the frogs that inhabit the shore, the
foliage, the lichens on the boulders.
It's inspired by a bend in the Merced
River near El Capitan.*

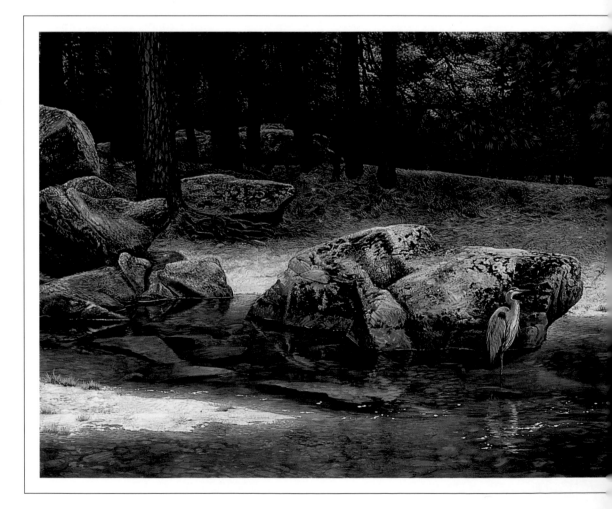

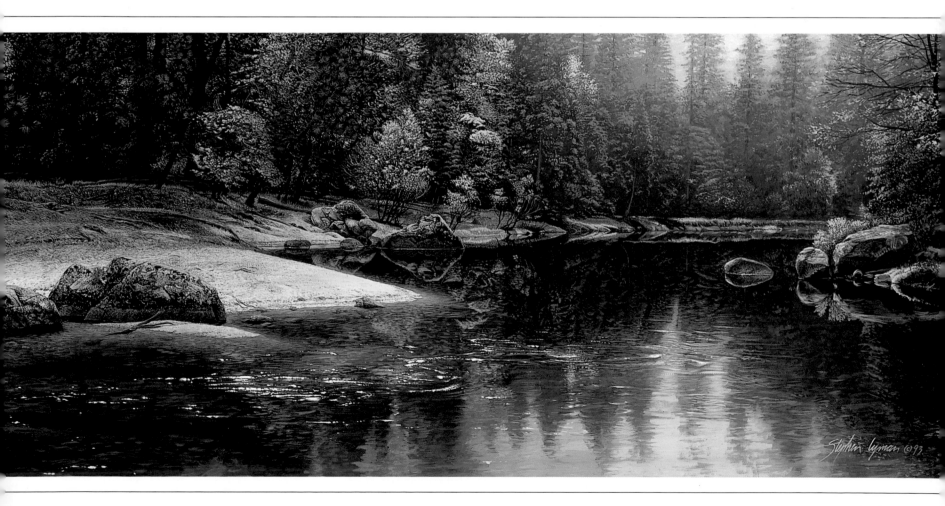

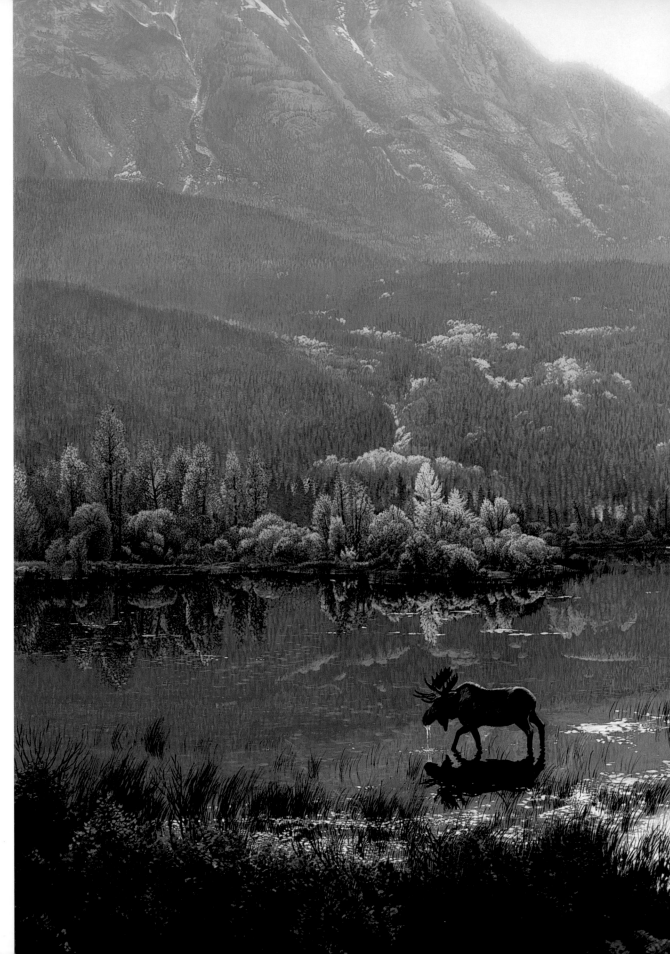

Canadian Autumn

I enjoyed the opportunity to paint diffused light reflected from a pond in the Canadian Rockies, with one of the largest North American animals appearing quite small in relation to the vast landscape.

[92]

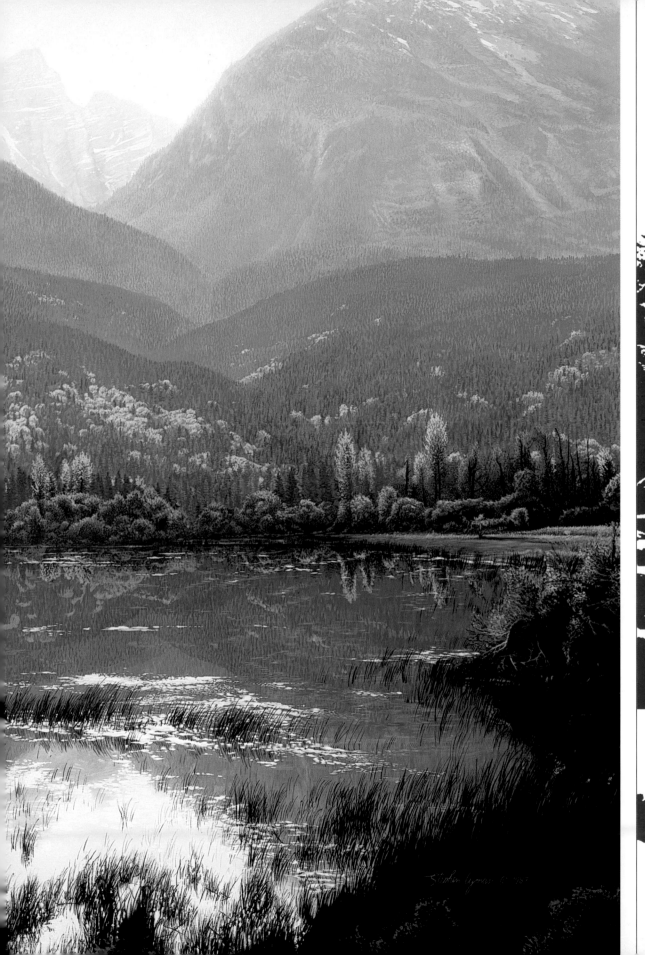

[93]

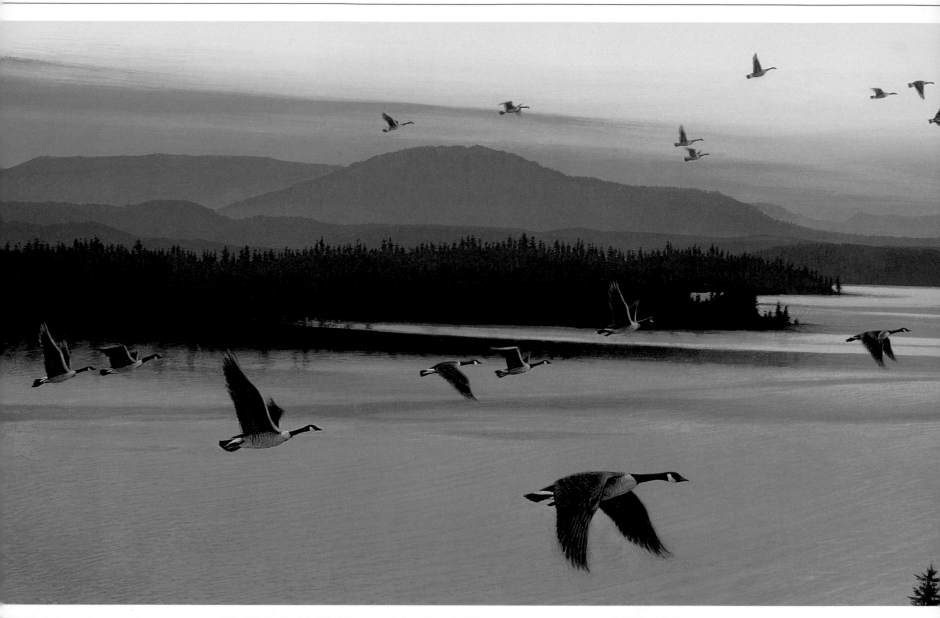

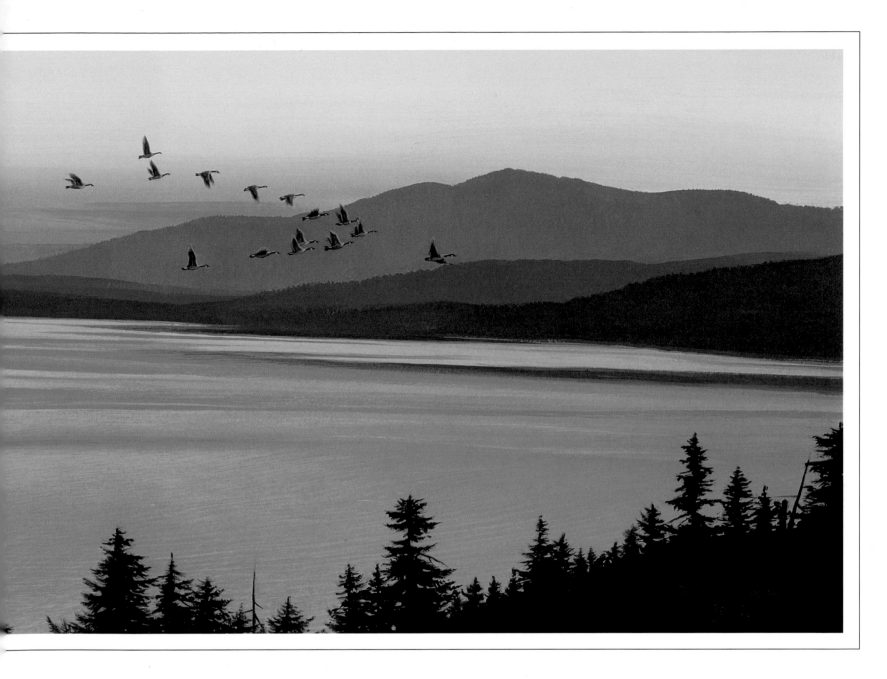

But while it is technically spring, winter envelops the land.

So he continues onward, a long day's journey up the canyon. Only at the junction of Rancheria and Deep Canyon creeks does he begin looking for a way to cross the torrent, so as to explore the deep canyon. He traces Rancheria up into a gorge that at first glance looks passable, but whose steep walls require him to climb using only tiny hand- and footholds, and finally persuade him to descend and retrace his steps downstream.

He remembers a certain log he had passed by, noting at the time that it spanned the creek and might be traversable. There, he now realizes, lies his best hope for crossing.

Sounds of Sunset

Pend Oreille Lake in northern Idaho is one of the deepest fresh-water lakes in the country, over 1,000 feet deep. The Canada geese are on their migratory journey north for summer.

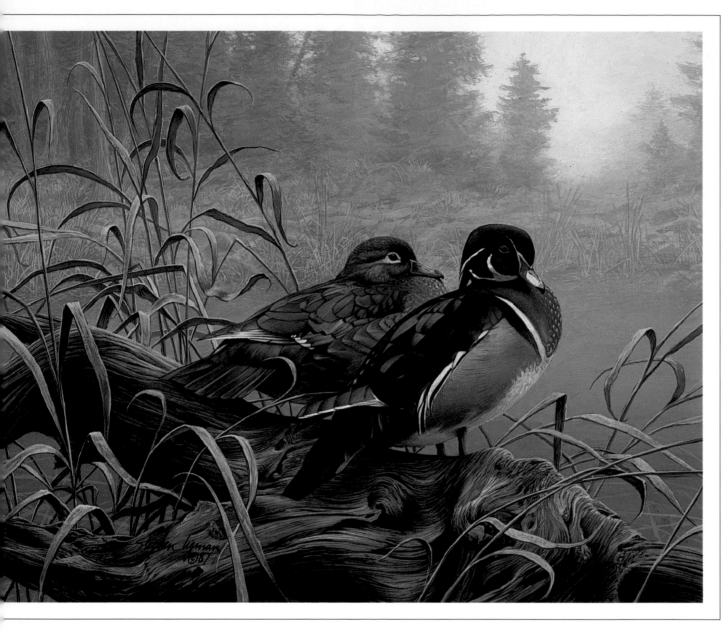

An Elegant Couple

As is usual with many species, the male wood duck is more color-ful and more strikingly feathered than the female. But she has some gorgeous iridescent feathers in her wings, too. They're called wood ducks because they often nest in hollow tree trunks.

Sure enough, the log is there, stretching across the rushing water, a perfectly feasible bridge. A few balanced steps and he's across, into the unknown territory of Deep Valley.

Before setting out on this trek, Steve had been told by his friend Jim Snyder that this valley harbors several bears. Unlike those scavenger bears common to campsites, it's a rare treat to see completely wild bruins. Steve searches for their tracks in the snow, but he spies only the prints of a pair of coyotes, weaving in and out of each other. Claw marks on an aspen tree, however, provide ample evidence that at least one bear has been scratching here. He knows that a bear could be nearby without his noticing it. The

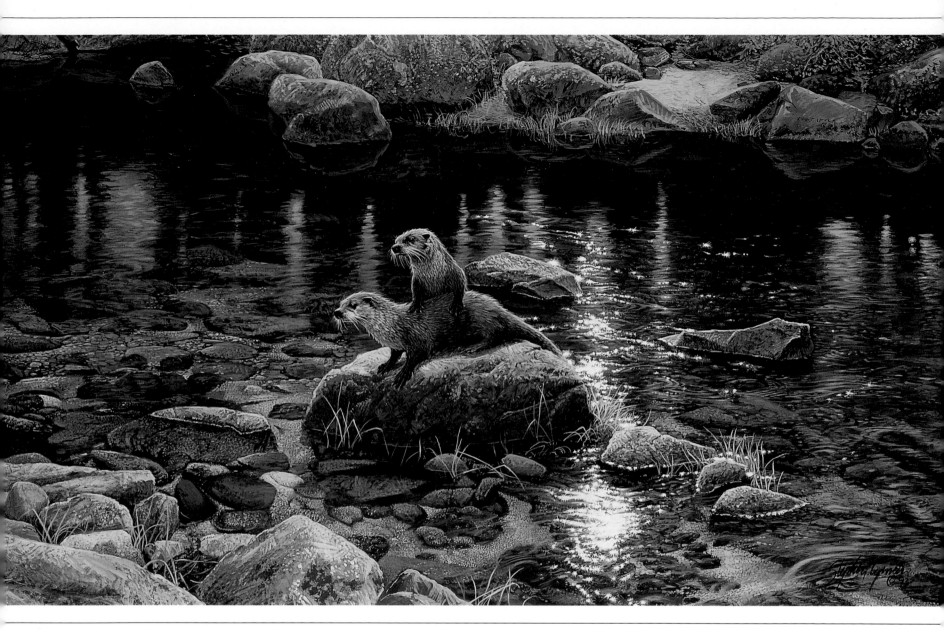

animals can blend discreetly into their environment, appearing as shadows among thickets of trees.

He's thinking of black bears, of course, not grizzlies with their pronounced shoulder hump, dished forehead, and (of course) grizzled fur. The last known California grizzly in the Yosemite area was killed in 1895 or thereabouts. By that time, most of the state's grizzly population, which at its peak is thought to have numbered in the tens of thousands, had been wiped out by hunters. The bulk of them were

New Kid on the Rock
These quick, curious, and playful otters have suddenly discovered the plodding, deliberate turtle that has blundered into their riverside kingdom.

killed during the Gold Rush years between 1849 and 1870. The last reliable sighting of a grizzly in the California wilds occurred in 1924, in Sequoia National Park.

John Muir, in *Our National Parks*, described his one

[97]

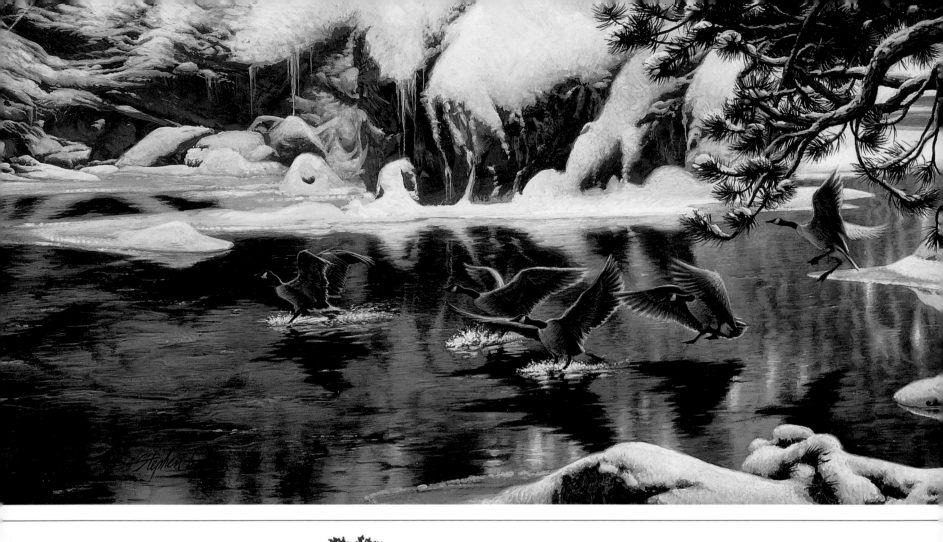

River of Light

The river weaves through a landscape of ponderosa pine, over and under the ice and snow, all the while burning with the warm reflections of a golden sunset.

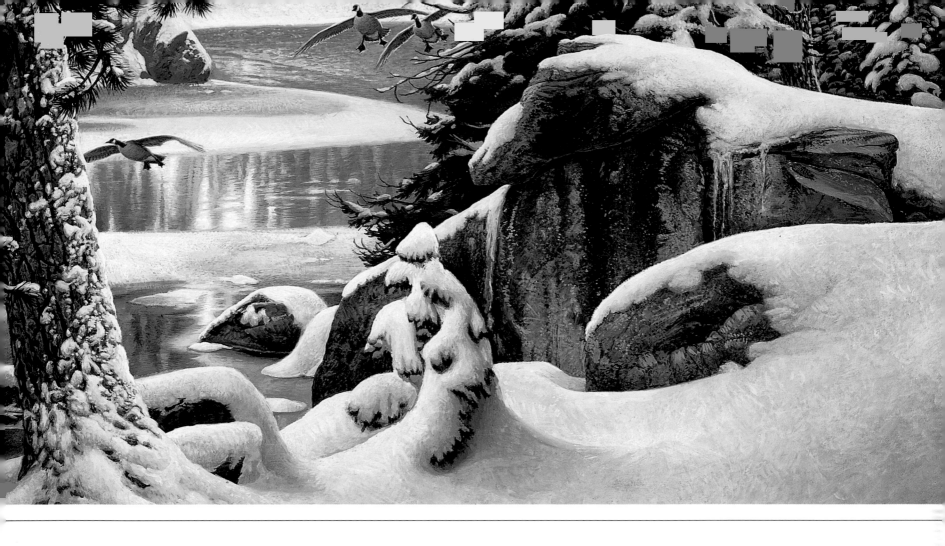

encounter with a wild grizzly in Yosemite:

"Though not a large specimen, he seemed formidable enough at a distance of less than a dozen yards. His shaggy coat was well grizzled, his head almost white. When I first caught sight of him he was eating acorns under a Kellogg oak, at a distance of perhaps seventy-five yards, and I tried to slip past without disturbing him. But he had either heard my steps on the gravel or caught my scent, for he came

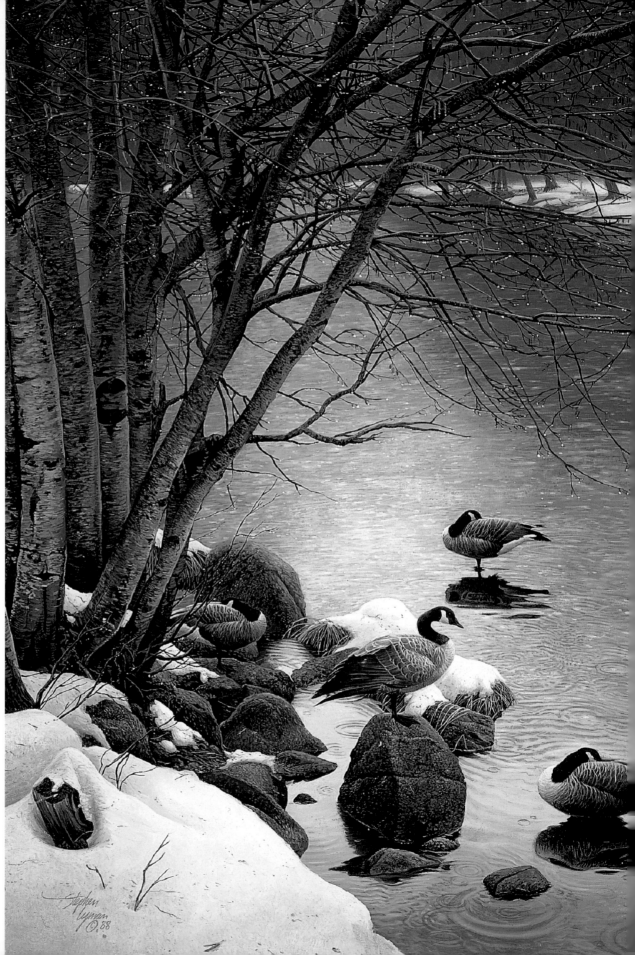

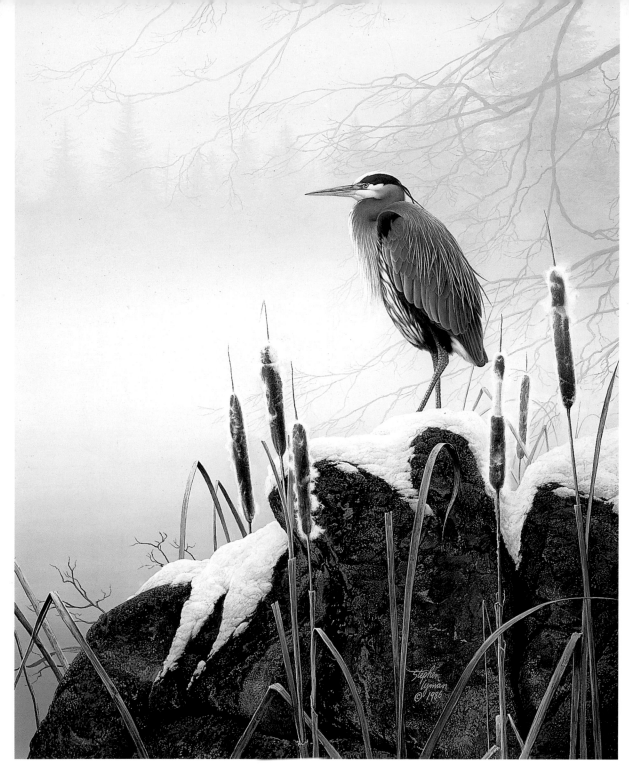

Morning Solitude

Shrouded in winter mists, the graceful beauty of a great blue heron at the edge of a pond suggests a peaceful, oriental quality.

Quiet Rain

(Left) This painting is about quietude: a very gentle, relaxed, and delicate mood. The raindrops rhythmically drip off the branches, creating concentric circles in the water.

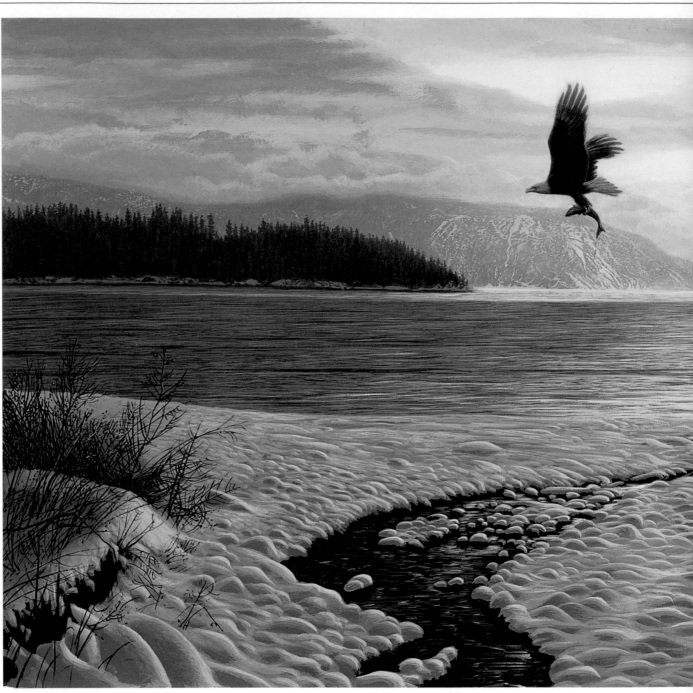

straight toward me, stopping every rod or so to look and listen: and as I was afraid to be seen running, I crawled on my hands and knees a little way to one side and hid behind a libocedrus, hoping he would pass me unnoticed. He soon came up opposite me, and stood looking ahead, while I looked at him, peering past the bulging trunk of the tree. At last, turning his head, he

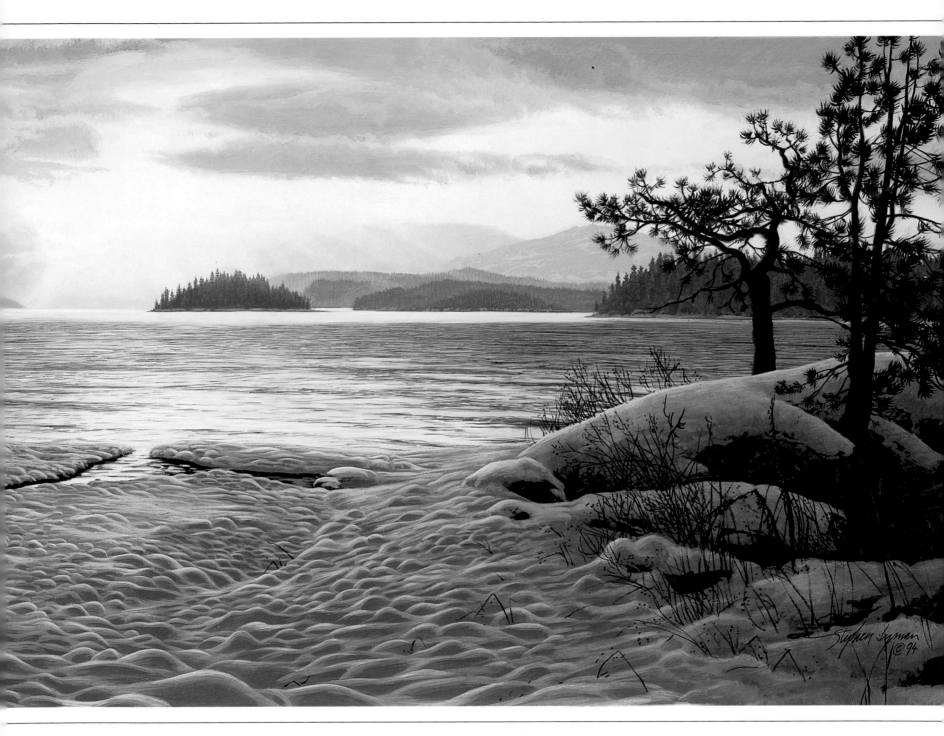

North Country Shores

Similar in subject to Last Light of Winter, *this painting has a very different feeling. Pristine and suffused with golden light, it is accented by the bald eagle poised in flight with a fresh catch in its claws.*

caught sight of mine, stared sharply a minute or two, and then, with fine dignity, disappeared in a manzanita-covered earthquake talus."

The grizzly had been universally vilified in

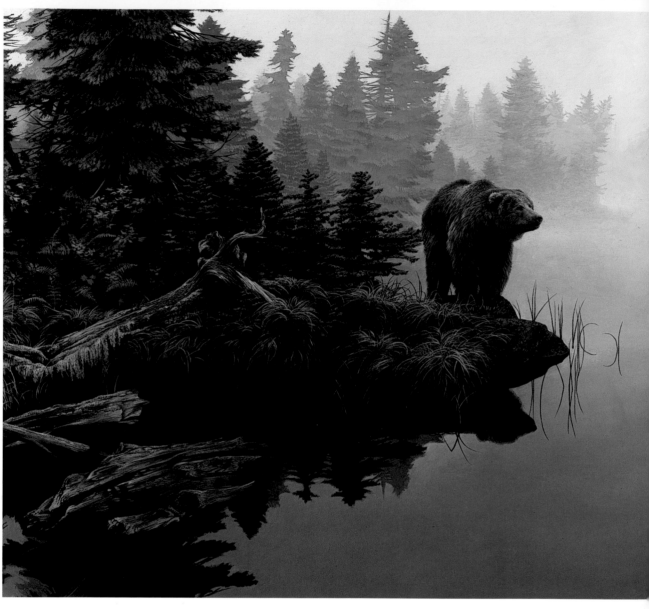

Noisy Neighbor

In the early morning mists, a grizzly emerges from the forest, reaching the water's edge. Suddenly, the silence is broken by the screech of a Steller's jay, sounding the alarm of this intrusion into its neck of the woods. Knowing it would be fruitless to go after the bird, the powerful bear just stands watching, while the jay boldly chastises him.

California since the coming of the first European settlers. The bears were resented and slaughtered for the damage they did to livestock and gardens. It was the grizzly's great physical strength, fearlessness, and seeming contempt for humans that fostered the fear that was its undoing. That Muir should ascribe dignity to such an animal tes-

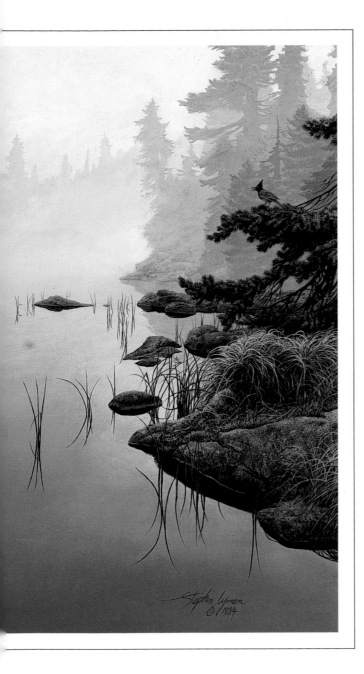

National Park, "was full of meat and skins hung in bundles from the rafters, and the ground about it was strewn with bones and hair—infinitely less tidy than a bear's den."

For all of Yosemite's wildness today, its lack of grizzlies ambling down to streams to quench their thirst makes it a tamer place than it once was, a fact that makes Steve nostalgic for an unspoiled land. He often imagines himself adventuring in the Sierra when its most magnificent creature still roamed the valleys, meadows, foothills, and mountainsides. Then he would follow their well-worn trails to observe them as they foraged for grasses, bulbs, huckleberries, acorns, field mice, ground squirrels, deer carrion, frogs, and any number of other such delicacies.

Grizzlies are great lovers of water. Though Steve was born too late to see them frolicking in Sierra streams, he has observed them along the Toklat River in Denali National Park. There the grizzlies would emerge from the woodlands, gallop over gravel bars, plunge into the chan-

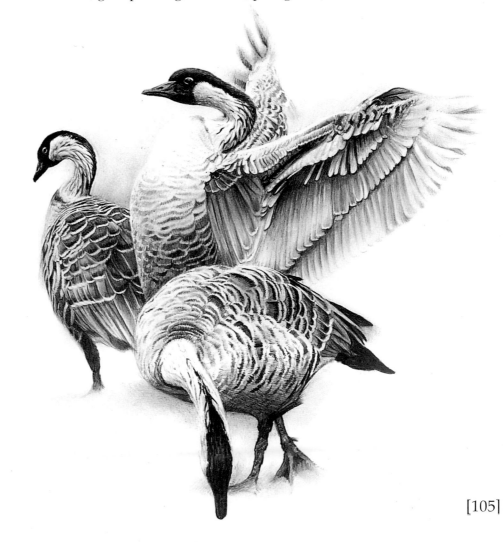

tifies to his enlightened naturalist's sensibilities, free of animosity toward any living thing—except barbarous humans who abused wilderness.

Muir once noted wryly that the residence of the most famous bear-killer in all of California, on the shore of Crescent Lake near the south boundary of Yosemite

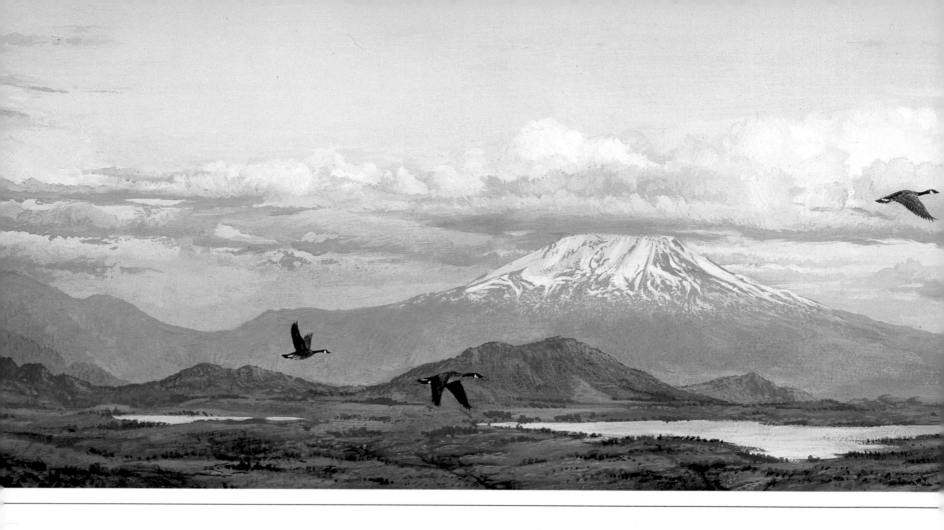

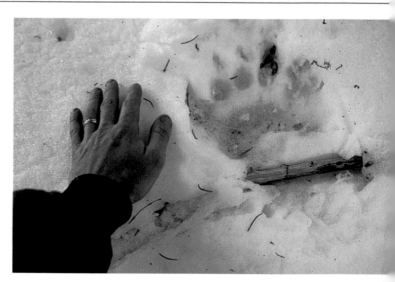

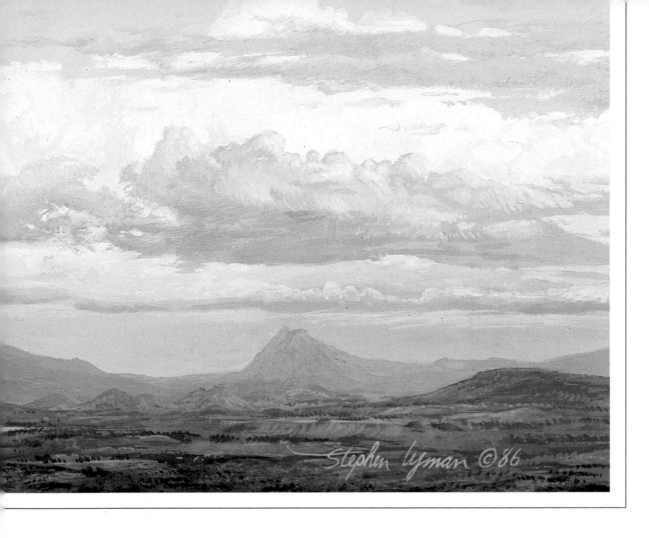

Stephen Lyman ©86

nels of glacial water, and romp and splash about with great abandon. When they were hungry, they scooped up fish and devoured them with their massive jaws. In the summer months, occasionally the bears sought ponds and streams in which to bathe, cool off, relax, and forget their woes.

It is snowing again in Deep Valley, but only a thin scattering of flakes. Finding no bears of any kind here, Steve begins a steep ascent to the north,

Shasta Flight

Mount Shasta is a dormant volcano, rising dramatically from the northern California plain to 14,162 feet above the sea. It creates its own weather, often shrouding its summit in late afternoon thunderclouds.

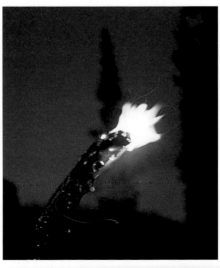
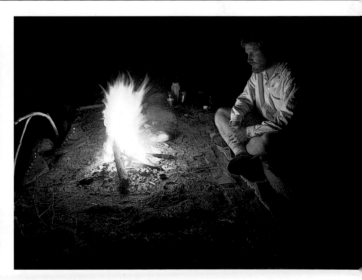

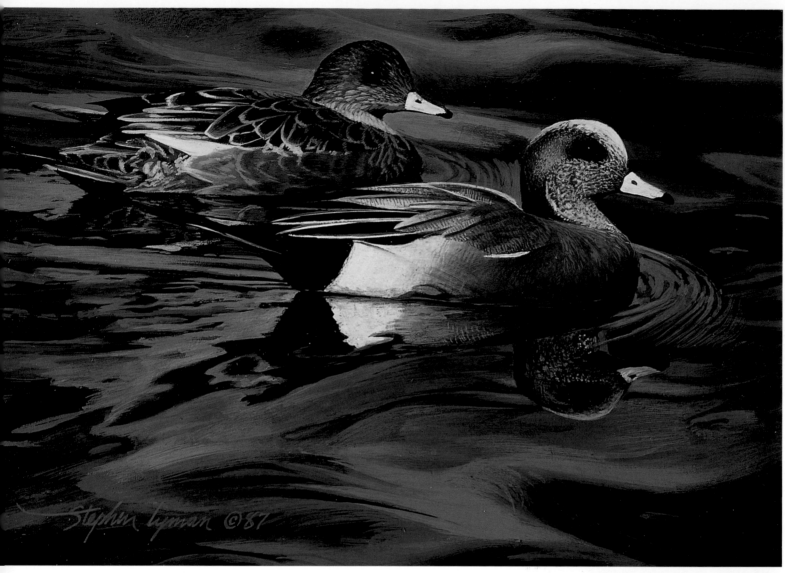

Stephen Lyman ©87

Sundown

(Above) Male and female American widgeons catching the last warm rays of the day.

New Territory

On the Toklat River in Denali National Park, a mother grizzly ambles along the shore, intent on reaching a good feeding area. Her cubs, however, are distracted by every little thing along the way.

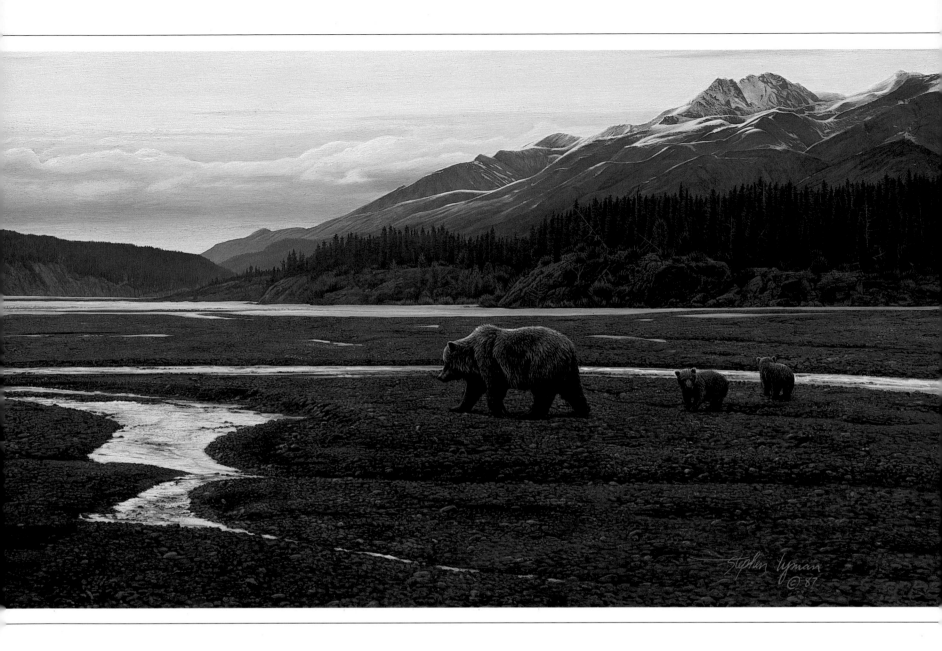

heading for a lake on a bench high up in the Sierra. The clouds are bluffing, he assures himself. The sun is squinting through them. In looking at his map, he thinks it seems a simple matter to reach his destination: he just climbs to a certain height, then follows the contour line along for a ways and, presto, he's at his lake. Piece of cake! But a map with 200-foot contour intervals is deceptive. Granite escarpments, talus slopes, boulders the size of small houses, bush thickets, and imposing trees pay no heed to the lines on paper. Steve proceeds to bushwhack—or, rather, bushbend, since he dislikes whacking bushes—until he reaches some unclimbable cliffs, forcing him once again to retreat.

At length he comes to a creek heading in the direction of the lake, its sandy banks making for relatively easy travel. There are the usual obstacles to be overcome: the exposed roots of junipers and oaks threatening to trip him; thickets of huckleberry scratching at his legs; stones and boulders that teeter unexpect-

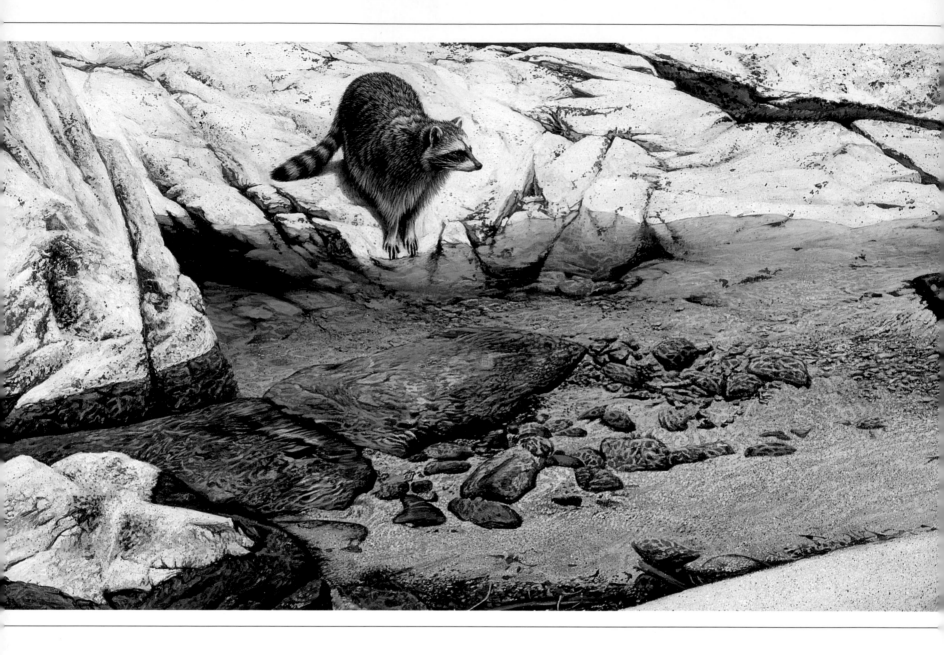

edly from the weight of his footfalls. But by and large, the going is pleasant.

Like all highways, however, this one comes to the inevitable roadblock and detour. The canyon walls on either side of the creek suddenly pinch inward, rising vertically and squeezing the shorelines into nothingness.

The prospect of backtracking sends a shiver up Steve's spine. But perhaps the hours of retreat won't be necessary. After careful examination, he determines that the water here is about waist-deep. He has already declined an inviting dip once, and now he has a good excuse to accept. It may be frigid with snowmelt, but he's confident it won't take long to wade around the obstacle.

After removing his clothes and stuffing them into his pack, Steve tests the water with his toe—icy, to be sure, but not Arctic. So he takes the plunge, immediately to realize how mistaken he was on two counts: the water is up to his neck, and it instantly turns his body into a giant goose bump.

The Waiting Game

The raccoon obviously sees the trout, and the trout, the raccoon. It's a standoff of sorts, with the raccoon waiting to see if the fish gets careless. I also enjoy the way the invisible water changes the color of the rocks it's covering.

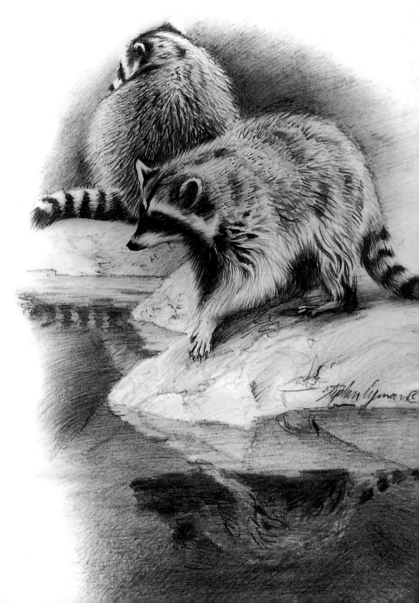

Fortunately only a couple of minutes of wading are necessary before Steve is around the obstructing cliff. His leg gets scraped in the process of hauling himself out of the stream onto the rocky shore, and the contents of the back-pack have soaked up some water, but otherwise he judges the operation to be a success.

In due time, Steve reaches his lake, and though he's damp and exhausted, he's nonetheless buzzing with reserve energy, delighted to be in so gorgeous and inspiring a setting. The

Moonfire

A favorite lake of mine high in the Sierra. I've worked into this image concepts of warm and cool, active and passive, bright and subtle, heavenly and earthly — a panorama using the fire and moon to suggest "balance," an essential aspect in life. I also make use of my ever-trusty artistic license, as I would never build a fire this close to water, especially in such a fragile and sensitive alpine ecosystem.

[112]

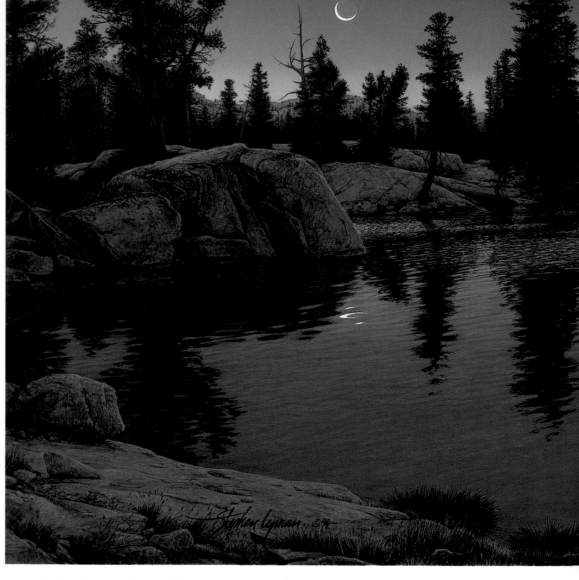

lake is a marvel of contour design, he thinks. With two peninsulas extending into it from opposite ends, nearly meeting at the center, it resembles a giant, misshapen "H." In order to commemorate his arrival here, Steve sets up his camera on a tripod near the center of the letter, focuses the lens, sets the timer, and dashes out to the end of the rocks before the shutter clicks.

A dull, gray sky adds to the somber, lonely feeling here. At this elevation the sounds of spring—birds singing, frogs croaking, water trickling—have not yet begun. A couple of sleek, black-and-white ducks, however—

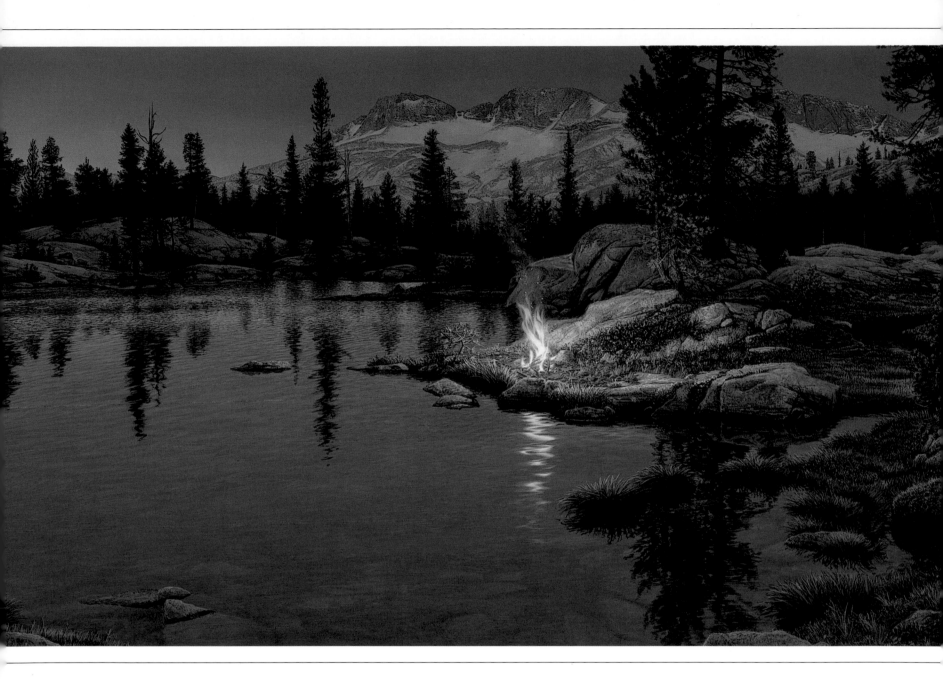

perhaps common mergansers, which remain in the Sierra through the winter—are swimming in the lake. He makes his camp on a knoll, beneath an old sugar pine and a not-so-old Jeffrey pine. A couple of mountain chickadees fly by, but barely a cheep does he hear.

Steve has spent countless nights in places like this, where the wind and rain may sap body warmth quickly. But he has learned how to live with such hazardous storms. As long as the mountains draw his spirit upward, he's not about to let the weather drag him down. He has only to think about tomorrow, when he will leave the water's edge and climb to the upper limit of the forest. With so much of nature's wonder—trees, rocks, birds, and clouds—to delight him along the way, he'll be in good company. "One cannot be lonesome," wrote Muir, "where everything is wild and beautiful and busy and steeped with God."

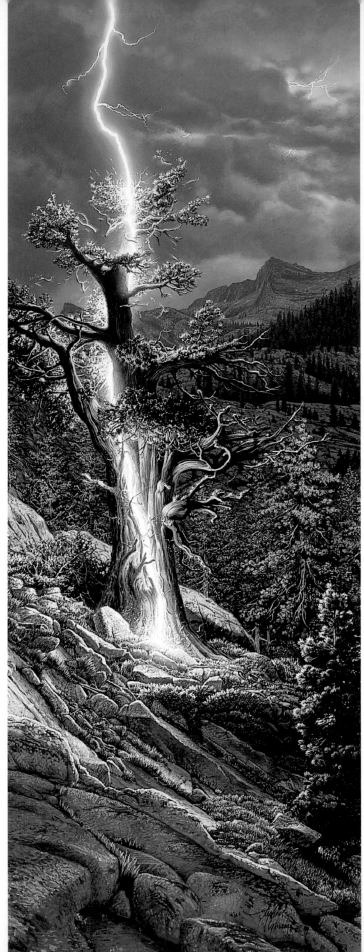

Thunderbolt

*Not having experienced
even a close lightning strike,
I nevertheless imagined the
deafening crack of the atmos-
phere, and then painted the
intense power and light flashing
down an old juniper, exploding
its bark and illuminating the
surrounding rocks and trees.*

—5—

TOWARD THE
SUMMIT

*1…am
glad to touch
the living rock again
and dip my head in the
high mountain
sky*

TOWARD THE SUMMIT

I...am glad to touch the living rock again and dip my head in high mountain sky

—John Muir

A trail along the slope high above the creek takes Steve upward through a burned forest area where heaps of dead branches litter the ground, still combustible but presenting little further fire hazard in the cool, damp air. The tall, stately, densely packed red firs that dominate Yosemite at elevations between 5,000 and 8,000 feet are virtual lightning rods during summer thunderstorms. The resulting fires create openings in the otherwise nearly pure stands of firs, making way for lodgepole pines—often the first tree to invade a burned area—as well as for understory herbs and shrubs that normally cannot grow in the deep shade of the firs.

Steve makes his camp on the south-facing slope amid unscorched firs, their symmetrical shapes and deeply furrowed, reddish-brown bark intact, their trunks and limbs decorated with pale-green staghorn lichens, their purple, fine-toothed, cylindrical cones reaching skyward like candles on Christmas trees. He relaxes and inhales the rich aroma of their boughs, listening to their whispers.

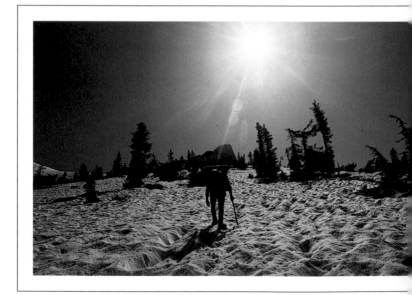

It is in areas of forest such as this that one can become aware of the cathedral-like quality of the wilderness. It is as if a step has been taken into a place created specifically to inspire thought that transcends our daily routines. Sound is hushed, muted, or quickly absorbed; dramatic shafts of hazy light penetrate down through the canopy above, which itself rests upon magnificent columns of red fir.

Even at sunset, a peak time for animal foraging, few creatures move among these somber trees. There is only the occasional twittering high in the canopy and the solitary *tap, tap, tap* of a woodpecker. Because of the density of the forest canopy, with the branches of neighboring trees overlapping, the consistent stream of life-generating sunlight does not exist here. As a consequence, understory plants are scarce, as are the animals that depend on them for foraging and nesting.

What *does* cover the ground are the trunks and limbs of many old trees, those that have reached the end of their short life spans of a mere 250 to 350 years. Unlike most other conifers, which typically remain standing long after the life has gone out of them (Douglas firs, for example, stay vertical—slowly rotting—for 75 to 125 years), deceased red firs soon topple, their wood quickly decaying. The thick bark that shielded them through so many snowstorms, however, stubbornly resists decomposition, and chunks of it from any one tree may remain, littering the forest floor for many decades.

Breaking out of the dense forest the next day on his uphill climb, Steve comes across the remains of a Douglas squirrel summarily dispatched to the great beyond by a hungry coyote whose tracks are still fresh in the dirt. The unfortunate squirrel must have been scampering across the ground when it met its fate. Its kind and the coyotes have long shared the same mountain homelands, but never with equanimity. So long as the sleek, diminutive squirrels stay on

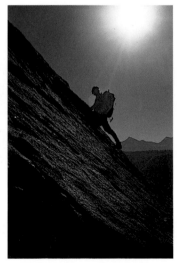

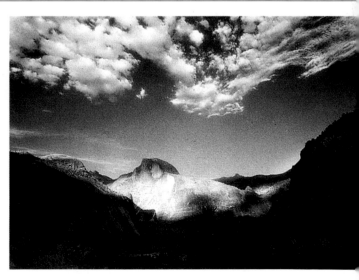

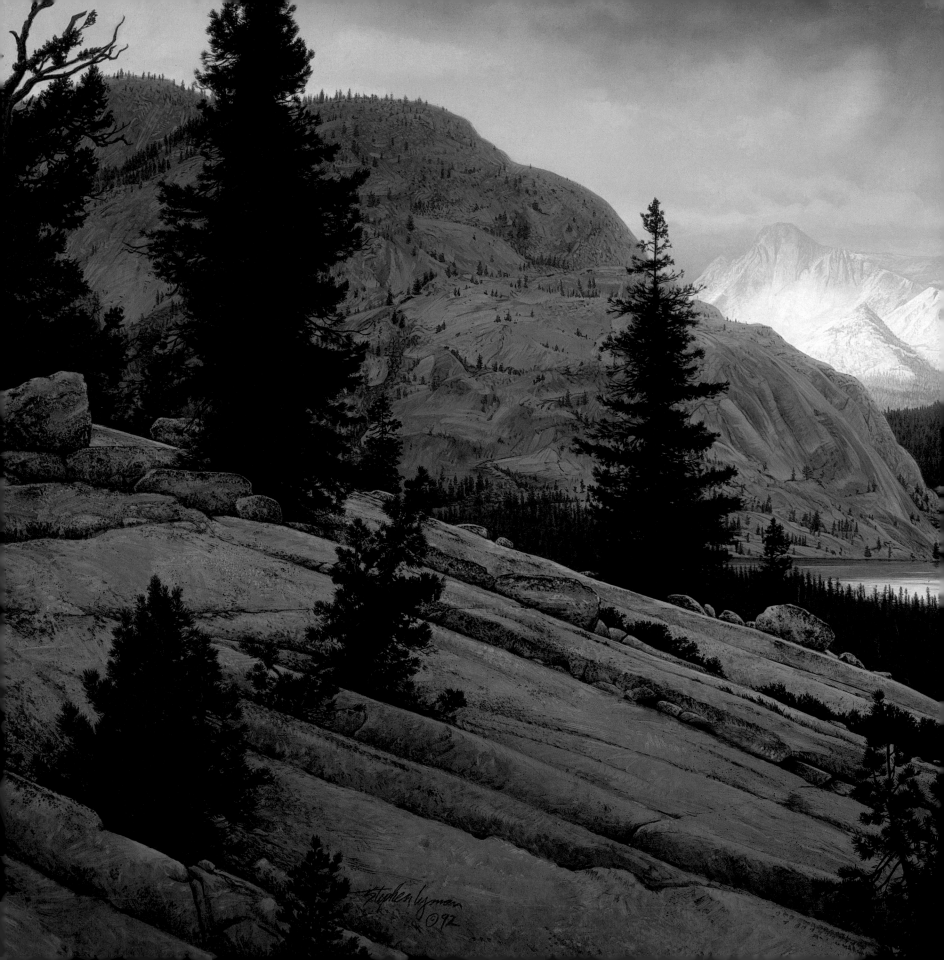

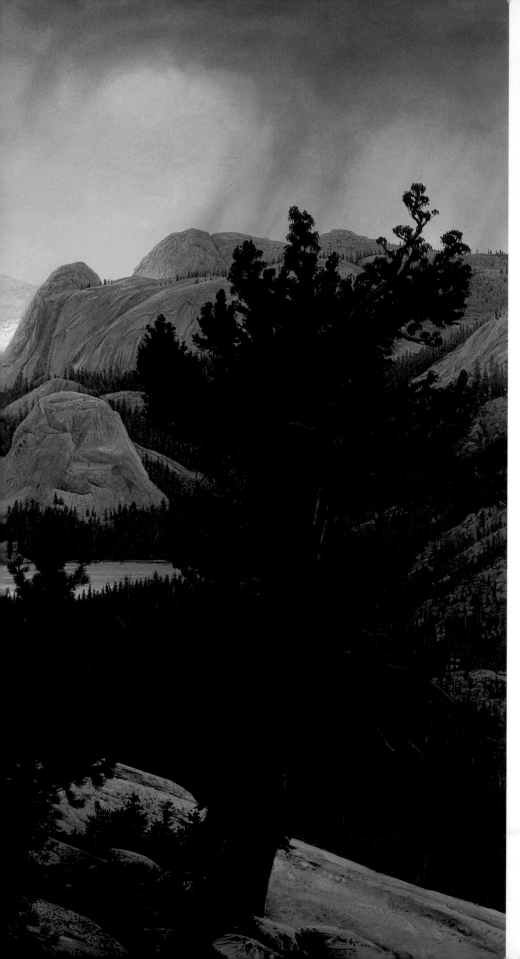

their branches, they can scold and make faces at prowling canids with impunity, but woe to the squirrel that gets so immersed in its acorn-gathering that it forgets to keep a wary eye out for marauders. Perhaps that's why Douglas squirrel tempers seem always to be on edge and why, despite the animals' small stature, they'll charge forward on their tree limbs, feinting, scowling, and making themselves as noisy as possible at the slightest provocation by passersby many times their size. The feisty critters possess all the reckless bravado of

Lake of the Shining Rocks

This is the type of powerful landscape I most like to paint. Simply stunning drama. The orginal Miwok name for the lake in Yosemite, "Pywiack," means "shining rocks." The rocks around it actually do shine, polished smooth by massive glaciers thousands of years ago.

[119]

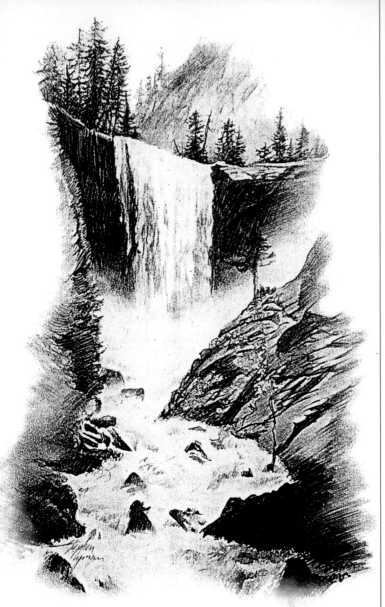

Bronx-raised bantamweight fighters.

Muir considered this squirrel species to be "the most influential of the Sierra animals…a firm, emphatic bolt of life, fiery, pungent, full of brag and show and fight…so quick and keen they almost sting the onlooker, and the acrobatic harle-

Dance of Water and Light

A wilderness phenomenon not so often noticed is a rainbow waterfall. Yosemite's Vernal Falls, however, is well known for this. The spring hiker, passing by this 320-foot falls, is guaranteed a thorough drenching.

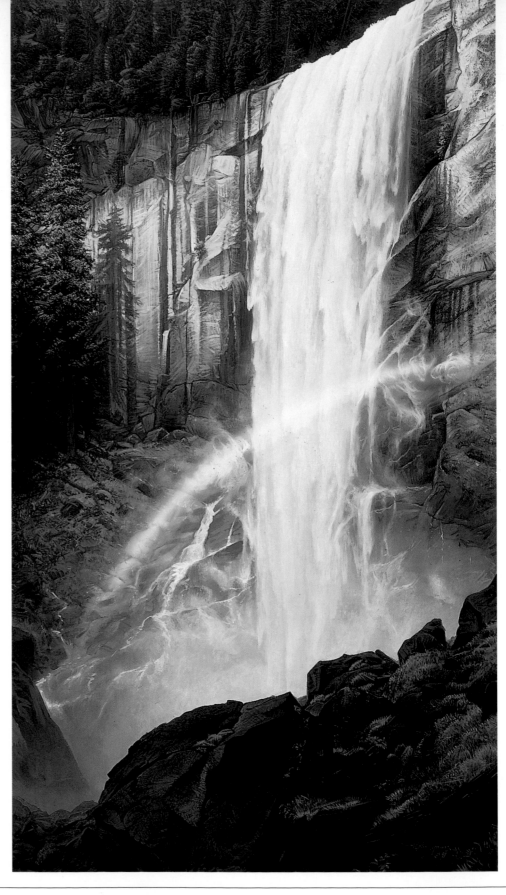

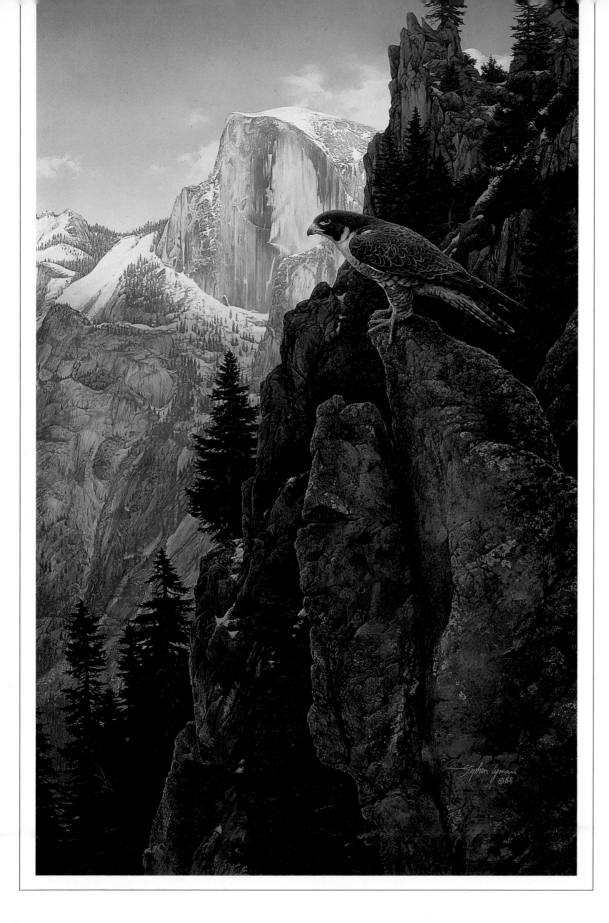

quin gyrating show he makes of himself turns one giddy to see."

Yet another burned area presents itself farther along the trail, with many a scorched tree still standing, very likely to live on through many more thunderstorms. But one dead tree section does catch Steve's attention. It seems to have stood in the ground through many revolutions of the earth around the sun, its bark peeling away, exposing its wood to the elements. While the sides of the dead fir are charred, its upper surface is smooth, bleached to a uniform gray, and

Return of the Falcon

This beautiful, swift raptor nearly became extinct because of DDT, but now, thanks to conservation efforts, it's surviving and slowly returning to Yosemite. The painting celebrates its return, with the bird emerging out of the darkness, its head silhouetted against the illuminated face of Half Dome.

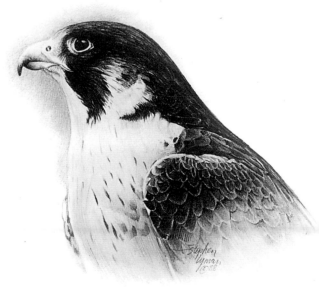

as inviting to an artist as a chalkboard. This presents Steve with an irresistible temptation. He takes a piece of charcoal in hand and sketches a woman's face, not in bold outline, but subtly, with shadings and blurred features, so that an unsuspecting hiker coming upon it later might wonder

Autumn Gathering

Come September, an ordinary, unexceptional slope bursts into its colorful autumn glory. Here, one may by chance see a deer or two, and, after this initial discovery, perhaps find six more in the gathering, camouflaged by the intricate texture of the hillside.

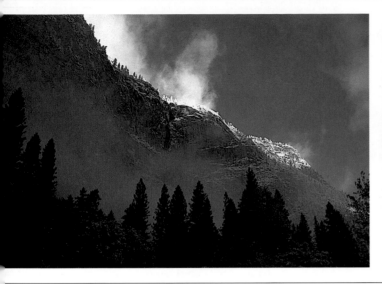
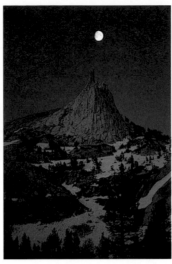
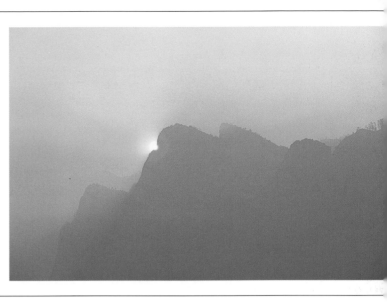
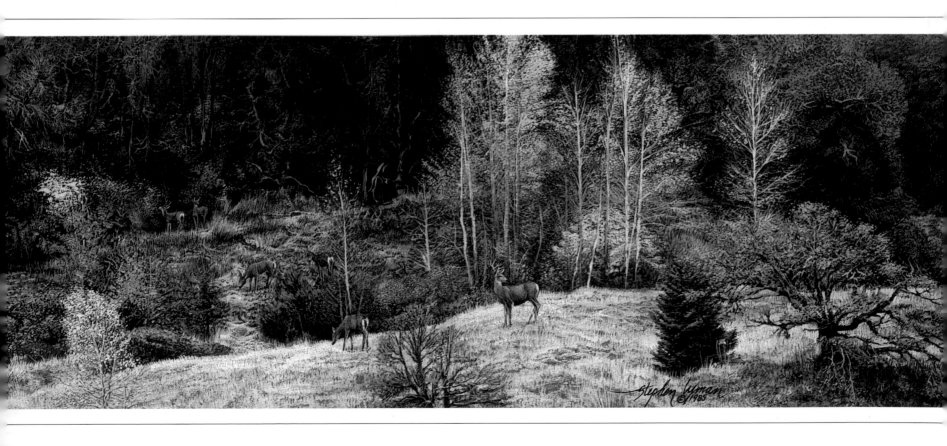

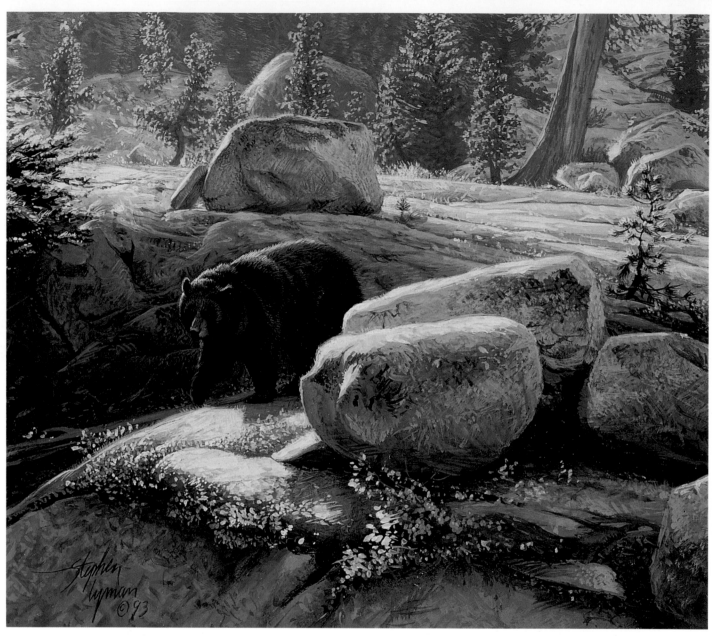

if Mother Nature hadn't drawn the image herself.

Perhaps the sketch violates the wilderness maxim entreating hikers to take only memories and leave only footprints, but the charcoal will soon wash away and, in any case, leaving such an indistinct mark, but a creative one, seems a minor transgression. Moreover, interacting with nature in a playful way is always preferable to a destructive one.

Some trailblazers do leave more lasting signs of their having passed through, and whether that's a good thing or not is a matter of some debate. Cross-country-trek leaders can't always count on the rest of their party's keeping up with them or finding the proper route on their own. Rather than risk losing stragglers, certain leaders will mark trails at intervals by leaving behind ducks—not the waterfowl

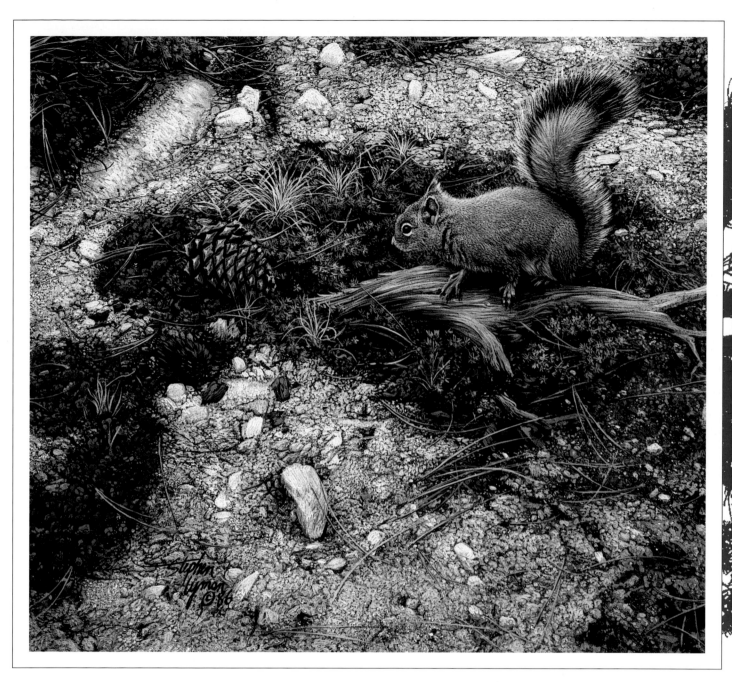

variety, of course, but cairns, piles of stones stacked one on top of another.

Trailblazing in Yosemite is nothing new. In the 1890s, United States Cavalry troops, charged with ejecting sheepherders from the newly established national park, routinely carved fat *T*s into the bark of conifers as a way of marking the trails they had forged. The practice may have been justifiable at the

Red Squirrel

(Right) There are many of these red squirrels in Canada and Alaska. They are closely related to the Douglas squirrel, which is gray.

Boulder Bruin

I often come across beautiful little spots such as this: colorful foliage growing among granite slopes and boulders, backlit with warm afternoon sunbeams. The bear, not as often.

[125]

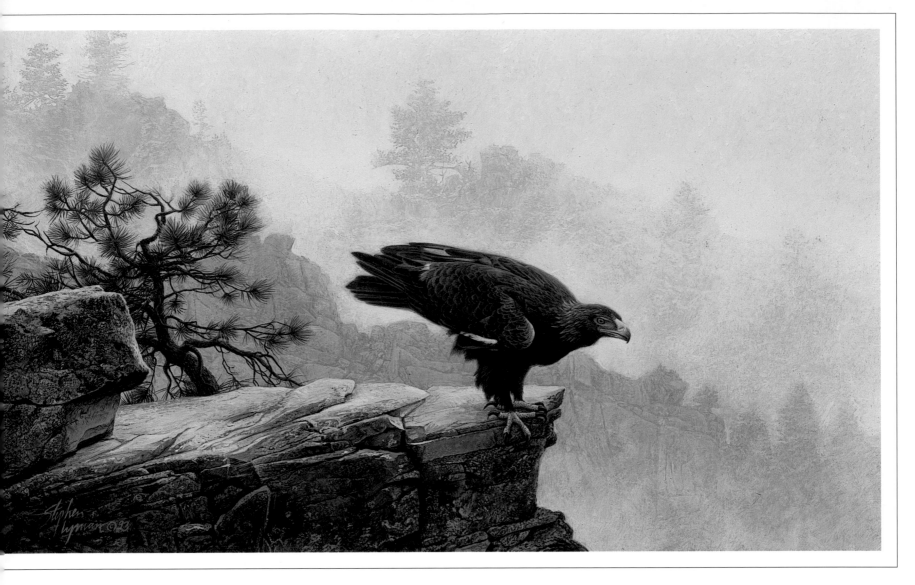

On the Brink of Flight

A golden eagle is poised, ready to leap off into space and spread its wings on the wind.

time, when trail networks and detailed topographic maps were nonexistent, but is hardly so now—though some individuals, at best for nostalgia's sake, persist in carving their own.

At just under 9,000 feet, as he nears Lower Merced Pass Lake, Steve takes a breather, resting on a stone bench conveniently situated alongside the trail. He's admiring a particularly impressive western juniper nearby, gnarled

but erect, its crown a ragged mass of scaly twigs and leaves supporting masses of berry-like cones—when several yards up the trail a mother bear and her two cubs amble into view. For a moment he and mamma bear stare at each other, sizing each other up, wondering how they should react. Magnificent animals! Steve remarks to himself: cinnamon colored, the most luxurious coats he has ever seen on a bear.

"Bears are a peaceable people," Muir once wrote, and Steve has never had reason to believe otherwise. But neither are they trusting and friendly, under normal conditions preferring to shun humans rather than consort

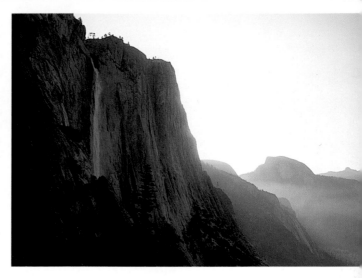

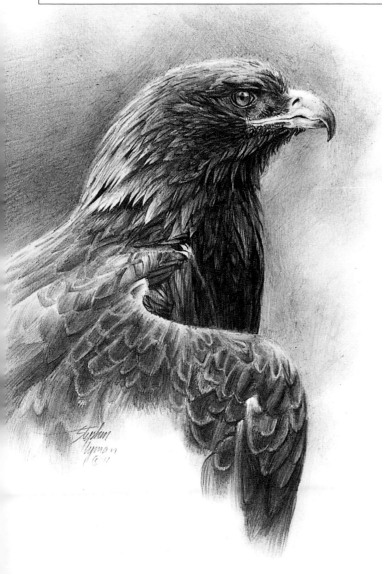

with them. Accordingly, the mother bear dutifully puts herself between her cubs and the two-legged stranger, assessing his intent. Friend or foe? Better not wait around to find out, she decides, and shoos her cubs up the slope into the trees, loping after them herself, her coat rippling elegantly over her flanks.

As any experienced wilderness backpacker knows, not all black bears (in this case, showing off their cinnamon-brown phase) are so skittish around humans. Certain pesky ones have developed a taste for the edibles so conveniently available to them wherever campers congregate. Many a tale has been told by backpackers startled by bears strolling nonchalantly into their campsites at night—completely indifferent to the humans' trying to get a good night's sleep—and attempting to claw their way into whatever pack, stuff-sack, tent, or other container smells like it might contain a tasty treat.

The bears will literally go out on a limb to reach hoisted sacks of food, as Steve well knows. Over the years he has become proficient at keeping his provisions out of the reach of hungry bruins and their nose for chocolate cookies, apples, and freeze-dried tortellini casseroles.

Despite chill weather, shiny yellow buttercups bloom along the route. But their cheery aspect is offset by a brooding sky. Dark clouds have rolled in, heavy with moisture. Tiny, feathery snowflakes drift about, occasionally touching down on his nose or catching in an eyebrow. Golden-mantled ground squirrels dash out of his way as he approaches. Mountain chickadees and Clark's nutcrackers flit here and there among the patches of red moun-

Color in the Snow

This is a study in contrasts. The complex and brilliantly iridescent feathers of the pheasant in a nearly black-and-white setting act as an accent on the landscape.

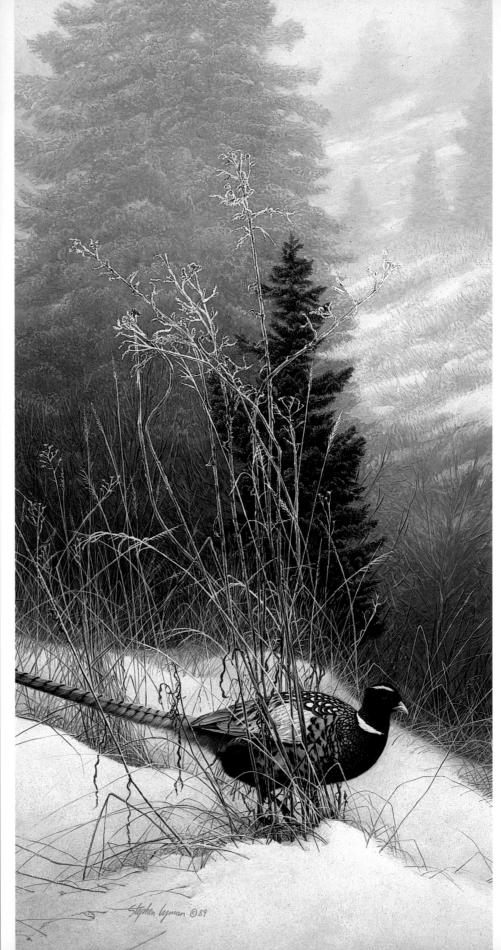

Stephen Lyman ©89

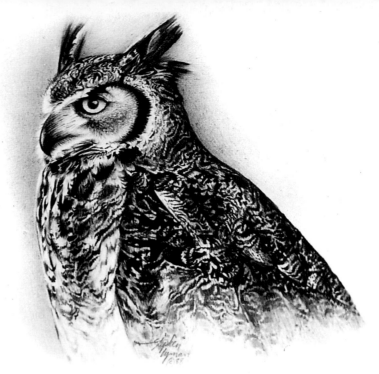

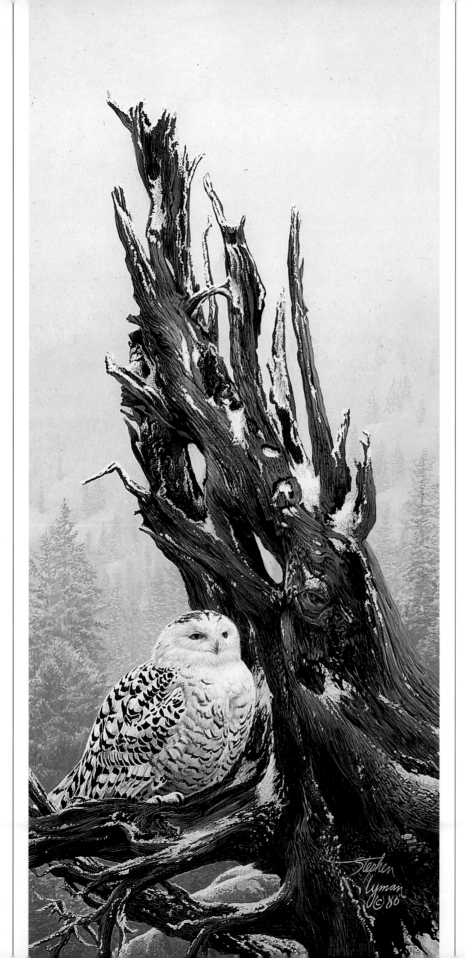

tain heather growing amid granite outcroppings.

Contorted whitebark pines and dwarf lodge-poles decorate the landscape like sculpted bonsai, their misshapen forms—called *krummholz*, a German term meaning "twisted wood"—dictated by incessant winds. Whitebarks are an especially tough species, sprawling low to the ground at timberline, their twigs thick and extremely resilient, their needles short, stout, and spiky, their cones dense and sharp-edged. They are the most primitive of North American pines, a throwback to an evolutionary stage in which pinecones had to rot on the ground in order to release their seeds. They're also notoriously antisocial, eschewing the company of other pines, preferring to live solitary lives far above the madding crowd. Somehow these ancients endure on high, exposed crags, clinging to rocky, well-drained soil, where blizzards

Snowy Throne

A female snowy owl sits on this windblown snag. These owls fly farther south in some years, often into the northern United States. It's rare and exciting to see one of these striking birds fly overhead and perch nearby.

[129]

beat them and sun scorches them relentlessly, season after season for centuries. Their color seems testimony to the harshness of the climatic zone they inhabit, so pallid are their scaly white bark and dull-green needles.

Soon Steve is climbing well above treeline, across a vast expanse of schist—metamorphic rock folded and arrayed in layers, with bands of minerals in shades of gray and red. Such a wild and rough landscape! he marvels, a joy for his feet to travel across. It seems that the higher he goes in these mountains, the more character and beauty they possess.

Looming above him at the top of a series of switchbacks is Red Peak, rising to 11,699 feet, and in the distance is 11,522-foot Mount Clark—both mountains he knows all too well. It was on his approach to Mount Clark that, years before as a novice solo climber, he once experienced snow blindness. Though it was early summer, much of the Clark Range was still covered in white. He hadn't thought to bring sunglasses with him, and, as he slogged through the snow, he found himself continually squinting from the sun's strong glare. Before long, his eyes began stinging, increasing in intensity until he could no longer keep them open.

The situation was unbearable. He couldn't see to navigate along the range, or even to place his feet, much less to climb the peak. Once he realized what was happening to him, he knew he had to shade his eyes, but how?

High Trail at Sunset

I liken this image to a self-portrait. I don't really have a particularly favorite animal to paint, but I identify with the mountain goat: often solitary; climber of rugged cliffs high in the mountains; stocky, muscular legs for bounding from ledge to ledge; shaggy hair, bearded…well, you get the picture. By the way, there are five goats in this painting.

[130]

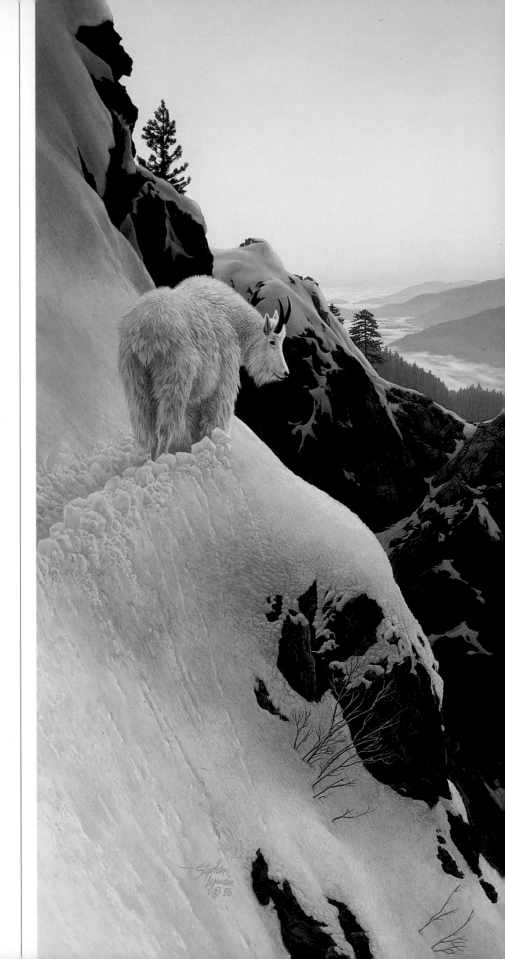

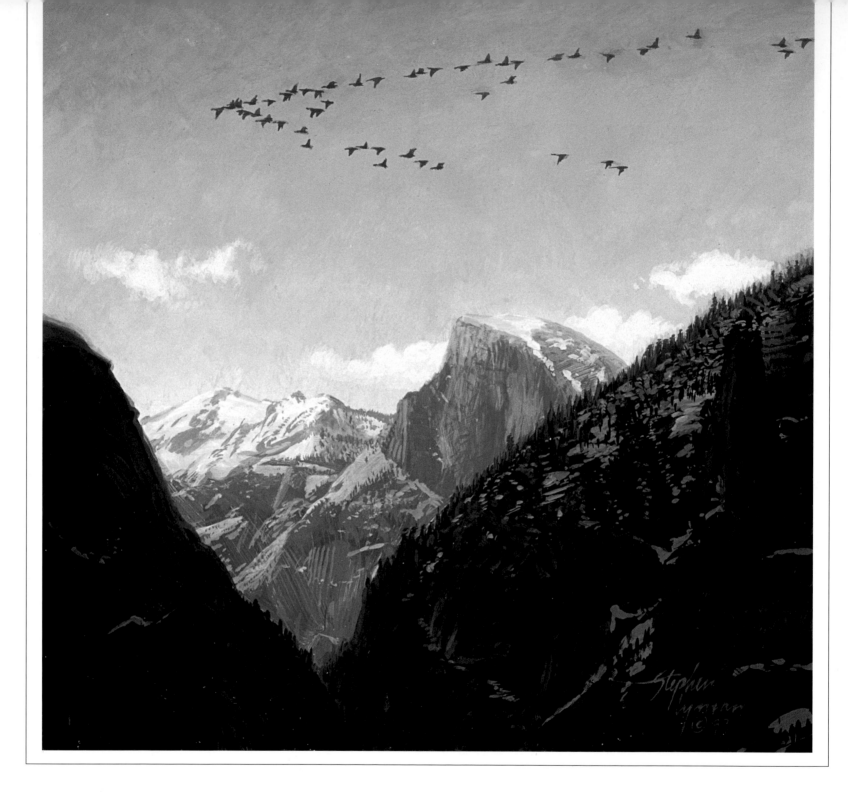

He rummaged through his pack and pulled out a piece of cardboard, carved a notch in it to fit over his nose, cut two slits to peer through, and then tied the makeshift shades against his face by means of a flexible pine bough twined around his head.

Awkward though it was to wear, the mask worked. Perhaps it was a bit silly-looking, of course, but Steve hadn't noticed any fashion critics in the vicinity, except maybe a pika or two poking up from a jumble of rocks to bark their approval. At last,

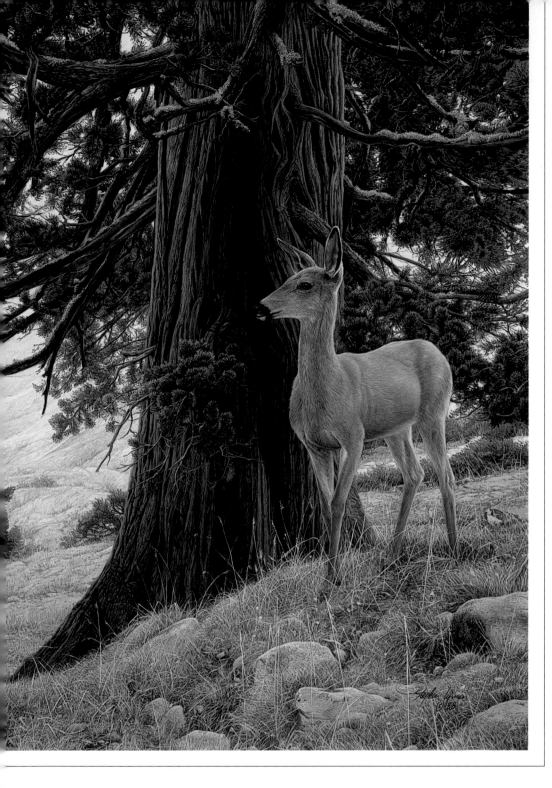

Graceful Steps

(Left) The doe's smooth, curving, slender form contrasts with the rough-textured bark of the Sierra juniper. She is a study in gentleness and grace.

Evening Glow in Yosemite

(Opposite) As you drive through the foothills of the Sierra Nevada up into fir forests, anticipation builds for that first glimpse of Half Dome and the cliffs of Yosemite. Suddenly the road dives into a long underground tunnel, which ends in the dramatic display of Yosemite Valley. Sunset light creates an even more spectacular scene, a flock of geese being the perfect movement in this dynamic landscape.

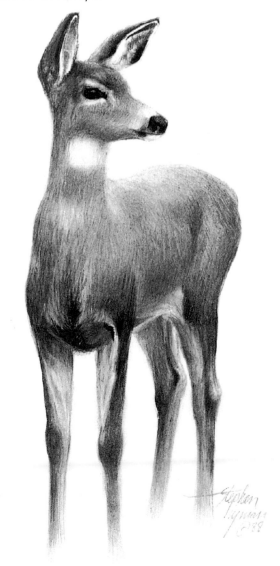

thank goodness, he could open his eyes and see where he was going. The stinging refused to go away, but he was too restless to sit out the remainder of the day nursing his eyes. Sore or not, he headed up to Mount Clark. The climb went smoothly. Getting to the top of what used to be called "The Obelisk" required some scrambling, but no technical

skill. By early evening he was back down, heading over to Red Peak for the next day's climb.

By dawn his eye pain eased. Tired, but eager to climb again, he headed up Red Peak, wearing just his regular hiking boots. He had no crampons or ice ax, but the traverse across the upper edge of the snowfield looked safe enough, so he headed across.

Suddenly he slipped, and he was on his side shooting down the icy slope. For 100 yards he was in "free-slide."

Everything was a blur. He couldn't see if he was nearing the rocky ledge that he knew was below, but he wasn't waiting to find out. He flipped on his stomach and dug his fingers into the snow. Finally he slowed and stopped, about 100 feet from the ridge. Very tensely, digging little toe- and heel-holds in the snowpack, Steve worked his way off the slope.

Passing by Red Peak now, he can't help but smile at the memory of its nearly doing him in. It was a youthful, full-bodied adventure: good for discovering his limits and quantifying risk assessment in traversing snowfields. Here, now, the view is breathtaking, with lofty pinnacles arrayed like a diorama in front of him—the Minarets, Mount Ritter, Banner Peak, Foerster Peak, Electra Peak, and Rodgers Peak among them. Stretching before them, like an orchestra pit, is a deep fissure in a wide basin—the 2,000-foot-deep Merced River canyon.

Steve would like to stay for several hours. But the wind is blowing with such ferocity here that it's all he can do to stay standing. It chills him to the bone.

So, it's on down to Red Devil Lake, which he reaches at around noon. It's as lovely as he remembers it from his last trip here. But with the sky looking like it wants to storm in earnest, he decides not to linger very long. A blizzard could descend any moment. So he efficiently traces the shore of the lake, photographing it from various vantage points, quickly using up three rolls of film. Once the photo shoot is done, he finds the lake's outlet and follows

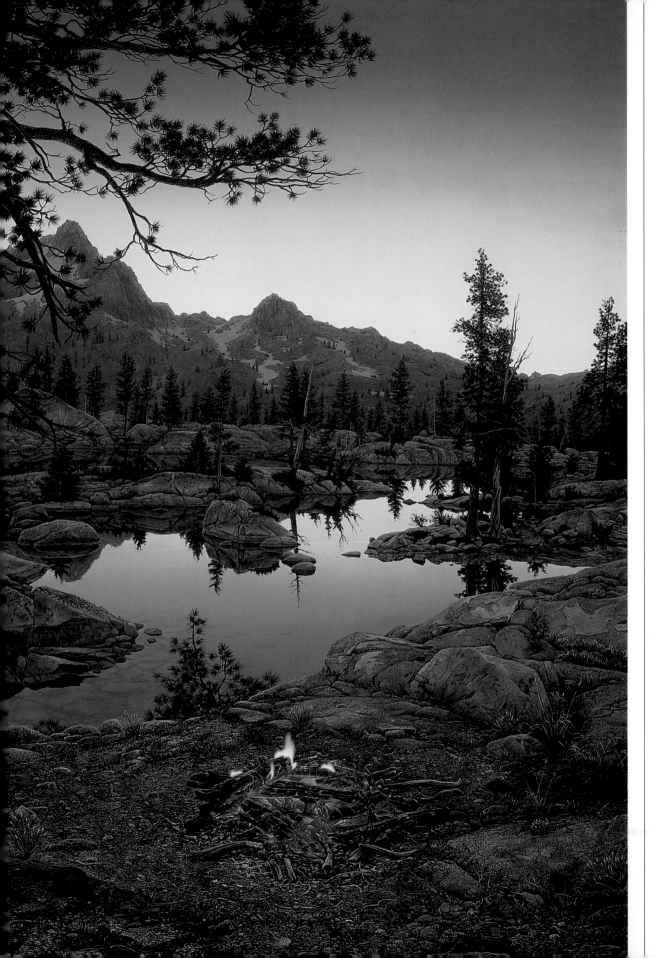

its stream course downhill, rambling cross-country en route to the Merced River.

He *is* delayed, though, but not by weather. Again and again, he comes across natural beauties he can't resist, pausing to admire and photograph: twisted old logs lying on the ground; polished granite slopes; intimate narrow gorges with creeks slipping through them; another couple of bears, mother and yearling; a mountain ash with its saw-toothed leaves in full fall dress, its twigs bearing tiny, shiny, red, apple-like fruit. Steve never knows for sure what he's going to see when he sets out on a trek, but he does know he'll see images to inspire paintings. And, sure enough, here they are in abundance.

Yes, indeed, Steve smiles to himself: another glorious Sierra day.

Embers at Dawn

This was my second campfire painting. I wanted some continuity with the first, so it's the same size, and the fire is in the same place—as if you're sitting in front of it. I didn't want to repeat myself, though, so I changed the location to lakeside, the time of day to dawn, and the age of the fire, which is pretty much at its end: glowing and still warm.

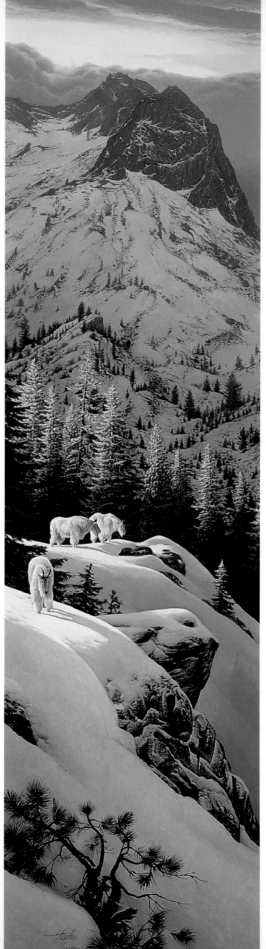

High Light

(Detail) You'll notice
that in the trees behind
the mountain goats
there's a ponderosa
pine that's dying. The
rusty brown needles
indicate this. The cycles
of life in each ecosystem
are continually in motion,
and I try to be as true
to them as possible.

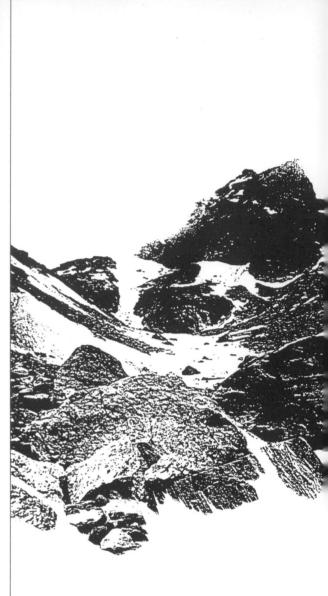

THE PEAK EXPERIENCE

the tops of mountains are among the unfinished parts of the globe... only daring and insolent men, perchance, go there

THE PEAK EXPERIENCE

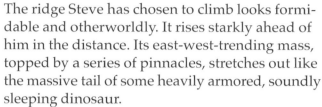

the tops of mountains are among the unfinished parts of the globe...only daring and insolent men, perchance, go there

—Henry David Thoreau

The ridge Steve has chosen to climb looks formidable and otherworldly. It rises starkly ahead of him in the distance. Its east-west-trending mass, topped by a series of pinnacles, stretches out like the massive tail of some heavily armored, soundly sleeping dinosaur.

At the base of this reptilian arête, Steve comes upon two men in their camp, just finishing their breakfast. One of them has a noticeable limp. They tell him they're packing up and preparing to head back out of the wilderness. They had attempted to climb the challenging ridge the day before, but one of the men's legs had given out, so they had to abandon their effort.

This news gives Steve pause, making him wonder if he isn't setting himself too ambitious a goal. But the doubt is fleeting. Never one to be easily deterred, he has tested himself against mountaineering hardships countless times, always rising to the challenge of getting around or over tough obstacles. Rigorously exercising the body and mind in the pursuit of an elusive goal—moving as efficiently and fluidly as possible

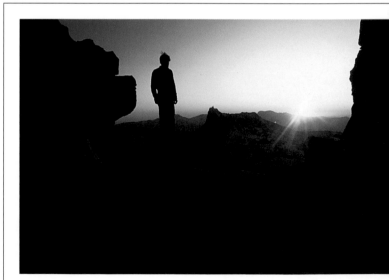

up difficult rock faces—is one of the more intoxicating aspects of the wilderness experience. This adrenaline surge gives added impetus to Steve's mission, which is not simply to reach the top, but to reach a closure, a moment at which he can say he's arrived at his destination.

Steve decides to do a little reconnoitering. Surely there's a way up that won't break his leg. Consulting his topographic map for the best approach is no help since its contour intervals are too large. No matter: there's bound to be a route that doesn't require technical climbing aids of ropes and other gear.

On closer inspection, the ridge appears less intimidating. In fact, it seems readily climbable in several places. He selects a cleft in the ridge and begins picking his way up, clambering over boulders, pulling himself over ledges, choosing handholds carefully, occasionally wedging the toes of his boots into cracks between blocks of granite, balancing precariously, and managing to keep from sliding backward. The effort is long and tiring, so he makes the ascent with care and a keen awareness of his limits.

The vista from on high is grander than he had imagined. On either side of him plunge immense canyons, carved by glaciers in the Pleistocene Ice Age that ended a mere 10,000 years ago. Back then, rivers of ice up to 60 miles long and 4,000 feet in depth scraped and gouged the land all around. To Muir, who first discovered living glaciers in the Sierra Nevada and determined the effects of their glaciation, the shaping of these mountains by compacted snow was a poetic irony. In its carving the range, he observed, "Nature chose for a tool…the tender snowflowers noiselessly falling through unnumbered centuries, the offspring of the sun and sea."

In front of Steve, connected to the crest, looms a unique, tabletop mountain whose gentle plateau slopes down to a small, V-shaped valley. From a geological perspective, this landform seems

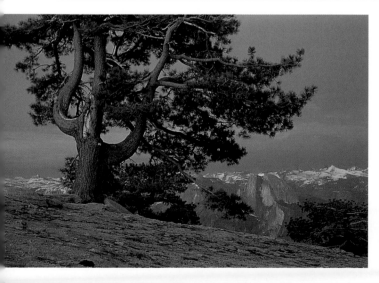

wholly unrelated to the
sheer, ice-sculpted mountain-
sides and crevasses all around.
Somehow it managed to remain
unscathed during the glacial era.
A journey through that valley
would be a journey through time,
Steve thinks, and he decides to
visit there on his descent.

Early Winter in the Mountains

*I camped here—the lakes basin of the
Wallowa Mountains in northeastern
Oregon—when a foot and a half of snow
fell. This is the panorama I woke to.*

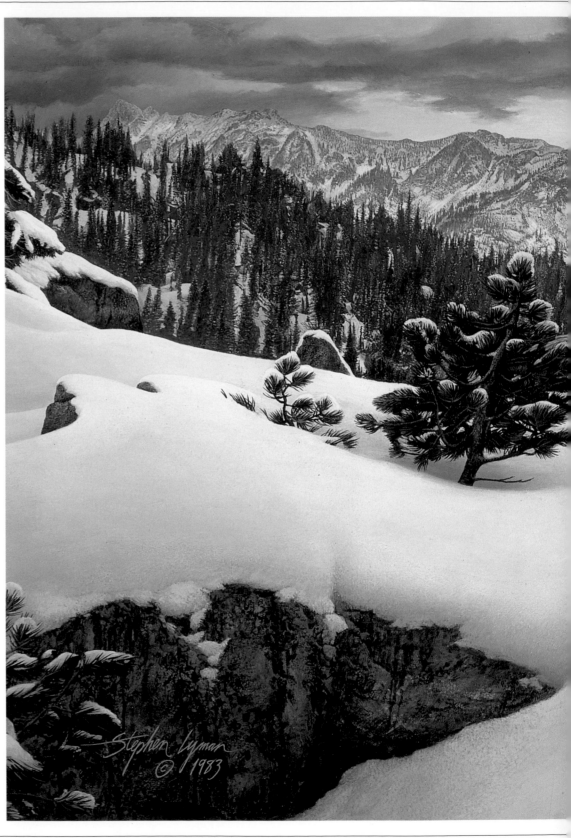

Stephen Lyman
© 1983

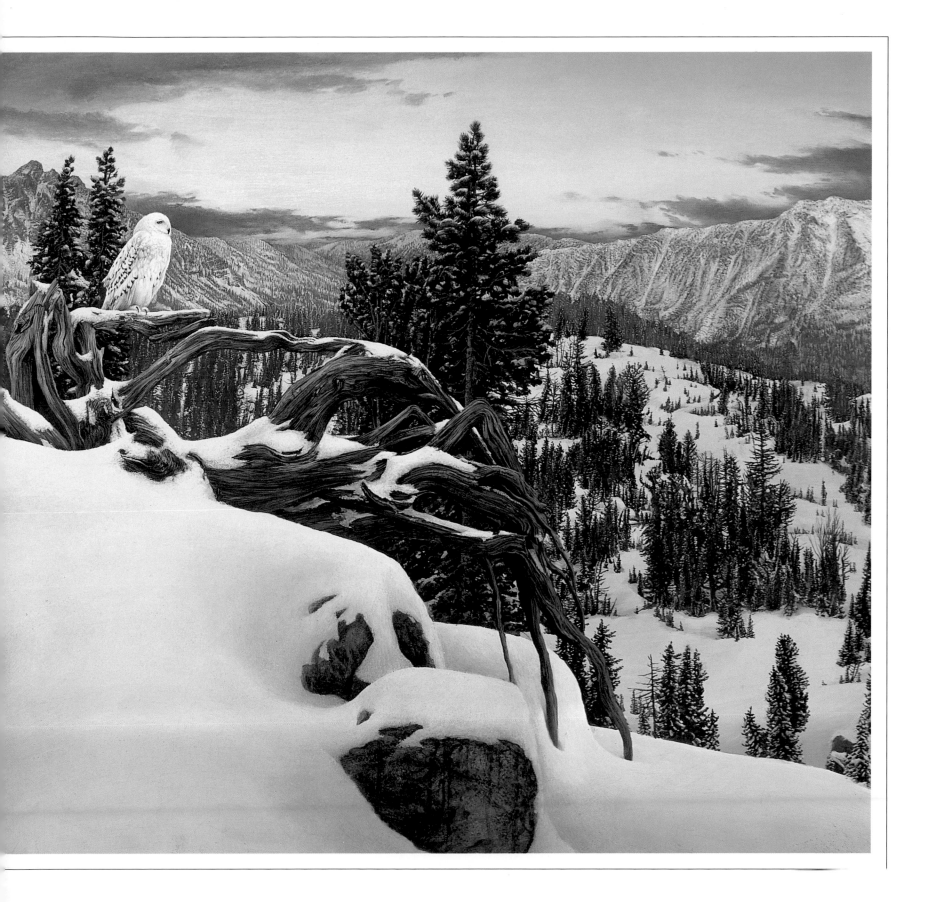

Though the sky is clear and the sun is bright overhead, a strong, steady, southwesterly wind presses against Steve, chilling him and forcing him to keep his parka zipped. The thin air at this height makes him light-headed, so much so that he must pause often to steady himself and wait for his altitude-induced headache to subside. There are no trails up here, and traversing the crest requires hopping from boulder to boulder. He can understand now how someone's legs could give out. Trekking along a dinosaur's spine is no easy saunter.

Unfortunately, the going gets no easier. In his scramble along the crest, Steve finally runs up against an insurmountable barrier— a pinnacle so steep and sheer that he can climb neither over it nor around it. He must, instead, descend to the base of the crest and find another notch, farther on, by which to make his way back up. In so doing, he traverses an icy snowfield, a slick, tricky crossing that calls for perfect balance and delicate foot placement. It's no glacier he's on, but the white expanse crackling beneath his boots allows him to entertain the notion that he's back in the Pleistocene, a primitive mountain dweller trudging across one of the massive frozen rivers to get from one bit of exposed earth to another.

The snowfield remains year-round because it's sheltered from the sun and heat of southern exposure. On this northeastern escarpment, tundra conditions prevail. What little plant life there is must be tenacious enough to endure blistering summers and fierce winters. Flake lichens cling to the gravelly soil wherever the lingering snow leaves moisture trails. Here and there, patches

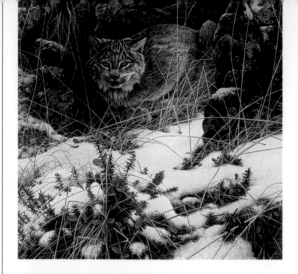

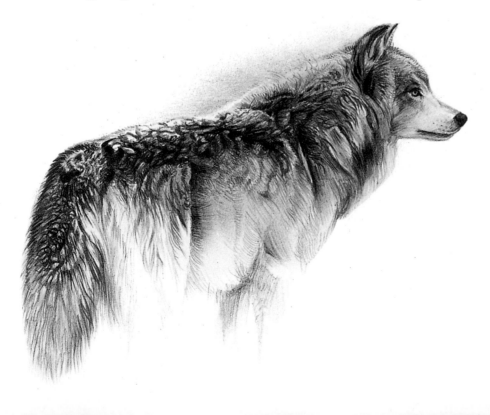

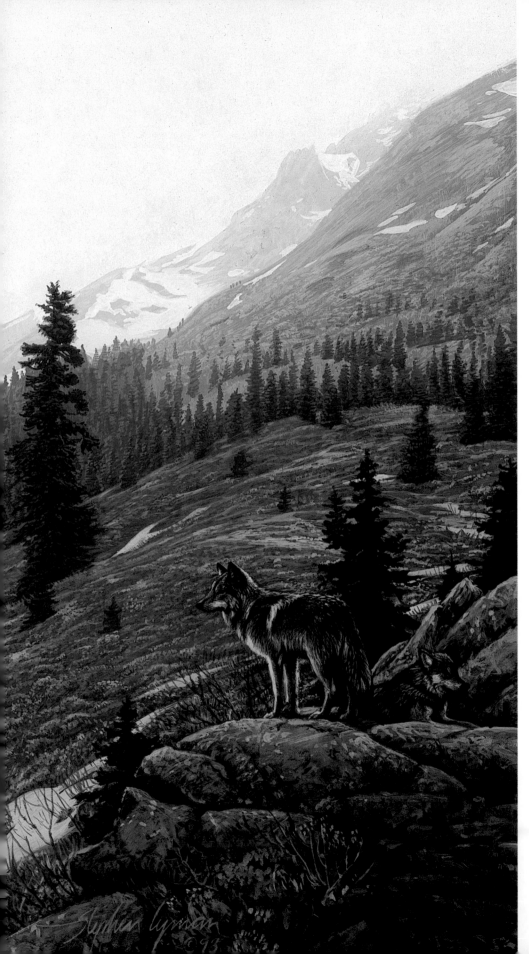

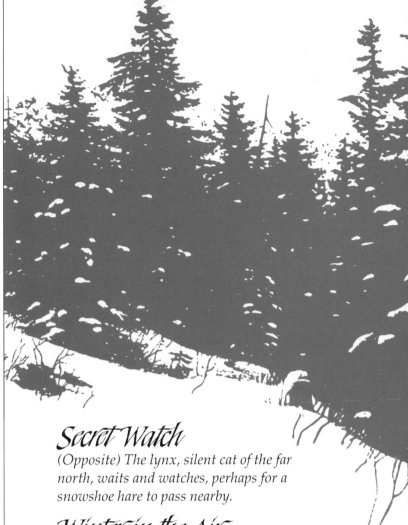

Secret Watch

(Opposite) The lynx, silent cat of the far north, waits and watches, perhaps for a snowshoe hare to pass nearby.

Winter in the Air

(Left) Late autumn in Alaska, when the sky is becoming predominantly overcast. The wolves can just feel that the snow is about to fall.

Yosemite Alpenglow

(Following page) This spectacular view of Yosemite Valley and the High Sierra from Eagle Peak, the highest of the Three Brothers. One winter I camped here for two days and two nights, sitting on this throne and enjoying the scene laid out before me. The painting style is like an Ansel Adams photograph in which every detail is sharp and clear, with virtually no haze or diffusing of the landscape as you get farther away. Unlike a photograph, however, it is minus the myriad buildings, roads, and trails of the valley floor.

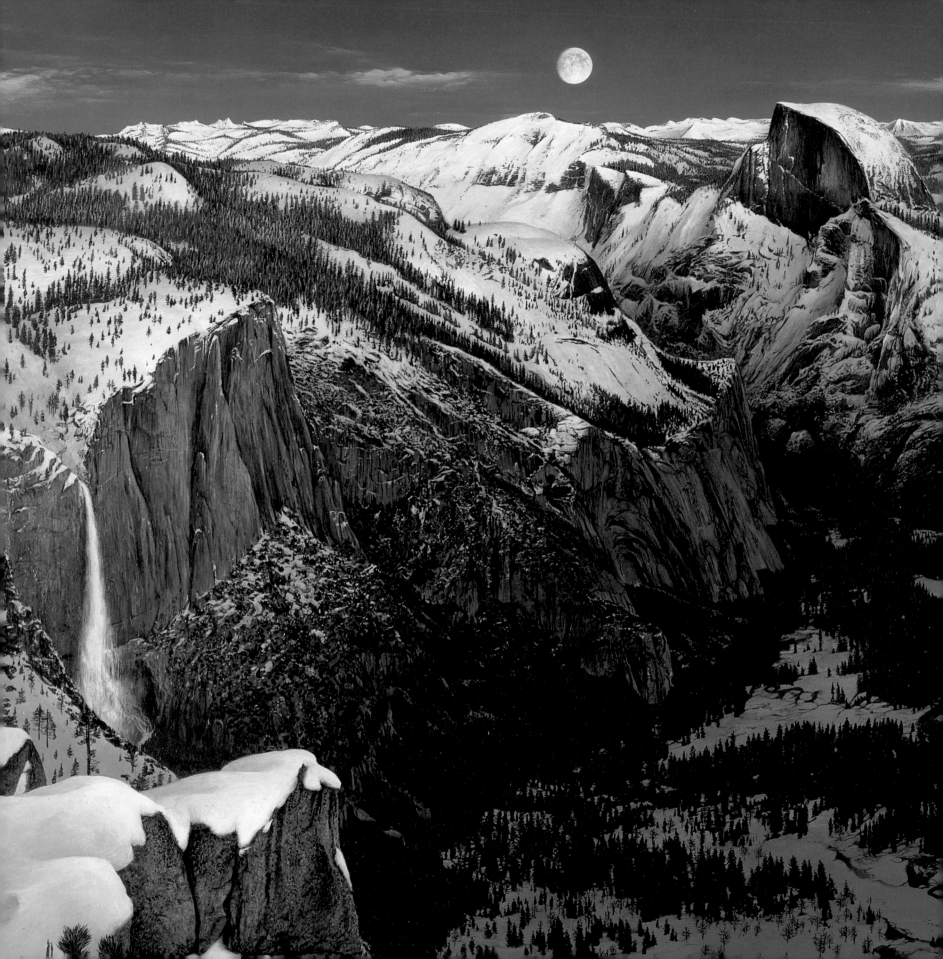

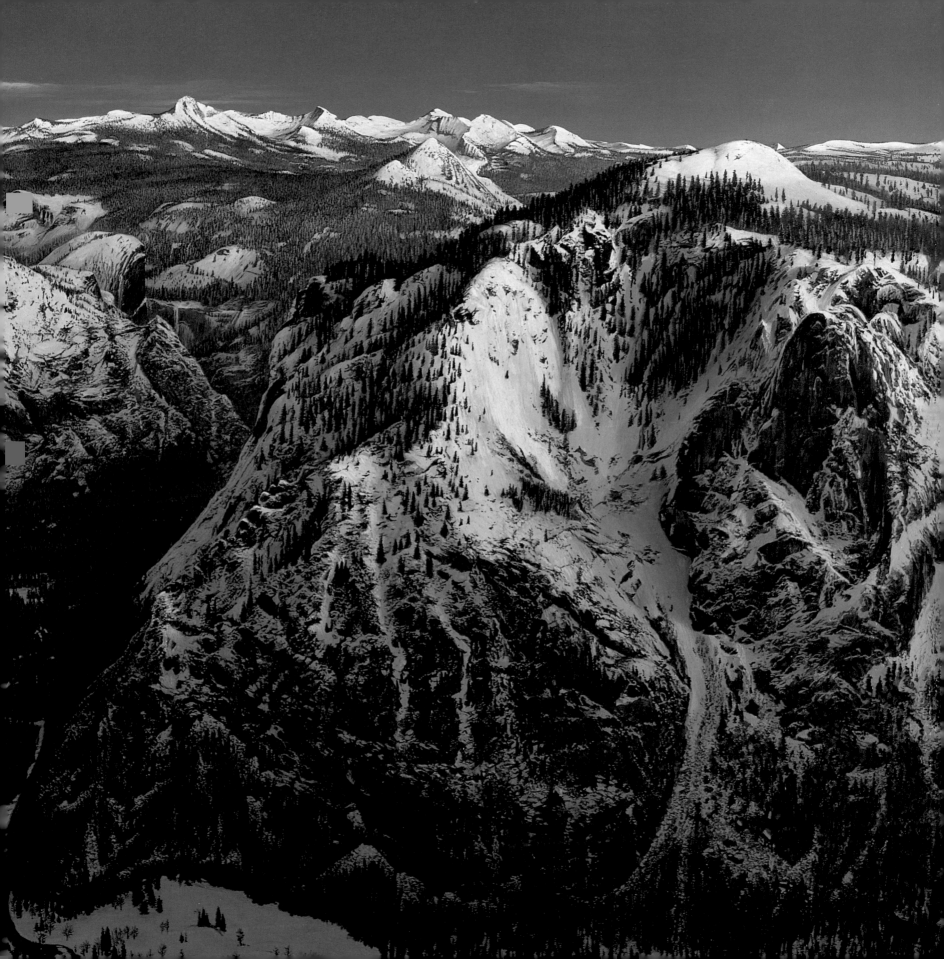

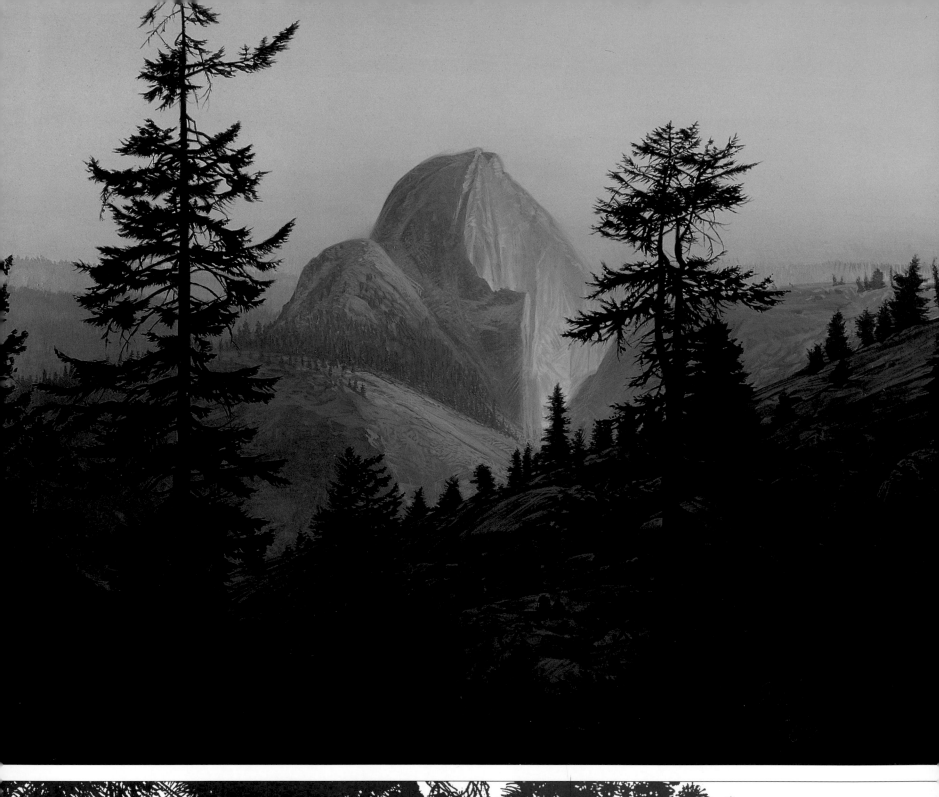

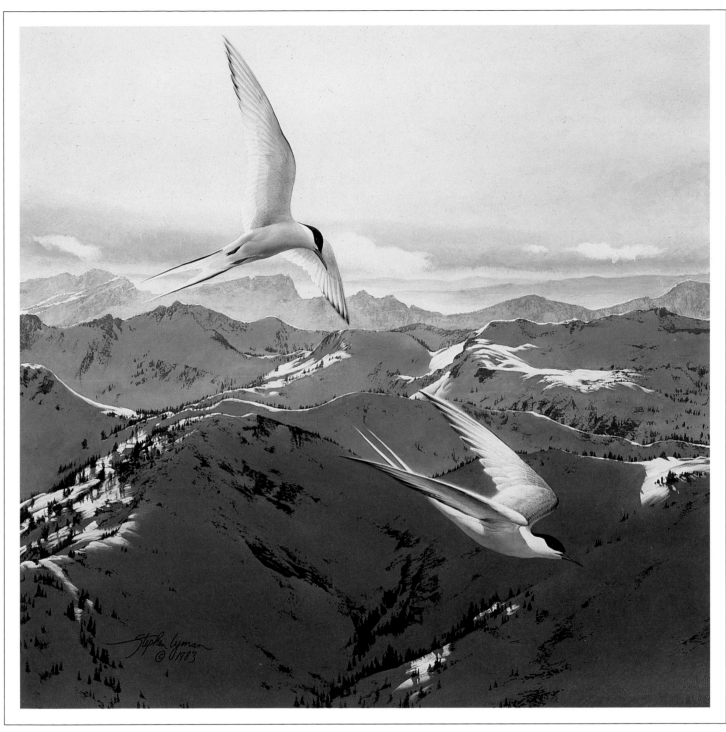

The Light of Tissiack

"Tissiack" was the Miwok name for Half Dome. From Olmstead Point, on the road to Tuolumne Meadows, it has a very different form. Also, I enjoy painting the quirky growth patterns that make each tree unique.

Free Flight

Two arctic terns in a very balanced portrait. One is dark against a light background; the other, light against a dark background. One going up and one going down — a graceful, complementary relationship.

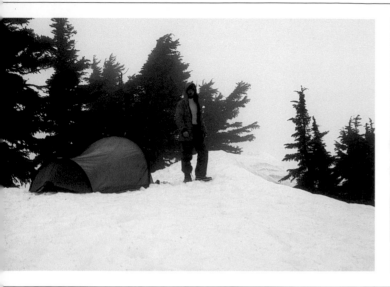
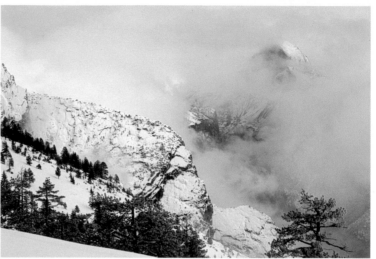
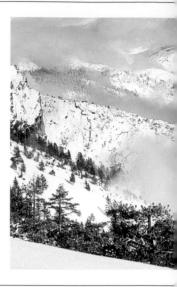

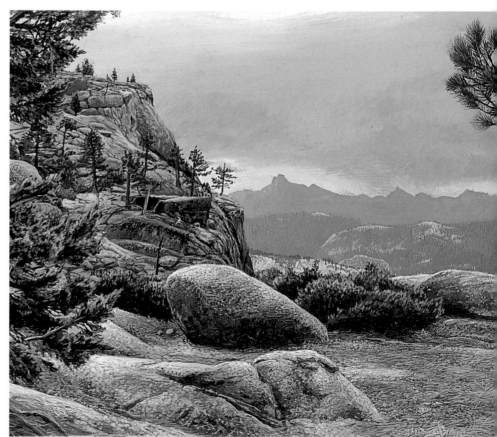

Yosemite Landscape

This painting was inspired by the scene at the top of
Yosemite Falls on the north rim of Yosemite Valley.
There, one has a panoramic view of Yosemite Point,
Mount Clark, Gray Peak, Red Peak, Mount Starr King,
Glacier Point, Sentinel Dome, and Sentinel Rock.

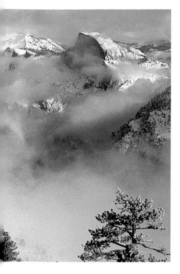
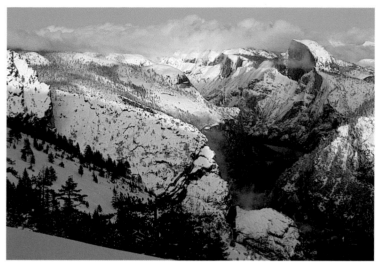
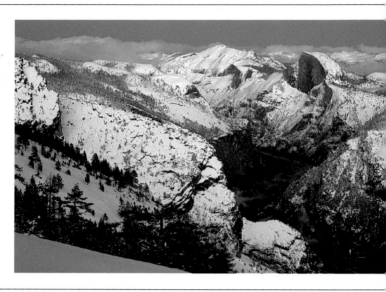

Stephen Lyman
© 1984

of saxifrage, penstemon, mountain sorrel, and columbine snuggle into rock crannies. An occasional buckwheat, dwarf daisy, or tiny elephant's head braves more open territory on the gravel flats and rock rubble. A flock of nervous, gray-crowned rosy finches wheels suddenly into sight from over the ridge, settling momentarily at the edge of the snowfield to search for insects. These little pink-bellied birds are the High Sierra's year-round residents, foraging on summits so windswept that they remain clear of snow even during the heaviest of winter storms.

Once again Steve gains the top of the ridge, and once more he's faced with a jungle of rocks. Such a wild land of boulders I've never been through! he thinks. No vegetation softens the contours of these crags. The stones are sharp-edged and steely gray. It's a desert up here.

The sun is now low on the horizon, bathing the west-facing slopes in a warm, orange glow. The canyon bottoms on either side of the ridge are fading from view, drowned in shadows that steadily rise toward their rims. Steve begins to think of finding a level spot on which to spend the night. But first, having approached the highest point on the crest— at 11,860 feet, the best possible lookout point— he decides to climb this main mast to its crow's nest, there to sit and absorb the mystical aura of his primeval surroundings.

Steve sits on the peak, conscious of the gigantic base of rock beneath him, its mass sloping up to the point where he is and thrusting him into the sky. It's like being seated on a throne, he thinks, imbibing an elixir of fresh

End of the Ridge

On a steep and strenuous climb up a slope that I thought would take me up a mountain, the rock suddenly dropped away into space, and I realized I was on a ridge. Inspiration came quickly to create this painting of two mountain goats surveying the expanse of a clearing storm.

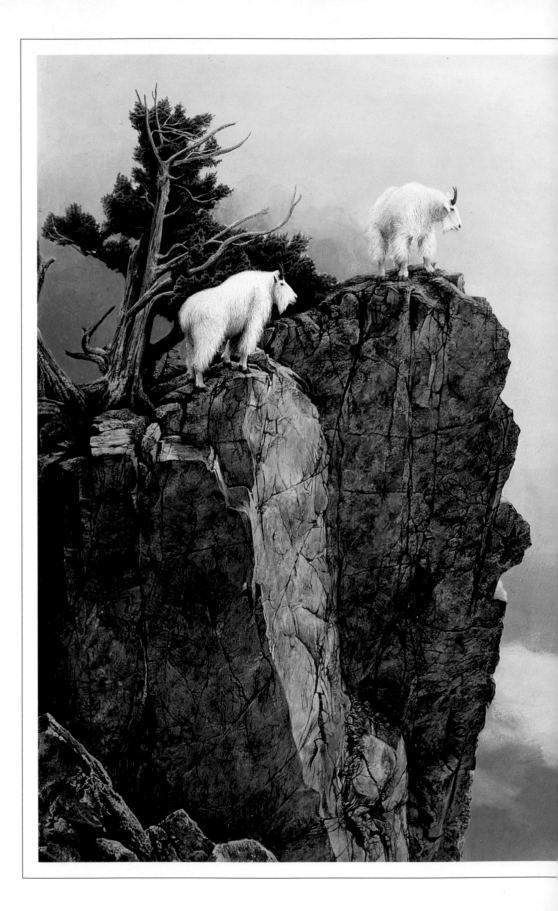

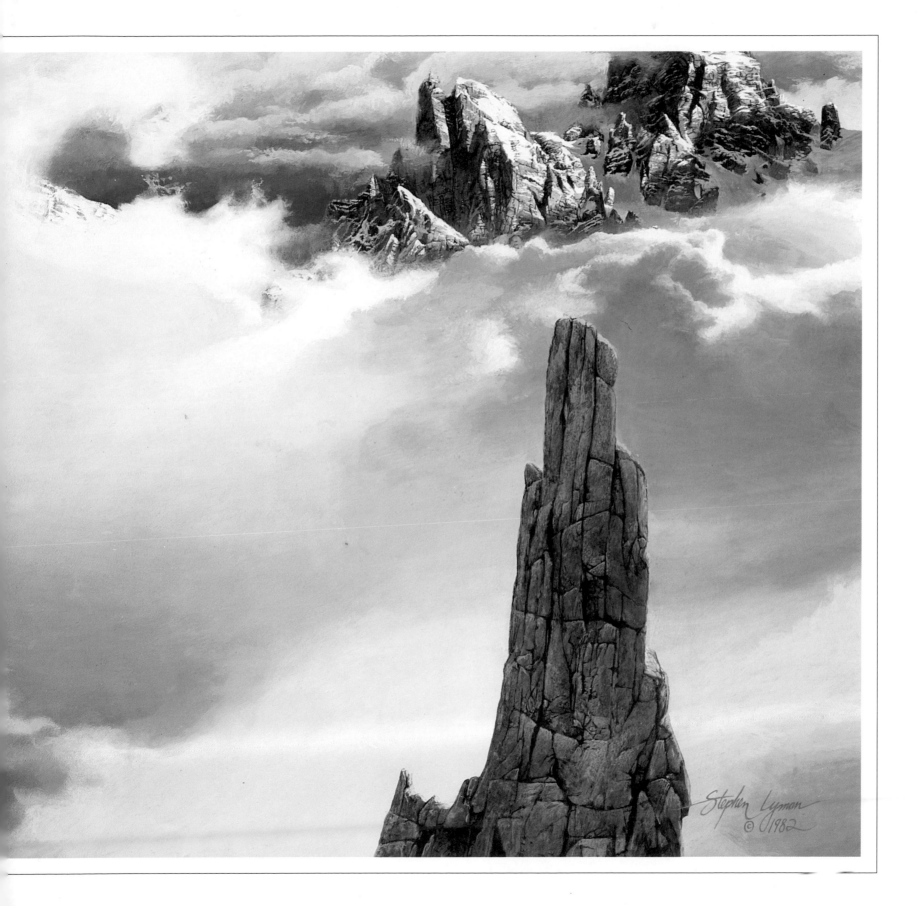

Stephen Lyman
© 1982

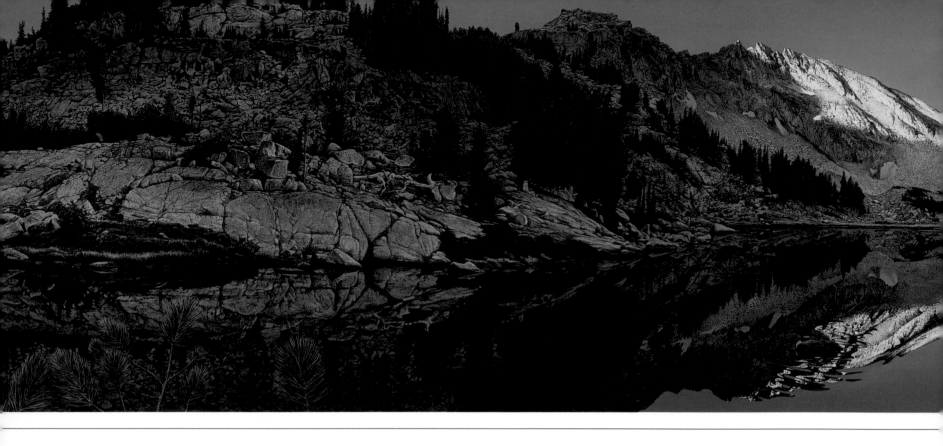

air, the lightness of which is making him giddy. Here the universe seems topsy-turvy, as though gravity is irrelevant and the sky around him has become an ocean. He feels himself bathing in the purest water imaginable. No wonder Muir once observed that whenever he sat upon a mountain peak, he loved nothing more than to dip his head into the sky.

Sunrise in the Wallowas

(Above) The Wallowa Mountains are a small range far removed from any major metropolis and consequently a little less used by people. Camped by this lake many years ago, I awoke in the morning to watch the crest of the ridge catch fire with the golden light of sunrise.

Alone in the High Winds

A lone wolf travels across a windswept plain in the mountains of Alaska.

[152]

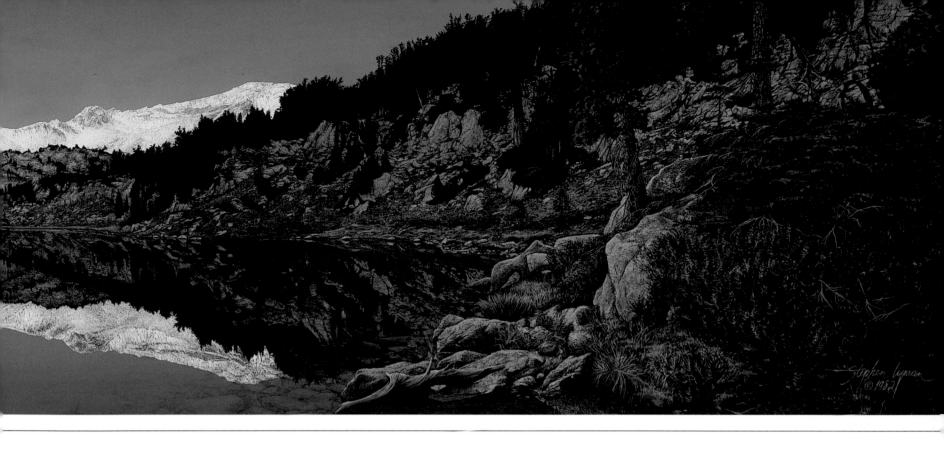

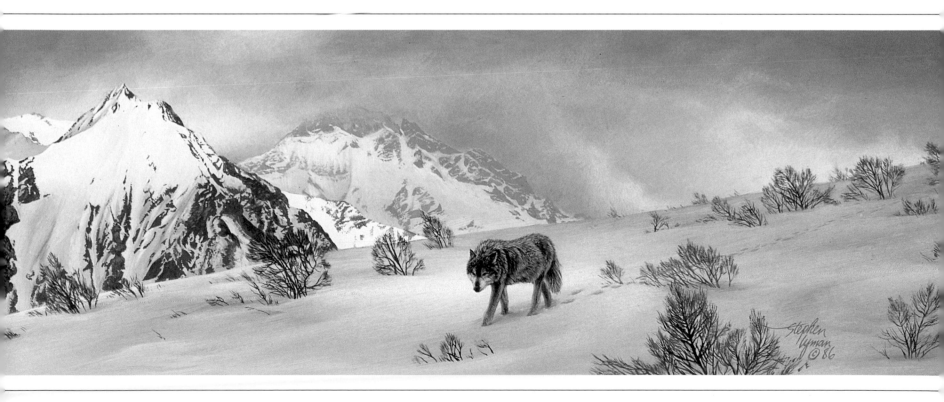

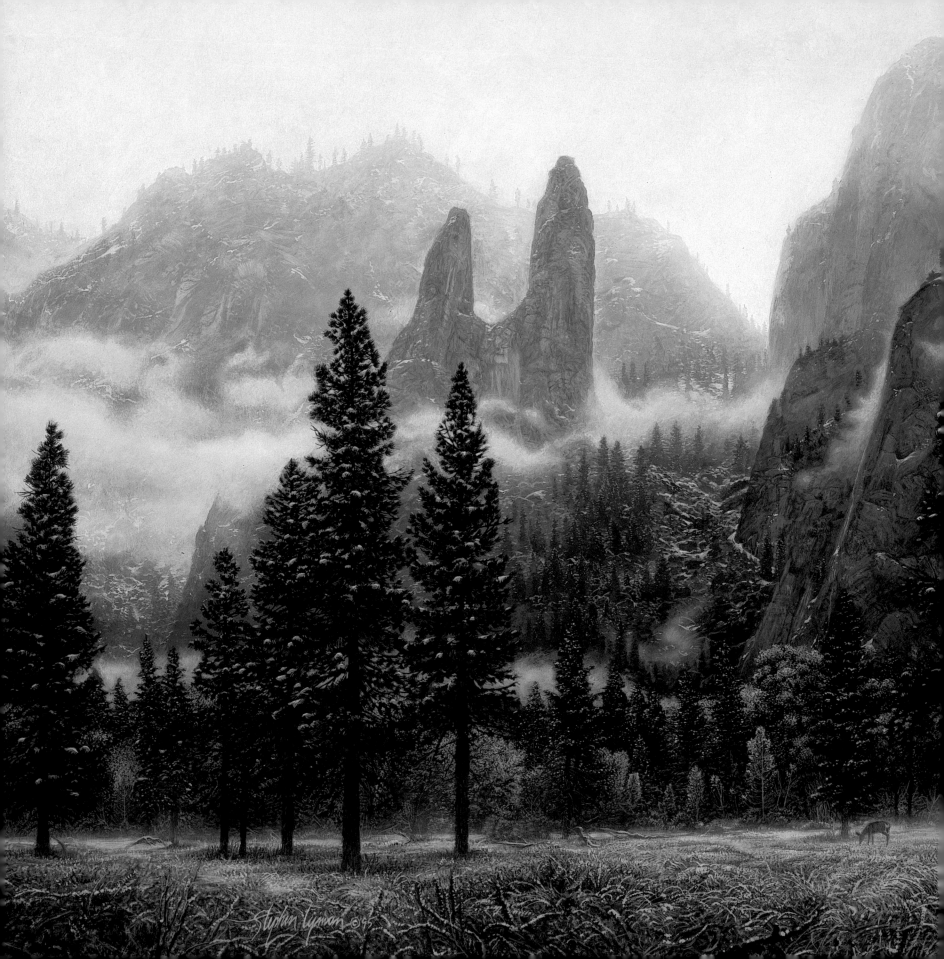

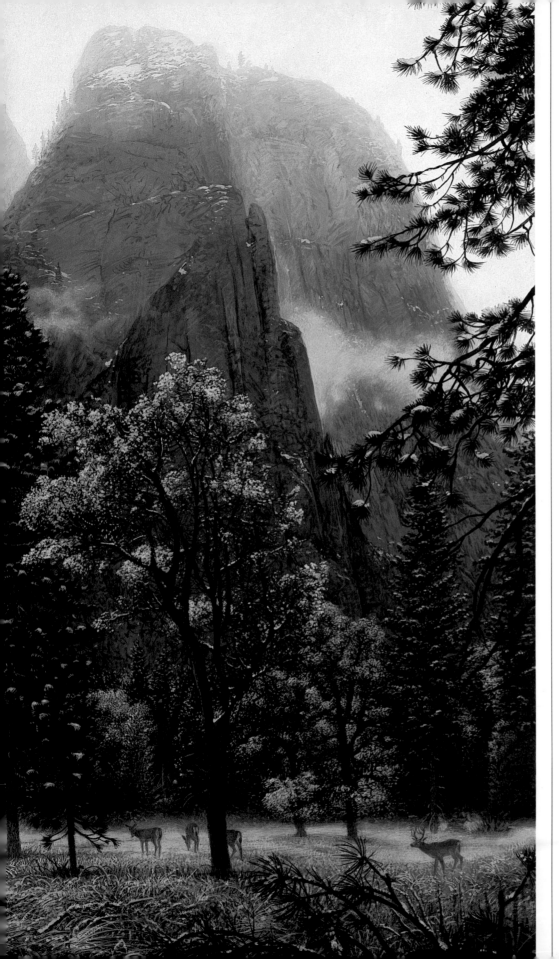

Cathedral Snow

Muir described Yosemite Valley as "an immense hall or temple lighted from above." Beneath the Cathedral Rocks and Spires, in late fall, after the oaks had turned color, the first snow had fallen, and the clouds and mist hovered around the cliffs, I gazed up in awe at the sacred beauty of this natural temple. Inspiration from wilderness is always present for me.

As Steve contemplates the gathering dusk, a golden eagle soars by, swooping down and landing on a rock jutting out below. By crawling to the edge of his precipice and craning his neck over the edge, Steve can just make out this magnificent bird's nest, a huge stick structure, perhaps six feet in diameter—and that is shorter than the bird's considerable wing

[155]

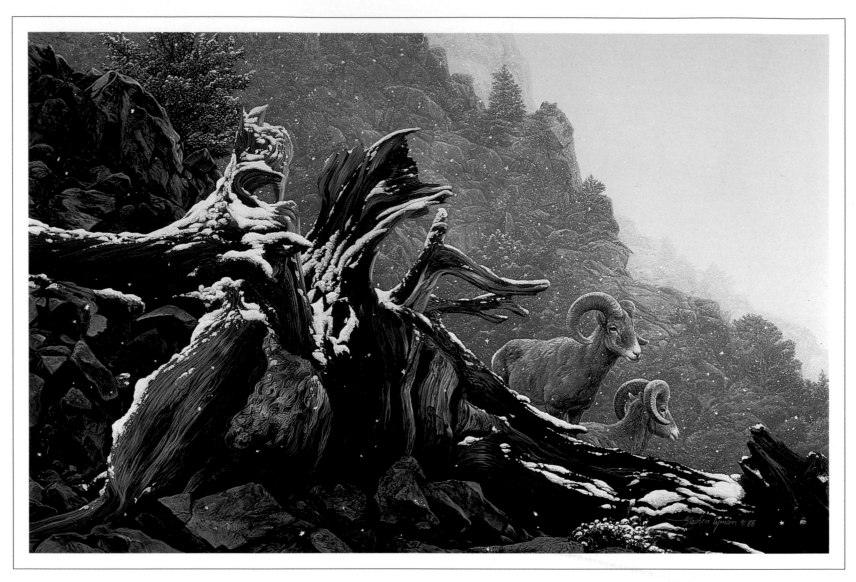

Snowfall on the Ridge

In the mid-1980s, after bighorn sheep had been missing from Yosemite for decades, a few were relocated to Yosemite from another part of the Sierra. The herd is surviving and slowly growing, a bright story in the history of man's impact on the mountains.

span. This individual may be a female, thinks Steve, still guarding her brood. He is close enough to make out the golden hue of her head and the light barring on her tail and wings, which contrast with her otherwise dark plumage.

To have reached this spot, where life exists tenaciously and survival depends on complete self-reliance, Steve feels himself to have grown immeasurably in stature, with his soul expanding to encompass the vastness of his surroundings. He reflects on the clarity of awareness here:

I am only a speck in this immensity, but connected as I am to everything in sight I am as tall as the mountains and as wide and deep as the canyons. I am here for only an hour, but while I am here time has no meaning and I am as ancient as the rock beneath me. On my own in these surroundings I am powerless, but with the mountains girding me I am as strong as Earth herself. My knowledge of the world is limited, but here I find wisdom—the possession of which is more valuable than all the facts stored in all the libraries and computer banks of the world. Here at last I unite in my mind

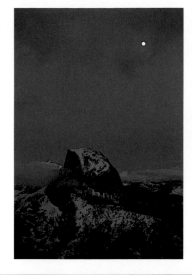

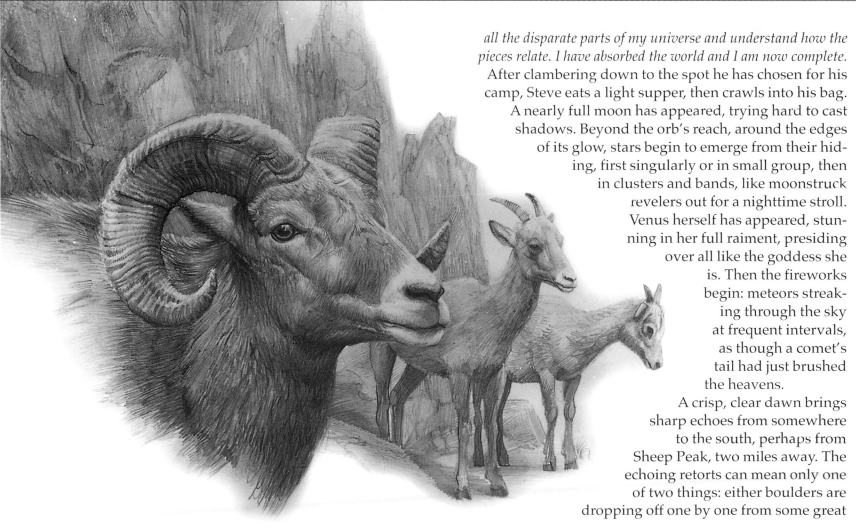

*all the disparate parts of my universe and understand how the
pieces relate. I have absorbed the world and I am now complete.*
After clambering down to the spot he has chosen for his
camp, Steve eats a light supper, then crawls into his bag.
A nearly full moon has appeared, trying hard to cast
shadows. Beyond the orb's reach, around the edges
of its glow, stars begin to emerge from their hid-
ing, first singularly or in small group, then
in clusters and bands, like moonstruck
revelers out for a nighttime stroll.
Venus herself has appeared, stun-
ning in her full raiment, presiding
over all like the goddess she
is. Then the fireworks
begin: meteors streak-
ing through the sky
at frequent intervals,
as though a comet's
tail had just brushed
the heavens.
A crisp, clear dawn brings
sharp echoes from somewhere
to the south, perhaps from
Sheep Peak, two miles away. The
echoing retorts can mean only one
of two things: either boulders are
dropping off one by one from some great

[157]

height, cracking on the rocks below, or bighorn rams are engaged in a butting contest, trying to determine which is worthiest to mate with the available ewes.

To hear the sound of bighorns in the Sierra is a rare privilege, for only a few hundred of the animals still survive in the range. Before the coming of Europeans to California, bighorns had roamed in ample numbers throughout most of the Sierra. But with the arrival of settlers, the population of wild sheep was sharply reduced by hunting and competition with domestic sheep, which took over forage land and transmitted scabies. Yosemite hadn't seen bighorns for forty years until some were reintroduced in 1986.

The time has come for Steve to leave the crest, but not before visiting the little hidden valley high in the sky. He clambers down to it and immediately sees that it is a marvel of architecture, its angular, jointed forms having been cleft and hewn by centuries of repeated freezing and thawing. For millions of years the sun and wind must have poured over the low southern edge of the crest, flowing directly into the valley. The wind, then, with its constant velocity, would have blown the snow in great powdery ribbons over the mountain crest to the northeast, sending it swirling down to the canyon below. The few snowdrifts remaining into summer would have been consumed by the sun. These actions would have prevented the formation of any glacier in the valley, sparing it the grinding fate of the surrounding terrain. The land in this valley is as the range would have appeared

before the last ice age. Steve walks down the center of this prehistoric monument, feeling its old age, conscious of his own youth and the fleetingness of his life.

The path takes him to the head of a steep gully that will lead him down to McCabe Creek. It's a quick descent down the shute, one that's hard on his knees, which must absorb much of the shock of his every step. They're smarting from the weight placed on them, but a little physical discomfort is a small price to pay for the experience of journeying through the geologic past and the depths of his own soul.

It will be good to walk out of the wilderness tomorrow, Steve thinks, and to be home the next day. He misses his family. Having completed yet another creative, sustaining, solitary venture, he feels rejuvenated, clear-headed, at peace, and capable of taking on tasks at home with renewed vigor.

Warmed by the View

Perhaps this seems an odd place for a campfire, but this cliff edge above Yosemite Falls is typical of where I like to camp. Fortunately, it's hard to go sleepwalking when zipped in a sleeping bag.

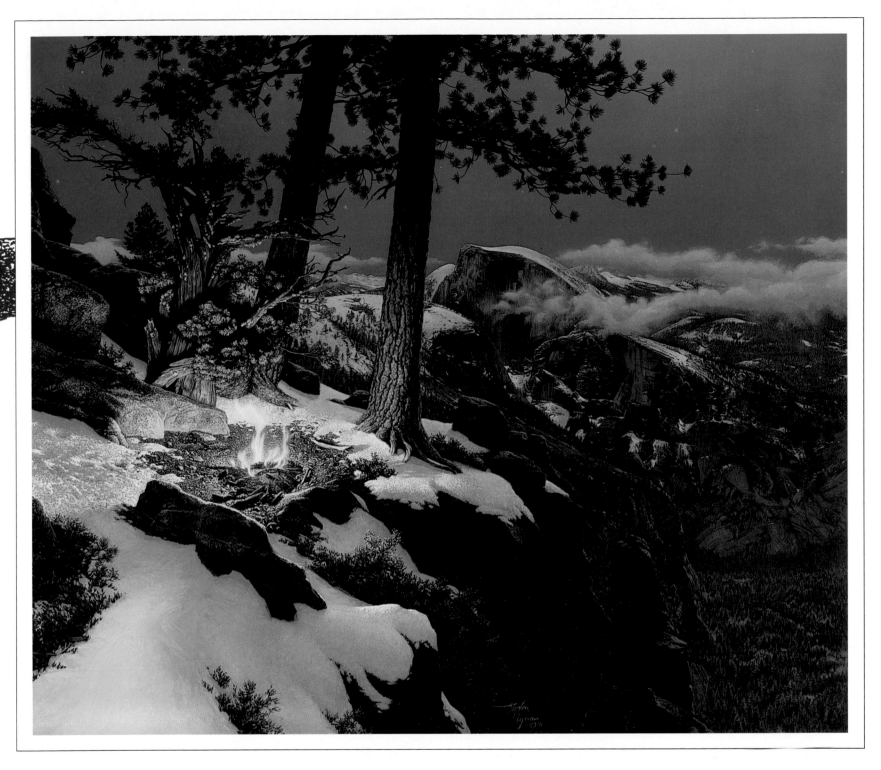

He feels very much as Muir did at the conclusion of his first summer in the Sierra: "Weariness rested away, and I feel eager and ready for another excursion a month or two long in the same wonderful wilderness. Now, however, I must turn toward the lowlands, praying and hoping Heaven will shove me back again."

Lantern Light

(Detail) Walk up onto the cabin's porch in "Wilderness Welcome" and take a look at the beautiful lantern. Its old, crusty, dented frame is backed by cold icicles. Break one off and crunch a piece of winter!

A HOME IN
THE WILDERNESS

we are all, in some sense, mountaineers, and going to the wilderness is going home

A HOME IN THE WILDERNESS

*we are all,
in some sense,
mountaineers,
and going
to the
wilderness is
going home*

—John Muir

It's a pleasure to be back home in northern Idaho, Steve acknowledges, grateful to be with his family once again. Here, in the foothills of the Cabinet Mountains, a sub-range of the Rockies, he has only to look out a window, step out on the porch, or wander down the road to the mailbox to satisfy his hunger for the sight, sound, scent, and touch of the forest. It's a wonderful place to return to after a journey through the Sierra.

It is no accident that he, his wife, Andrea, and their two young sons, Muir and Jarré, reside here. Steve feels strongly that the spirit of wilderness conveyed by his paintings should be embodied in all aspects of his life. Even when he's not rambling through the remote backcountry, he wants to continue to be in touch with wildness so that it can enrich his life each day. For this reason, the family dwells in a rural area where wildlife and humans exist in close proximity. They have established bonds with the land and its community of living things, taking pains to limit their impact on the environment. Their reward is a front-row seat in a never-ending display of natural wonders.

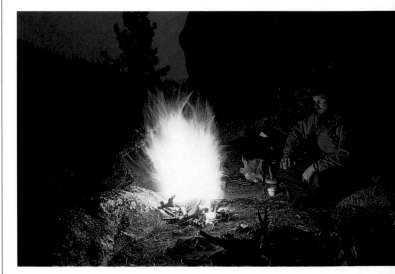

The snapping of twigs in the woods nearby alerts Steve to the movements of a moose among the trees. Or perhaps it's an elk or a white-tailed deer. It's hard to say exactly, since he can just make out an animal's form as it ambles through the early-morning shadows.

Muddy paw prints all over the porch indicate that a family of raccoons visited during the night. They often come sniffing around, and countless are the times Steve has stepped outside for a breath of night air, only to find himself confronted with several pairs of raccoon eyes reflecting the light from within the house. At other times, black bears have paid occasional visits, but since he is careful not to make any food available to them, they invariably wander off to forage in the forest.

One of the local beaver clans has again spent the night building a dam where Steve would prefer they not do so—just downstream from the bridge on the dirt road leading to the house. If they are allowed to continue, the reservoir that backs up behind the dam will wash over the bridge. Steve has tried several times to entice the beavers farther upstream, above the bridge, but so far they haven't budged. Having settled on what they regard as a perfect dam site, they're disinclined to change locations.

A rich aroma of moist humus fills the air, intoxicating to any gardener in the spring. The snow has melted away, the sun is lingering a little longer each day, and the ground is bursting with new life. As is usual at the beginning of spring, much work needs to be done around the house, especially in the five gardens. Steve, who grows vegetables and grains, and Andrea, who cultivates herbs and flowers, must attend to soil preparation, seeding, transplanting, composting, mulching, watering, staking, pruning, and other gardening essentials.

Potatoes are one of Steve's specialties. He grows about 20 different kinds. Some are heirloom varieties, descended directly from strains originating in the Andes of Peru—the ancestral home of all potatoes—and others first developed in Europe.

Spuds aren't Steve's only crop, of course. He raises everything from asparagus to peas to zucchini, enough produce to supply a small but important part of the family's diet. But growing things is more than a hobby for Steve; it's a passion. In no form is that zeal better demonstrated than in the remarkable fruits and vegetables resulting from his labor: strawberries the size of basketballs, seven-foot-tall carrots, cobs of corn the length of a pickup-truck bed, and potatoes so hefty that each requires a wheelbarrow to transport.

"I use lots of compost and sing to them," Steve admits with a smile when asked how he gets his plants to grow to such outsized proportions. Once he grew a pole-bean plant so tall he was able to climb it like Jack up the beanstalk.

If gardening is one way Steve expresses his love of the earth, another is to take every step he can to limit his impact on the environment.

His efforts toward this end will be abundantly evident in the new house he's building, on a mountainside surrounded by U.S. Forest Service and Bureau of Land Management land. Here he'll utilize a variety of "green" technologies for heating, refrigerating, and lighting. The house will be "off the grid," meaning that it will not be con-

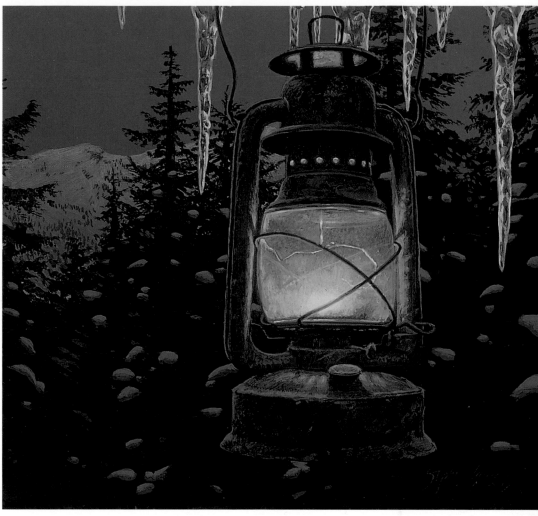

nected to a public utility, but rather will generate its own power by means of solar-electric (photovoltaic) panels on the roof that will charge a bank of batteries in the basement.

To keep perishable foods fresh in the new home, Steve will install a super-insulated, meticulously constructed refrigerator that will use one sixth the amount of electricity required by standard models. Similarly, energy for lighting the house will be reduced by using only compact fluorescent bulbs, which produce pure, warm light with a fraction of the power consumed by incandescent bulbs, and they last ten times longer.

Wilderness Welcome

(Left) The peaks of Oregon's Wallowa range are in the background, but the cabin is from my imagination. The feeling I've created is a warming one. The composition leads you to the front door, welcoming you home after tramping around the wilderness all day.

Lantern Light

(See page 160)

Perhaps the most innovative environmentally sound technology Steve is using in the new house is a centuries-old concept from Europe: a masonry heater that, by means of a wood-burning stove and a series of flues, transmits heat into all of the house's brickwork. The bricks then radiate heat for up to 24 hours after the fire has died. It's the most efficient use of wood fuel available anywhere and burns far cleaner than traditional woodstoves.

The house will be as free of toxic materials as possible, with every effort made to avoid pollution from paint, carpets, vinyl wallcoverings, floorings, and plastics, many of which release chemicals into the air. No plywood will be used inside, avoiding his use of the glues, formaldehyde, and other chemicals that go into its production. Wherever possible, Steve is using stone, slate, and ceramic tiles.

To save trees, Steve is using reclaimed wood in the construction of the kitchen cabinets. That does not mean the wood will be inferior. On the contrary, the wood has been recovered from buildings constructed out of old-growth timber in the nineteenth century, and it is as clear-grained and strong today as it was 100 years ago.

All these efforts are part and parcel of Steve Lyman's love for the wilderness, which is expressed most eloquently through his art. It was in northern Idaho that Steve first came to know and love wilderness. He was raised in the town of Lewiston, on the Snake River, downstream from Hells Canyon, the deepest canyon in North America. His family would drive 30 to 35 miles upriver on a one-lane dirt road to go angling for steelhead, sturgeon, and catfish. But he was more interested in exploring than in fishing. While the others sat for hours tending their lines, he would spend the time wandering along the riverbank, investigating nooks and crannies, an explorer in search of hidden beauties.

An abiding love of nature seemed to be an inherent part of his makeup. The wilder a place was, the more he liked it. Yet even at an early age, he perceived with dismay that the natural world was being trampled. Even Hells Canyon was not safe from abuse, as more and more people came to the national recreation area to "get away from it all." The canyon was being loved to death.

His concern manifested itself through art. In a high-school art class, he put together a montage

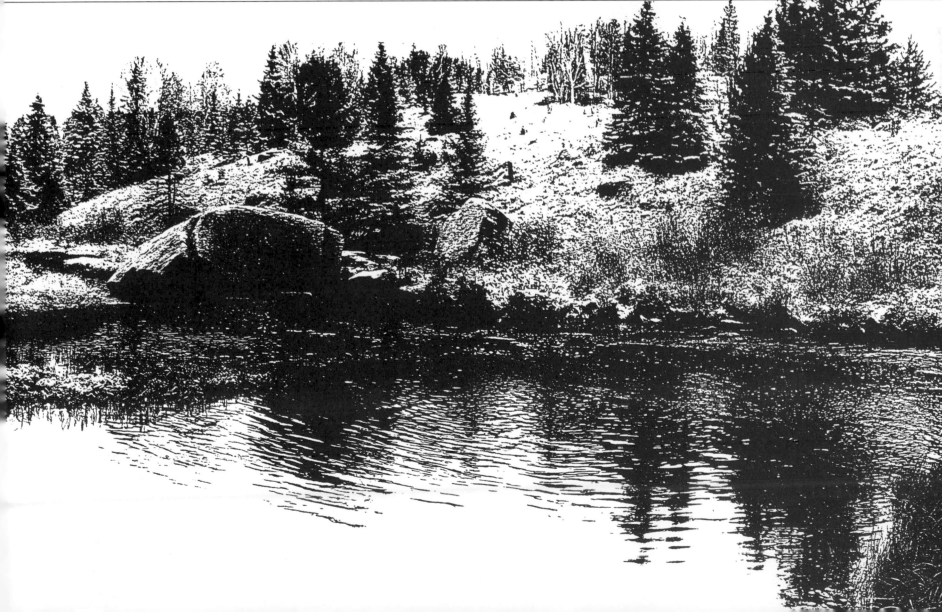

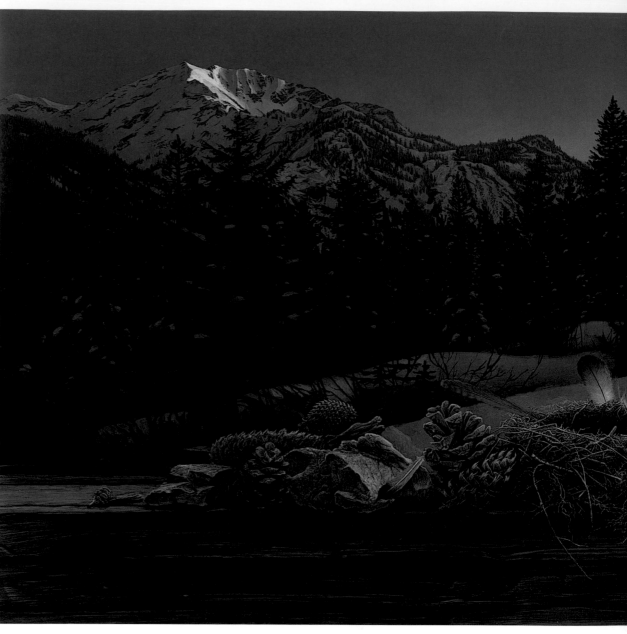

Evening Light

I don't normally paint interiors, but by doing a still life from inside a cabin, looking out through the window, I was able to get a different take on the wilderness experience. The candlelight serves the same function as a campfire, giving a warm glow to the scene.

[168]

of photographs from news and natural-history magazines. On the top of the piece he arrayed images of mountaintops, waterfalls, clouds, and other symbols of the world in its pristine state—similar in effect to the wilderness images he paints today. But along the bottom of the piece

he pasted pictures of smoke-belching factories, strip mines, asphalt highways, and other archetypes of the industrial age. Between them he drew two cartoon characters. As both were looking at the top and bottom of the piece, one turned to the other and said, "Well, I guess you can't

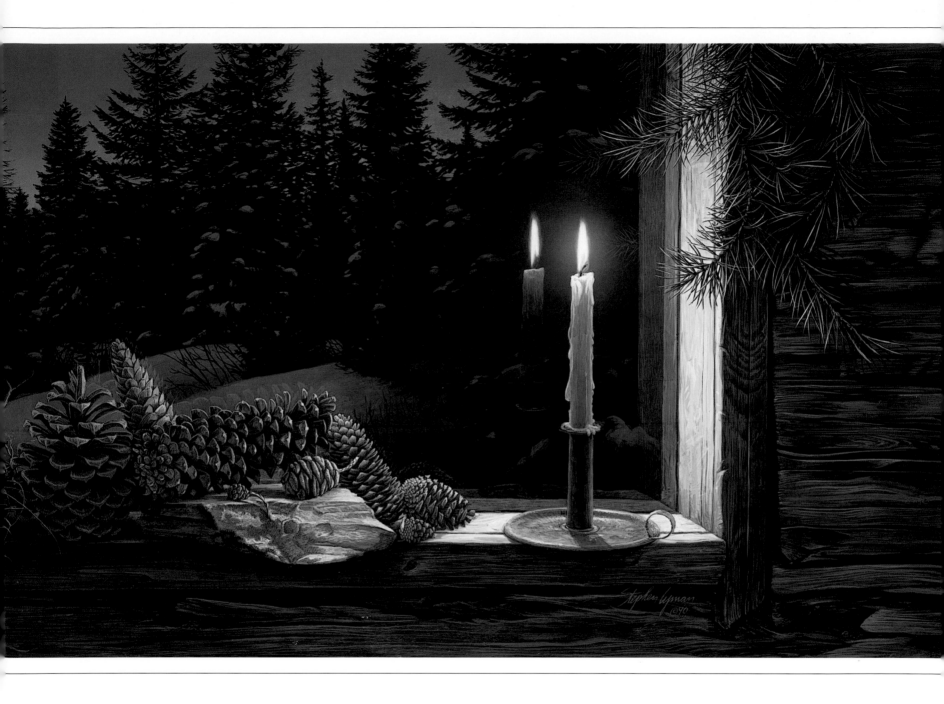

stop progress." The other replied, "Yeah—
the progress of destruction!"

"Technological development has
become a real challenge to people," Steve
says. "Too often it has nothing to do with
the betterment of humankind. If we don't
work more on our attitudes toward life,

on our relationships with each other and
with the earth, technology could be our
ruin rather than our salvation."

After high school, he attended the
University of Idaho for a semester before
enrolling in the prestigious Art Center
College of Design in Pasadena. At first he

was doing most of his work in the illustration department, but soon realized the world of commercial art wasn't for him. He was having difficulty with the restrictions it put on his creativity. Also, he was developing an aversion to trying to fulfill other people's profit-motivated design needs. He found himself unable to do the necessary homework. He needed a break to reflect on where he wanted his art to take him.

Taking a week off from school, he borrowed a pickup and headed to Yosemite. He had seen Ansel Adams' awe-inspiring photographs of the place and was reading Muir's *My First Summer in the Sierra.* His first backpacking trip through the park proved to be a milestone in his life. The mountains and valleys filled him with awe. They rekindled his latent love of the wilderness.

Back at school, he was newly inspired to create. He devoted as much of his art as possible to depicting the wilderness. His goal was to paint imagery that conveyed the majesty of the places he had seen. He knew that in wilderness he had found his calling, and this inspired him to adopt it as the main subject matter of his art.

After graduating, he stayed in Pasadena for a few months, researching the life and work of Muir. The first biography he read was Linnie Marsh Wolfe's *Son of the Wilderness: The Life of John Muir.* He strongly identified with the passionate and responsible way that Muir adapted his beliefs to his lifestyle.

His classmates asked him if he was going to stay in Los Angeles or go to New York to make his reputation. They gave him strange looks when he said he was going back to Idaho.

For the next couple of years, he worked at

The Spirit of Christmas

(Left) I have two young boys, and I wanted to create for them the magic and wonderful, warm-hearted feeling of Christmas. I decided to do a painting of the real Saint Nicholas — my interpretation of him, anyway. Indeed, he was a real person, a bishop in the fourth century, on the coast of what is now Turkey. He wore a red robe and was very generous, especially to children. I wanted to paint a character who embodied that love of giving.

Moonlit Flight on Christmas Night

What a ride it would be to join Saint Nicholas in his magical sleigh, silently cruising over a moonlit landscape of fresh snow!

[171]

ARCTIC DELEGATION

North America	Polar bear
South America	Andean condor
Africa	Zebra
Europe	Hedgehog
Asia	Giant panda
Australia	Kangaroo
Antarctica	Adélie penguin
Oceans	Humpback whale

The Intercontinental Oceanic Summits on What to Do about Humans

While the nations of the world met in Rio de Janeiro in 1992 for the earth summit conference on environment and development, other creatures on the planet began planning an agenda of their own. I was privileged to receive a special invitation to attend the summits in the arctic, desert southwest, rainforest, and alpine locations.

DESERT DELEGATION

North America	Desert tortoise
South America	Vicuña
Africa	Mountain gorilla
Europe	River kingfisher
Asia	Snow leopard
Australia	Koala
Antarctica	Black-browed albatross
Oceans	Walrus

Summits (continued)

As an artist, I was honored to be able to record such historic events. They welcomed me with open paws, wings, and flukes. At each, I noticed that there was an animal from every continent, as well as a representative from the oceans. They had come together bringing from their homelands their individual and unique perspectives on the effects humans have on their lives and environments.

Summits (continued)

What to do about humans? The animals now graciously invite us to participate in their summits to find solutions. They simply ask that we come to the table ready to pledge respect for all the other creatures of our planet and to live in ways which do not destroy their lives and homes. It is my hope that we can respond to them with caring and commitment. RSVP!

ALPINE DELEGATION

North America	Mountain goat
South America	Iguana
Africa	Elephant
Europe	Bat
Asia	Siberian tiger
Australia	Platypus
Antarctica	Antarctic tern
Oceans	Lobster

RAIN FOREST DELEGATION

North America	Black-footed ferret
South America	Giant anteater
Africa	Black rhinoceros
Europe	Ibex
Asia	Bactrian camel
Australia	Kookaburra
Antarctica	Emperor penguin
Oceans	Bottlenose dolphin

[175]

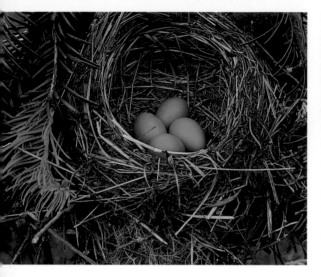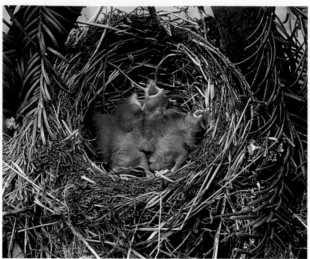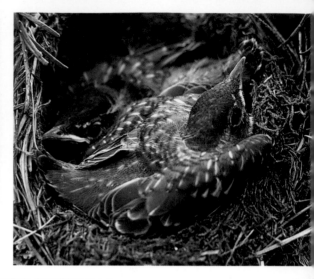

home, developing his style of art, endeavoring to create the most beautiful wilderness paintings he could. This artwork concentrated more on conveying his emotional reactions to the wilderness than on any particular trend.

Steve now spends most of each weekday in his studio at home, producing paintings that, perhaps inevitably, invite comparisons with such early Western-landscape masters as Albert Bierstadt, Thomas Hill, and William Keith. Yet while he admires the work of those painters and admits that they influence him, he nonetheless sees them as part of another era. Steeped as they were in artistic romanticism (Bierstadt and Hill were prominent figures in the Hudson River school of painting), they infused their landscapes with soft, warm light, casting mountains, forests, and animals in an often exaggerated ethereal glow, the painterly equivalent of a Keats poem ("'Beauty is truth, truth beauty'—that is all / Ye know on earth, and all ye need to know.").

The Edens they depicted are a far cry from the rugged, storm-swept precipices, forest interiors, rocky streams, and lake shores that dominate Steve's work. In his detailed, dramatic representations of wilderness and wild creatures, the viewer finds not transcendent lyricism, but a dynamic realism. His are landscapes in which only wild animals and the hardiest backcountry explorers can be imagined.

Yet there are times when Steve's art departs from the solemn grandeur of pristine wilderness to embrace other aspects of his character. A delight with children and their vivid world of imagination is revealed in Steve's storybook images of Saint Nicholas and his reindeer, while a nostalgia for a pioneering way of life is presented in his paintings of a cabin in the woods. A compassion for all species struggling to survive in an increasingly crowded and polluted world is humorously if poignantly expressed through his allegorical Intercontinental Oceanic Summits series.

"I want to open people's eyes to points of view and perspectives that aren't human-based," Steve says, "to suggest a less self-centered outlook in their role on the planet."

Under the expansive skies of northern Idaho, amid forest and gardens bursting with life, Steve Lyman is engaged in a lifelong quest to invoke in people an appreciation for the beauty of wilderness, and to rekindle humanity's connection to the Earth. But most of all he's relating his own journey in life, the unspoken reason for his being an artist in the wilderness.

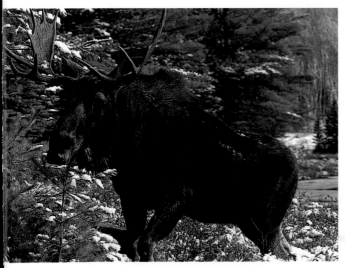

List of Photographs

When backpacking, I carry Nikon FM2 and FE2 bodies, small, older models which are light and tough. Lenses are 24mm, 35mm, 55mm macro, and an f2.8 80-200mm zoom. Most of the color images in this book are Fuji Velvia, the rest being Kodachromes. All black and white images were shot on Kodak High Speed Infrared film with a #25 red filter. These I process and print in my darkroom, but the slide films are commercially processed and mounted. When in the wilderness, I have an eye for both paintings and photographs. Shots which include a person are self-portraits. Most of them were taken by my setting up the shot on my tripod, starting the 10-second timer on my camera, then racing out to get into position. If I don't make it in 10 seconds, I do it again and run faster! All images are from Yosemite National Park unless otherwise noted. —Steve Lyman

Pages 12–13: Firelight beneath the pines; Sunlight through the morning mists, black oak tree, Yosemite Valley; At work in the studio on *Return of the Falcon*; Sunset, north Idaho

Pages 16–17: Sunset meditation, Tuolumne Canyon; Late winter, near Tiltill Valley; Taft Point, overlooking Yosemite Valley; Half Dome from the relatively unknown but spectacular Ledge Trail, below Glacier Point (photo by Shauna Lyman)

Page 21: Coyote pouncing on a meadow vole, Yosemite Valley

Pages 28–29: Aspen leaf on the trail; Pool in solid rock with reflection of sun; Granite stains and striations;

Walking a "dike"; White quartz that filled a crack in the older granite millions of years ago; Aspen leaf and lodgepole pine cone

Pages 34–35: Winding trail in Lyell Canyon; Setting out on an old logging road, north Idaho; Red-tailed hawk; Near the Continental Divide, western Montana

Pages 40–41: Alder leaf and lodgepole pine flower, Oregon; Snow-capped mushroom, Denali National Park, Alaska; Buds and berries, Wallowa Mountains, Oregon; Jeffrey pine cone; Cone dismantled by a Douglas squirrel for seeds

Pages 46–47: Rancheria Creek at sunset; Yosemite Falls; Hetch Hetchy Valley and Reservoir; Valley view, Merced River. El Capitan is left of center, Cathedral Rocks with 620-foot Bridalveil Fall right of center; Glacial erratic boulder and shadow; Merced River sand bar and Half Dome

Pages 52–53: Caterpillar; Prairie dog; Autumn foliage, western Oregon; Bachelor button; Frog; Foliage growing out of crack in granite; Iridescent beetle, north Idaho

Pages 60–61: 2,000-year-old sequoias; Boulders and ponderosa pines; Inside a burned pine; Camped in two feet of fresh snow, north rim of Yosemite Valley

Page 66: Red fir snag with woodpecker holes; Hiking through a fir forest; Fir tree patterns and textures; Rainbow and western hemlocks, north Idaho

Page 70–71: Jeffrey pine cones; Western white pine cones; Ponderosa pine cone and needles on burned log; Western white pine cone; Ponderosa pine cone; Old decaying sugar pine cone

Page 75: Young seedlings sprouting out of a burned log; Live oak leaf on snow; Lodgepole pine cone and branch on forest floor

Pages 86–87: Reflections in a stream; Crossing Rancheria Creek on a log; A close view of Nevada Falls at the end of summer; Sunset from upper McCabe Lake during the fires of 1987; Relaxing in my easy-rock chair deep beside the river in the Tuolumne Gorge

Pages 90–91: Rainbow in the mists of upper Yosemite Falls; Sun sparkles on Virginia Lake; Waterfall over glacially polished granite; Driftwood and pieces of bark, worn smooth by weeks of wave action in Rancheria Creek; Giant boulder in the Merced River; Green depths of Rancheria Creek

Pages 98–99: Frost crystals and ice on Rapid Lightning Creek, north Idaho

Pages 106–107: Water flowing over granite; Merced Lake sun sparkles; Black bear track; Virginia Lake observations from log's end (I was required to make a mad dash to get out to the end of the log before my camera's timer ran out and took this picture. I didn't quite make it the first try and ended up a blur of motion); Torch of color from my fire; Warmth and light for a weary mountaineer

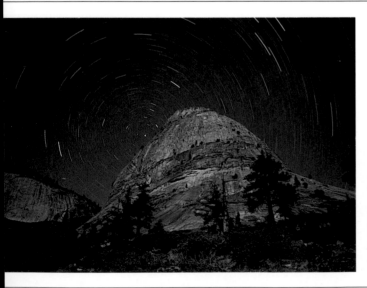
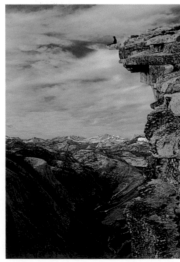

Pages 116–117: Climbing the snowfields on the flanks of Unicorn Peak, Tuolumne Meadows; "Sun dog" rainbow; Climbing the "Snake Dike" on the back of Half Dome; Lost! amidst the numerous cairns which many people set up on the trail to Glen Aulin; Clouds over Half Dome

Pages 122–123: Glacial erratic boulder on Turtleback Dome; Taking in the view from Shepherd's Crest, 11,500 feet elevation; The "Woman of the Woods" makes her face seen every once in a while, especially if I happen to find a piece of charcoal lying nearby; Aspen leaves; Morning sun on the rim of Yosemite Valley; Moonrise over Cathedral Peak; Sunrise over Cathedral Rocks during the fires of 1987

Page 127: Weathered wood and cone; A Lymanic eclipse of the sun; Upper Yosemite Fall and Half Dome

Page 131: Sunset colors over Tuolumne Meadows (photo by Terry Asker); Makeshift goggles to ease the sting of mild snow blindness; Fissure at Taft Point, south rim of Yosemite Valley; Pine cone travels

Pages 138–139: Sunset from Unicorn Peak, Tuolumne Meadows; Jeffrey pine and Half Dome from the top of El Capitan (While I was photographing this, two climbers popped up over the edge, having just completed climbing a difficult route on the 3,000-foot face of El Capitan in 15 hours.); The joy of rock, sun, and fresh mountain air; Peak-jumping at Red Peak Pass (photo by Shauna Lyman)

Pages 148–149: Camp on Mount Rainier, Washington; Half Dome and Yosemite Valley emerge from a clearing winter storm as seen from my camp on the top of El Capitan

Page 157: Half Dome and moonrise from Glacier Point; Sunset, north Idaho; Watching the sun set from Quartzite Peak

Pages 162–163: The fire's glow takes the chill away; Morning camp; Home sweet home in north Idaho, vegetable garden asleep under the snow; Backcountry cabin, Kokanee Provincial Park, B.C., Canada

Pages 166–167: Steve & the beanstalk: harvesting green beans; Idaho's famous potatoes; One of our vegetable gardens; Mouth-watering corn on the cob; Carrot-packing to get in shape for wilderness treks; Raspberries from the garden

Pages 176–177: Robin's eggs and nest in my garden trellis; Hatched and hungry; Winged and feathered, ready to leave the nest; Bull moose, Algonquin Provincial Park, Ontario, Canada; Solar-electric photovoltaic panels generate our electricity (photo by Andrea Lyman); Our scenic driveway, winter twilight, north Idaho

Pages 178–179: 20-minute exposure of star tracks around Polaris over an unnamed dome; Sitting at the edge of Half Dome, gazing 5,000 feet down (photo by Terry Asker); Pine and maple branches, Algonquin

Provincial Park, Ontario, Canada; Purple coneflowers from Andrea's garden; Reflections on glacially polished granite; Lake meditations, Wallowa Mountains, Oregon; Close-up of wildflowers high in the Sierra Nevada

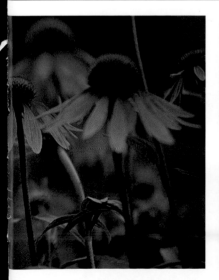

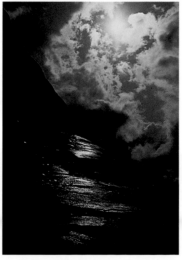

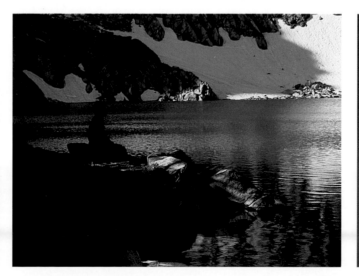

List of Artwork

PAINTINGS

Ahwahnee—The Deep Grassy
 Valley 46–47
Alone in the High Winds 152–153
Among the Wild Brambles 14
At Meadow's Edge 32
Autumn Breeze 50–51
Autumn Gathering 122–123

Bear & Blossoms 44–45
Big Country, The 22
Blue and Gold 68
Boulder Bruin 124

Canadian Autumn 92–93
Cathedral Snow 154–155
Cinnamon Teal 55
Color in the Snow 128
Colors of Twilight 27
Coyote Afternoon 20
Crimson Indigo 49

Dance of Cloud and Cliff 18–19
Dance of Water and Light 120

Early Winter in the Mountains 140–141
Elegant Couple, An 96
Embers at Dawn 135
End of the Ridge 150–151
Evening Glow in Yosemite 132
Evening Light 168–169

Field Watcher, The 52–53
Fire Dance 31
Fishing with Patience 24–25
Free Flight 147

Good Food, Good Drink 54–55
Graceful Steps 133

High Creek Crossing 72–73
High Light 136
High Trail at Sunset 130

Intercontinental Oceanic Summits
 on What to Do about Humans, The
 Alpine Delegation 174
 Arctic Delegation 172
 Desert Delegation 173
 Rain Forest Delegation 175
Intruder, The 76

Lake of the Shining Rocks 118–119
Lantern Light 160, 165
Last Light of Winter 28–29
Light of Tissiack, The 146

Midnight Fire 56–57
Monarch of the Meadow 23
Moonfire 112–113
Moonlit Flight on
 Christmas Night 170–171
Moon Shadows 48–49
Morning Solitude 101
Mountain Campfire, A 83

New Kid on the Rock 96–97
New Territory 108–109
Noisy Neighbor 104–105
North Country Shores 102–103
Northern Reflections 84

October Flight 67
On the Brink of Flight 126

Pass, The, detail 2–3
Pause in the Hunt, A 50
Pika, detail 6–7

Quiet Rain 100

Raptor's Watch, The 36–37
Red Squirrel 125
Return of the Falcon 121
Riparian Riches 90–91
River of Light 98–99
Rufous Hummingbird and Mountain
 Hemlock 70
Rufous Hummingbird and Nest 74

Secret Watch 142
Sentinel of the Grove 58
Shasta Flight 106–107
Shootingstars and Ladybug 42
Silent Sentinel 77
Silent Snows 26
Snow Hunter 64
Snowfall on the Ridge 156
Snowy Throne 129
Song of the Meadow 38
Sounds of Silence 71
Sounds of Sunset 94–95
Spirit of Christmas, The 170
Steller Autumn, detail 4–5
Sundown 108
Sunrise in the Wallowas 152–153
Swallowtail Butterfly and Pink
 Mountain Heather 39

Thunderbolt 114
Tiger Lilies and Grasshopper 43
Tom 69
Twilight Snow 80

Uzumati—The Great Bear
 of Yosemite 88–89

Waiting Game, The 110–111
Walk in the Woods, A 62–63
Warmed by the View 159
Wilderness Welcome 164–165
Winter Fir 40–41
Winter in the Air 143
Winter's Hunt, A 80–81
Winter Shadows 78–79
Woodland Haven 65

Yosemite Alpenglow 144–145
Yosemite Landscape 148–149

DRAWINGS

Half Dome 19
Willow ptarmigan 23
Coons 25
Reclining gray wolf 26
Douglas squirrel 40
Black tail beauties—mule deer 42
Black bear cubs 44
Canada goose 55
Bobcat 65
Mantling bald eagle 66
Bison 73
Uzumati 89
Nene trio—Hawaiian nene geese 105
Raccoon pair 111
Vernal Falls 120
Peregrine falcon 121
Golden eagle 127
Great horned owl 129
Doe mule deer 133
Gray wolf 142
Buck mule deer 155
Big horn sheep 157
Raccoon duo 175